Bone Deep

A Cooper School Novel

Jan Levine Thal

"I thoroughly enjoyed Jan Levine Thal's *Clean to the Bone*, with its bright dialog flickering around its dark subject matter."

> — **Peter Berryman**, coauthor *The Berryman Berryman Songbook*, *The New Berryman Berryman Songbook*, and *Frescoes and Bowling Balls*

"An unemployed teacher lands a dream job at a private school in an idyllic, mountainous landscape. But she can't ski. More seriously, she can't differentiate good guys from bad—and the bad guys here are very bad—very. This is a smart, witty, and suspenseful treatment of a woman who not only learns to forgive herself for her past, but applies the skills acquired there to protect those she's come to love. This novel entertains while making the personal political. Not nearly enough novels pull that off."

> —**Laurel Yourke**, UW—Madison, Emeritus, author of *Take your Characters to Dinner*

"You'll like Callie. She's tough without being hard. But she is tough—and needs to be."

> —**MJ Jones**, award-winning author, *Crime in Its Time*

"With crisp, clear-eyed prose and a gleeful irreverence, Jan Levine Thal builds a thriller that draws on the dark wit of such British mystery writers as P.D. James as well as the moral fortitude of Swedish ones like Henning Mankel. Calinda Franklin is my kind of dame."

—**Lisa Rosman,** media critic Her work appears in *NY1's Talking Pictures, Time Out New York, Salon, LA Weekly, Marie Claire, Word and Film*. Find her online at SignsAndSirens.com

"In the real world, the educational landscape is typified by racial and economic inequality. But at the Cooper School, an institution brought to life by Jan Levine Thal in *Clean to the Bone*, girls from society's lower rungs become empowered and engaged learners. By offering a prep school education to low-income girls of color, Cooper School gives life to the idea that every girl deserves a shot at success. Callie, a new teacher at Cooper School, brings literature to life for students in her classroom. Even more importantly, she creates a space outside the classroom for girls to speak up and shine a light into the darkness that hides sexual assault from view. Levine Thal's book represents an ideal education for young women, where they are inspired, challenged, and empowered to take control of their own lives and bodies."

—**Catherine Capellaro** former editor, *Rethinking Schools*. Co-author *Walmartopia, Temp Slave, the Musical*, and *In the Beginning*

> *Beauty is only skin deep, but ugly goes clean to the bone.*
> ~Dorothy Parker

Cover design by Trisha Lewis and Ingrid Kallick

Edits & Layout & Publishing via Van Velzer Press
Second Edition, 2020
ISBN: 9 7 8 - 1 - 9 5 4 2 5 3 - 0 0 - 1
* 1st edition published as *Clean to the Bone.*

Printed in the United States of America

VanVelzerPress.com

This book is dedicated to teachers.

Mine. Yours. The ones who buy their own supplies because the school system is too broke; the ones who sit next to us on the bus and say that one inspirational sentence; the ones in our families; the ones we'll meet tomorrow at the supermarket or on the picket line; the ones who poke us awake; the good ones, the bad ones, the ones we don't remember. And especially the activists who show us that we can make a difference by using our words.

CHAPTER 1

allie was early for the interview, the one she couldn't blow. Gone were childhood lies like Prince Charming—or anyone else for that matter—arriving in the nick of time. The nick had come and gone, and here she was, at a hotel in Troyville, Pennsylvania, with only her own wiles. She squared her shoulders for courage. *Ace this. You can't live without money.* The door to the hotel conference room opened soundlessly and a man in a conservative business suit left without acknowledging Callie who was standing on the ersatz-marble floor. His graceless clomp-clomp echoed down the hall.

Callie decided against waylaying her potential employer, apparently headed to the men's lavatory. Instead, she glanced into the meeting room, gauging where to wait. A nondescript conference table and chairs, a whiteboard with markers ... and silence. The only signs of human life were an open newspaper and a metal coffee cart exuding an aroma suggesting a fresh, hot brew. She longed to help herself but didn't want to presume.

While she deliberated about what was appropriate, a muscular man in worn denims—definitely not the designer kind—sauntered in and helped himself to coffee. Apparently the hotel staff could presume whatever they wanted. "Excuse me?" She willed him to welcome her as a fellow worker on the unfamiliar planet of bosses.

The man looked up, face blank, piercing black eyes sending a cold shiver along a couple of meridians Callie hadn't known she had. Maybe he couldn't tell she was tough like him. At thirty-one, her face remained unlined, its only blemish a scar from her

brawling days, mostly hidden under an eyebrow. The dove necklace she always wore reminded her to seek peace, as Aunt Sophie intended. Callie touched it briefly before speaking. "Are the Cooper School interviews here?"

"Yep." His calloused hand dwarfed a white ceramic coffee mug. He picked up the newspaper, no doubt prepared to leave once the suit returned.

Ignored by the interviewer and dismissed by the janitor. Perfect. She slid out of her coat, hoping the thrift-store navy suit still hid the rip in her pantyhose, an outfit meant to suggest trustworthiness and a thorough knowledge of English literature.

A ringing phone had begun this day. Forcing her eyes open, Callie cringed at the evidence of yesterday—the company pink slip, complaining muscles born of dancing on heels, aching head commemorating unaccustomed drinking to excess. Remnants of her last acceptable pantyhose, torn off at two a.m., drooped like a punctured lifeline across the standing radiator in her tiny rental. *Answer the phone. Might as well live—thank you, Dorothy Parker.*

The caller offered an interview for an English teacher at a private high school. Only the hangover assured Callie that the call was not a dream, a cruel twist on her usual anxious nightmares. Six hours of mad preparations had ended at the hotel women's lounge, where she'd applied ruby lipstick, wondering what an interviewer would see. Fit from years of running and lifting, she could steady the wobble on her rarely worn high heeled dress boots but couldn't magically fix her cheap haircut nor silence the *Charge of the Light Brigade*. The Valley of Death turned out to be a conference room with a bored custodian.

"Mind if I sit?" Callie nodded toward an institutional upholstered chair at the end of the table. *Notes reviewed. Internet consulted. Confidence? Not so much.*

"No problem." He waved in short spurts like a conductor dismissing a bad cellist. The man's unexpected grace distracted Callie. His disheveled newspaper effortlessly transformed into tidy folds as he set the paper aside and transferred his attention to her. Probably not dangerous, just large.

She was surprised that he sat across from her. Older than the

men Callie dated—probably in his early forties—he was decidedly attractive in a Paul Bunyan way. Maybe she'd given him the wrong idea. Wouldn't be the first time. Though not beautiful by classical standards, Callie knew that men tended to misread her hazel eyes and wide mouth as open to advances. *Give him a gentle nudge, or possibly a cold shoulder.* "I'm the next appointment."

The man opened his mouth, closed it, pointed to the insulated pitcher and several cups lined up on the cart like a firing squad. "Coffee?"

Callie noticed a plain gold band on his left hand. *Married. Just as well. Can't really date a janitor in Pennsylvania, attractive or not, if you become a teacher in upstate New York.* "No, thanks." *Focus. If you can't intrigue this guy, you'll be a dead loss with the suit.* "It'll make me jittery." No smile. She eyed the empty doorway, then her watch. Not four o'clock but close enough. She pulled her resume and transcripts from her tattered nylon briefcase. No degree despite the parade of As. "Any idea when the interviewer will be back?"

The man stared into his cup. "Cooper School."

Guy speak for "Don't know?" Focus on the job. Maybe rehearse? "The school was named after its founder, Gwendolyn Cooper, an early twentieth century eccentric."

"Eccentric?"

Perhaps he didn't know what it meant. *Don't be a bitch, Callie.* She hated it when she imitated Blake, even unconsciously. Her mother had married Blake to improve their lives, shattered when her father died. Never had a plan gone so awry. Though Blake should be in hell, prison would do for now.

Callie concentrated on winning over the maintenance man. "I mean the founder was considered odd because she didn't savor teas and polo matches. About a hundred years ago, she founded a boarding school in upstate New York for, in her words, 'talented young ladies of limited means.' Mrs. Cooper held the unpopular belief that poor girls could be smart, given half a chance."

He shrugged. Was she talking too much? She didn't care. Talking bolstered her courage. "In Gwendolyn's youth she championed votes for women, like her friend Jane Addams, who

invented Chicago settlement houses. Gwendolyn saw lots of poor girls work themselves to the bone, starting as children. Education could give them other choices." Callie got up to check the hallway—empty in both directions. "Her school is perfect for someone like me."

"Like you? Are you rich? Eccentric?" The man lounged back, surveying the conference room, perhaps finding it more fascinating than Callie.

His seeming indifference motivated a perverse desire to impart her own story—her mother's death, the evil Blake, the years in juvenile hall. While she generally revealed little, why not confess all to someone she'd never see again? Several barflies had heard bits and pieces. Fortunately, few retained much. Profound distrust of men stopped her. Her fallback was to find protective coloring in the mundane. "Neither. Out of work like everyone else."

She suppressed an urge to blurt Aunt Sophie's condemnation of social injustice: "You can't live without money." Extracted from a Living Theatre play performed before Callie's birth, Sophie's hippie homily meant that most people had to work, and few at something they loved. A generation later, those words became Callie's personal slogan to justify her minimum wage jobs and sympathy for other girls without resources.

Still no interviewer—once again she'd been stood up for no apparent reason. Under the table she stretched her legs. Her left toe popped through a new hole in the pantyhose, bumping against the unlined inside of the tight boots. Callie glanced at her hands, inexpertly self-manicured. "Private secondary schools can reek of marijuana and navel gazing. But Cooper isn't a granola school. Girls at the Cooper School don't have nicer cars than the faculty."

"Granola?" He appeared to be listening.

She doubted she'd last one day at a rich-kid prep school, even if they'd hire her. "You know. Touchy feely stuff. Not enough, well, three Rs. Cooper promotes serious study."

He swirled his coffee like expensive brandy. "Don't all prep schools say the same?"

Is he reading her my mind? "Cooper girls aren't typical preppies.

No holidays abroad, no family fortunes. They're chosen from hundreds of applicants, each needier than the next." She self-consciously suppressed a nervous giggle. "In the old days Cooper had a charm school."

"Charm school?" The man's face cracked a smile for the first time.

Callie shook her head at the transgressions of history. "Back then the school taught girls to act 'genteel.' Graduates in Mrs. Cooper's day married into good families or got jobs as tutors or shop girls. These days it sounds condescending to say that you'll help girls move to a better social class. But a girl from limited resources often hasn't been exposed to …" She stopped quoting Aunt Sophie, afraid to sound preachy.

The big guy poured himself more coffee, again offering. This time Callie accepted a cup and added tons of cream and sugar, though she'd never be so self-indulgent in front of that stuck-up interviewer who'd be here any second. "No doubt the lactose will offset the jitters." The man's face remained immobile, yet without hiding the smirk.

'Lactose' should have been a tipoff, but Callie was flustered. The recruiter was decidedly absent. Like Sophie. Following her aunt's funeral, Callie had dutifully followed Sophie's final wish and applied for a slew of teaching jobs. While waiting for the impossible dream, she endured eight-hour days at an insurance company keyboard, aligning numerals on the decimal point. The recession stole her hope for anything better. Yesterday's layoff seemed like the gateway to bag-lady-hood. Today's interview might be her only chance.

To distract herself, Callie plunged on. "The Cooper School is ranked about twentieth among all private high schools. Remarkable when you figure a lot of the girls don't get a good primary education or even decent nutrition before that." She fingered her jacket. *Is the back wrinkled?* The first thing evident to someone entering from the hall. If anyone planned on entering. *Does the interviewer have bladder problems? Even women don't spend this long in the bathroom.*

The impersonal corridor evoked memories of the hospital

where her aunt died. Last spring, when Sophie fell ill, Callie dropped out of school and moved home to Troyville. It was the least she could do for her mother's sister, by then depleted to bones and tubes. Callie sang her aunt's favorite jazz tunes, read aloud, and monitored the stream of adoring visitors. She teased her aunt about becoming a newbie ghost. "I bet you'll get to have sex again. Send me a sign—a flowering mountain, a perfect snowman."

Amid beeping monitors and wheezing oxygen machines, Callie clung to her aunt's life with greater ferocity than Sophie did, unwilling to lose the woman who'd wanted her to be more than an ex-con. Sophie paid for dental work, took her to concerts, and pushed her through college prep. Most of all, she made a home for Callie, the only safe one she'd known.

The man broke into her thoughts. "No more charm school." His black eyes, so intense, revealed little.

"No, thank heavens. Today girls from the inner city go to college." She mentally reached for her almost-complete transcripts buried in the file of materials she'd prepared for the interview. Or possibly for Godot.

"You're a teacher." He had a habit of making statements that required answers. He reached for his jacket, slung over an empty chair, pulling a pen from the pocket.

Planning to do the crossword puzzle? She glanced at a fleece-lined leather garment. Expensive. Red flags started to flap wildly! Under the table she clutched the edge of her chair. "I'm a few credits short of a teaching certificate but sometimes private schools value training more than paperwork." Callie squelched the defensive edge from her tone. She could still hear Sophie's scratchy, fading voice, "Go be a teacher. Don't die with me." Sophie never knew that every scrap of their pooled money went to hospital bills. Callie couldn't finish school. Her tuition payments were still in arrears.

The chugging of a pen rolling toward her brought Callie back. The man stopped it with his palm. "Do you know how the Cooper School pays its bills?"

Terrified that she'd already wrecked her chances, she tried to

answer like a teacher. "The endowment Mrs. Cooper left—plus a sound investment strategy—supports the school even now, a century later. About six hundred students and fifty teachers live on several hundred acres of woodland a few hours' train ride from New York City."

The man said something about either woods or good and shifted in a too-small chair.

She tried to approach her new worry politely. "What do you do?"

"Some people don't think I do much." He clasped his hands behind his head, perhaps to demonstrate his indolence, his mouth again inching toward a smile.

A lesser woman would be diverted by the well-formed muscles evident through the moleskin shirt or the jaw line worthy of a portrait. And that girl wouldn't realize he hadn't answered the question. *Uh-oh.*

"The Cooper School has been in the news." He made the statement without inflection but his confidence suggested he read the newspaper for more than sports scores.

"Always fodder for cable news. Wealthy girls and even a few boys try to buy their way in, the school says no, and the rich families hire teams of famous lawyers. So far, no one has won the right to undermine the school's mission. Rich people can go practically anywhere, but somehow they think they have the right to be where they're not wanted." Lifting her cup, she tried to cross her legs like the sophisticate she wished to become. Instead, the weakly brewed coffee assaulted her taste buds and she coughed, a slight dribble escaping her mouth onto her lapel. *Damn.*

He handed her a paper napkin from the coffee tray. Nervousness set her rattling on about her love of teaching and English literature. Minutes ticked by. Perhaps silence was golden. A lesson learned about ten minutes too late.

"Don't you have a job now?" His tone was neutral. His face was neutral.

She casually patted the wet spot on her jacket. "Laid off yesterday. Data entry. If not for the pesky need to eat, I'd have

quit long ago." She caught a flash in his wide set eyes. Pretty sure now, she closed her notebook in defeat.

He watched her yet didn't declare victory. "Data entry means working with adults. Teenagers are another story, aren't they? Raging hormones. Poor judgment. No sense of responsibility ..."

"You must have kids." The words came out edgier than she intended. Humiliation made her snappish.

He nodded, his dark hair brushing his shoulders. "A daughter. Nineteen. She's terrific but some of her friends are real hell raisers."

"Yeah. Teenagers can be a nightmare—when I student taught, some of my kids spent more time in juvenile detention than at home." She smoothed her heavy dark hair, remembering her own hot pink streaks and partially shaved head. "But most kids are like hip hop music—even when they're offensive they express some truths."

"You like hip hop?" His eyebrows rose.

"Don't you?" *Don't be rude, Callie.*

"What about its effect on kids?"

She glanced around at the geometrically arranged table and chairs where many others had discussed issues of note, no doubt with greater self-assurance. "Did Romeo and Juliet ever lead kids to suicide?" *As in juvie, go on the offensive.*

He, too, surveyed the room in a long, slow gaze that ended on her face. "I have no idea."

"Well, truthfully, me neither." They both laughed. His face crinkled along lines etched by sun and work.

Callie inhaled to offset the caffeine buzz, regretting the half cup of coffee whose twin grew cold in its white ceramic cup-coffin. "If I have to go back to data entry ..."

"You'll end up like Juliet?" He arched a single eyebrow. "Probably not. She killed herself for love."

Callie raised her unadorned hands. "Thirty-one. Single, no prospects." *Stop talking about yourself.* How Blake had ridiculed women revealing personal details in professional settings.

"Ah. A cynic."

"Not about teaching." She straightened her pile of notes.

"With a little guidance, young people can change the world. Martin Luther King, Jr. became a pastor at twenty-four. Emma Goldman was nineteen when she began organizing. Orson Welles was only twenty-five when he made *Citizen Kane* ..." She stopped when her roving eyes finally lit on his grin. "OK, a little hyperbolic but ..."

"Don't apologize. I'm sure your students will appreciate your advocacy."

Advocacy? "If I get the job."

"Oh, you got it." His laughter didn't fit the man of a moment earlier.

Gasping seemed so cartoonish, but she couldn't help it, though he just confirmed her worst fears. "You're the interviewer." She feigned innocence. "But ... who was the man in the hall?"

CHAPTER 2

Despite the table between them, when he stood, his sheer size—six four, she'd guess—seemed invasive. "In the hall? Oh, the hotel manager. Brought up the coffee." He extended his hand. "Harold Cooper, owner and principal of the Cooper School."

Incomprehensibly, touching him made regrouping difficult. "Pleased to meet you."

"I thought Nora would tell you when she called this morning, but I'm glad she didn't. This was by far the most relaxed interview I've ever conducted." He held her gaze a nanosecond too long.

Callie looked away, anywhere but him. Anger supplanted embarrassment. *Lies by omission are still lies.* She clenched and unclenched her fists under the table, hoping they were out of his sight. But she'd omitted a few things, too. Juvie, for a start. And murder. Sophie always lauded good manners for tense moments. Callie scrambled for cordiality. "Is Nora your secretary?"

"Nora's my daughter and office manager." He pushed his chair from the table.

"Does your wife work at the school, too?"

"My wife is dead." He hoisted a well-worn but elegant leather briefcase onto the table in one fluid motion, withdrawing a series of forms.

"I'm sorry for your loss." *Did that sound as hollow as it felt?*

He laid the papers on the table between them. "Page one lists salary, benefits, housing, and so on."

She glanced at the annual figure. *Holy moly.* An hour ago she

couldn't afford pantyhose.

"Page two outlines the classes I've assigned you. The rest is employment contract, policies, specifics about the school." He slapped the pages into a manila folder and slid it toward her. "Nora will call tomorrow. If you want the job, fax the contract. Nora will overnight the textbooks and a moving allowance."

"When——?"

"Second semester starts a week from Monday."

Short notice but evidently he didn't plan to apologize. "Well, then, let me save you some time." She yanked the contract out of the envelope, grabbed the pen lately occupied by table-rolling, and signed the school's copy.

"Don't you want to read it?"

Serious? Mocking? He gave so little away. She returned his pen. "Not as much as I want the job. I don't want you to change your mind when you realize you just hired a data entry clerk to teach Shakespeare and Hemingway. So I'd appreciate your signature, too."

Wordlessly, he signed both copies. "I won't change my mind. Don't you think I checked you out? I called your references, read your transcripts, Googled you. I knew you were qualified before you crept through that door. I needed face time to see if you were Cooper material."

"So you lied?" She hated liars, even though she was one herself.

His black eyes held steady. "I didn't lie. I just let your assumptions stand."

Tear that contract into little bitty pieces. Okay, maybe not. Good drama, bad anti-starvation technique. She mumbled through thanks and leave-taking, exiting as fast as the impractical boots allowed.

Out the bus window the neighborhoods diminished from the unstreaked glass expanses of downtown high rises to dented cars and hand-shoveled sidewalks. She got off the bus reliving the interview for the hundredth time, now free to shout every epithet she could remember from the ugly mouths in juvie. None seemed sufficient for her anger. Or embarrassment. Or gratitude.

Harold Cooper must be a descendant of the founder. If only she'd met his great-great-whatever-mother instead. Callie's research suggested that Gwendolyn was cut from the same cloth as Aunt Sophie, however different their eras and circumstances.

The pantyhose shredded as Callie peeled them off. The Sunday go-to-meetin' suit gave way to cotton sweats. Her evening run in the cold air unaccountably evoked Sophie's sweaty August memorial service. So many stories—Sophie at civil rights sit-ins, as a favorite babysitter, buttonholing a Congressman at the supermarket. Sophie and her sister, Callie's mother, Cecilia, singing duets at the founding of the Peace Center. With great discretion, no one mentioned Callie's felonious stepfather.

Blake swam up from the murk. His favorite epithet—slut. Favorite sport—boxing unwilling and defenseless opponents. Occupation—exploiting employees and self-righteous murder. His fortune went to defense lawyers, leaving his stepchild penniless but free of him. *If this is freedom.*

* * *

When her plane landed at La Guardia, Callie was still unsure whether she'd made the right decision. The shuttle to Grand Central Station was late. Callie worried through the entire ride that she'd miss the last train to Flambert, the little town closest to the Cooper School. The bus arrived just in time. Weighted down by her overnight bag and a disheveled carryall of books and lesson plans, Callie hastened into the terminal feeling like her refugee forbears about to begin life in a new world.

Under a ceiling of pinpoint lights arrayed as celestial constellations promising exotic mythical journeys, she extracted the last of her cash from an ATM and bought a ticket. *Are exotic mythical journeys possible without coffee?* Callie glanced at the clock above the information kiosk. *Just enough time.* She dashed to one of the station's bakeries, selecting an overpriced cappuccino and croissant. She handed over a flat new fifty dollar bill.

The piggy-eyed counter woman wore a stained apron and a mean scowl. "Don't you have anything smaller?" She held the

white paper bag hostage.

"Sorry, no." *Don't ask me to explain New York ATMs.*

"I can't change a fifty." The woman eyed the impatient customers behind Callie, New Yorkers no doubt schooled at coffee shop warfare.

A velvet male voice intervened. "Allow me." Whirling to find the source of the generosity, Callie slammed into an outstretched hand offering a ten dollar bill.

"Ow." Her cheekbone smarted.

He pulled his hand back, the sawbuck still tucked between his fingers. "Pardon me."

"Thank you, but I can't accept."

"Yeah, you can." The woman behind the counter grasped the stranger's money and gave him change.

As Callie stepped away from the counter, she looked up into vivid blue eyes.

"I hope I didn't injure you." Her benefactor's finger gently lifted her chin to inspect her face, allowing her a surreptitious counter-reconnaissance. He looked to be mid-thirties with a taut athletic body and a sleek, expensive haircut. A cashmere overcoat the color of caramel hung open to reveal a suit that, from what she could see, fit him like a dream. *No knockoff here. Hello Mr. Armani.*

Even though he'd soon be gone forever, for this moment things were definitely looking up. "No, no, I'm fine. Thanks. And I really can't accept. Can I—" *What? I can't return this.*

"Consider it a loan, then." He smiled with the relaxed charm and unstudied polish of the very rich.

"Uh, er, no, I, that is . . . okay, thank you very much." *Baffling inability to form English words.* "But, I don't have time to get change. My train ..."

"It's coffee, not a car. You can owe me." He handed her a business card.

"Deal!" She slipped the card into her pocket and sprinted. Hefting her bags up the narrow steps of the first train car, nearly spilling the ill-gotten beverage. She found a seat among several empty ones, eager to consume her booty while she reveled in

dreams of handsome, trouble-free men who existed only in fiction. The train lurched into motion and she pulled her Cooper School materials from her bag.

"Is that seat taken?"

She tilted her head up, prepared to lie, and found herself staring into those same blue eyes. "Uh, er, hmmm ... no. Please sit down." *English. Necessary skill. You teach it.*

"Permit me." He lifted her luggage into the overhead rack.

"Did you come for repayment?" *Remember how to flirt.*

"Naw, I'll just hire a collection agency." He chuckled and peered at the cheek he'd inadvertently assaulted. "I'll get ice from the club car."

"No, thanks, I can barely feel it."

But he returned a few minutes later with a cup of ice and a towel. "Might prevent a shiner."

"Are you a doctor?" She pressed the towel-wrapped ice against her cheekbone.

"Me? No, a hockey coach. My players seem to have endless small injuries. My main remedy for everything is ice." His grin came straight off the slick pages of GQ.

"Must be really helpful if they get sexually transmitted diseases." *Jeez, watch your mouth.*

"They better not. They're thirteen to eighteen."

"Oh, not pro hockey, then." Callie was happy the icepack hid the red cheek nearest him.

He laughed. "I coach high school girls and teach computer science. I think we're colleagues."

"Colleagues?" *I know the word. Really.* "You teach at Cooper?" She rummaged in her pocket but his business card had apparently fallen out.

He shed the cashmere overcoat and now shrugged out of his suit jacket to reveal a Marc Jacobs classic she'd admired in the style section of the NY Times. No ordinary teacher could afford three hundred dollar shirts. "Yep."

"How did you—?"

"The tell-tale insignia." He pointed to the school logo on her packet. "Some say the mark of the devil."

Observant. Always a good quality in a man. And funny.

"I saw it at the coffee stand. Hope you don't mind but I ... well ... followed you here."

Callie weighed her response. A little stalkerish, but he admitted it, so maybe he was as perfect as he looked.

He moved as if to get up. "I saw a couple dozen other Cooperites on the train, so if I'm intruding——"

Callie sat on her hand to keep from clutching him. "Don't be silly. After all, I'm in your debt."

"Peter Guy."

"Calinda Franklin. Callie." An entire storybook romance unfolded as she shook his hand. "I'm just starting this semester. English."

"Miriam Cooper's replacement. 'Bout time." His cappuccino was identical to hers but so much more elegant in his hand.

"Harold Cooper's wife?" Callie resented the intrusion of the cheeky Mr. Cooper but didn't want to seem uncharitable. "Was she sick very long?"

"Sick?" He seemed momentarily stumped. "Oh, no. She was killed in a car accident. Nearly a year ago. Kind of a scandal." His hand grazed hers on the word scandal, a delicious tease, but didn't continue the story, perhaps above gossip. He led the conversation to English literature, obviously well-versed himself but never missing an opportunity to compliment Callie's knowledge and insights, chuckling at the clever one-liners she'd practiced as ice-breakers for her students.

As Callie rose to use the women's room, Peter's gaze wandered to a pretty teenage girl a few seats ahead.

"Hola! Shauni." Peter hurried to the girl's side.

Callie couldn't overhear the exchange but gathered Shauni was resisting Peter. Nonetheless when Callie returned, the girl was helping Peter turn the empty seat forward of theirs. Seated facing Callie, the student deposited a heavy red jacket with a New Jersey Devils insignia.

Hockey fan. Probably someone he coached. Irritated by Peter complicating the romance Callie just invented, but eager to meet her first in-the-flesh Cooper student, she masked ambivalence by

crumpling her empty coffee cup. Peter touched Callie's arm and she felt reassured—*of what?*

His introduction was brief. "Shauni Rodriguez, from Newark. She was captain and star of my team until last year but she's sitting out this season." His tone mocked petulance but Callie sensed genuine hurt.

Shauni's green eyes, brilliant against mahogany skin, narrowed slightly. "Too busy, coach. College prep. Y'know."

Callie heard the lie and wondered what it hid. *Why wouldn't Shauni want to hang out with such a handsome, erudite teacher? Why would she abandon her favorite sport?* "You're in Senior English, right?" She leaned forward to shake the girl's hand. *Nice firm grip.*

"Yeah. I hope you'll get us out of the nineteenth century. I adored Mir, er, Mrs. Cooper but she was really stuck on Austen and the Brontës." Shauni looked directly at Callie, not including Peter.

Harold Cooper's dead wife formed herself in Callie's imagination: upper class, willowy, blonde—everything Callie was not. "I was assigned the reading list. Probably hers." She finger-combed her hair as if that would help her think. "I'm afraid you can't escape Jane Eyre, but I'll see what I can do later in the semester."

"And I wish some writing assignments were more, like, you know, about us." Shauni leaned forward, her focused energy reminding Callie of the few leaders she admired.

"Good idea. I—"

Peter interrupted, deepening his dimples without quite smiling. "Students want everything to be about them. Some people need to learn teamwork." He shifted his focus to Callie, though his words seemed addressed to Shauni. "Some of my team grew up playing in the street, or on rinks full of broken bottles and trash. They don't expect coddling."

Shauni lowered her voice to a growl. "Coach, you know that's bull—"

Callie felt Peter tense, though he smiled indulgently. She touched his arm, returning the reassurance from earlier. *Find something to say.* "Did you play hockey as a kid?"

His turn to exclude Shauni. "Of course. My prep school had the best of everything—perfectly groomed ice, the latest equipment, internationally known coaches, the works. But some of my classmates played because a sport would look good on their college applications. A few like that can undermine team spirit."

Shauni locked her fingers together, practically spitting. "Team spirit? Huh."

Callie recognized the girl's minute gesture telegraphing a desire to smack him. Callie raised her voice. "Prep school?"

"St. Johns."

Feeder for the Ivy League.

"You?"

"Troyville High, Troyville, Pennsylvania. Very exclusive. At least one relative in the slammer if you really wanted to rate."

Shauni sat up straight. "Your parents were criminals? And they let you teach at Cooper?"

"My father went to jail for being a pacifist. Minor compared with—"

"That's a crime?" Shauni cradled her chin on both fists.

Callie closed her eyes and opened them again, wishing teenagers learned more history. "He refused military service in the Vietnam War."

Peter flicked his hand dismissively. "Not a big crime, really. Unless he robbed a bank or something. Poured blood on draft records? Held a judge hostage?"

Knows the sixties. Callie tried to gauge whether he was for or against resistance. "None of the above. Just a garden-variety draft resister."

Shauni nodded. Evidently sad stories were not foreign to her. "Maybe you could talk to our social science class—or get him to come."

"He got sick in prison with something curable—if it had been treated. He died there." *Inhale. Then exhale.* "My mother was pregnant with me at the time."

Peter shook his head. "That's tough. But I don't understand. As a father, back then he wouldn't have been drafted."

Callie rarely talked about it, but Peter seemed so open. "My

~ 23 ~

father made a big public to do about how getting out of the draft was a class privilege. Burned his draft card outside the recruitment office, then waited to be arrested."

Shauni gave Callie a thumbs up. "Wow. A real hero."

Cliff Notes of the next few years: Her mother, desperate to provide for baby Callie, had hastily remarried, flattered that her wealthy boss thought her special. Callie's 'family' memories were Mommy losing her sparkle and succumbing to Blake's directives on how to dress and eat and raise 'the little brat.'

Callie shifted to neutral, questioning Peter and Shauni about Cooper, even though most of the details were carefully outlined in the packet she'd read umpteen times. Peter answered graciously, Shauni in monosyllables. Eventually the conversation stalled. The scenery shifted from the patchy gray snow of the exurbs to undisturbed bright white drifts.

Shauni followed Callie's gaze out the window. "Good skiing around here."

Callie watched the Adirondacks emerge, so different from the mining country of south-central Pennsylvania. "I've never been on skis. But I'd like to learn."

Peter took her empty cup, slid it into his. "I could teach—"

Shauni interrupted, "The Coopers give lessons. For teachers, too." She threw a sideways glare at Peter. "Best way to learn."

Callie sighed. "I don't have skis."

Peter ignored his rude student and pointed to Callie's information packet. "Nora Cooper makes a weekly grocery run to the glory that is Flambert. Teachers often go along for supplies or whatever. The town offers precious few niceties but it does have a ski shop." He pronounced it Flahm-bear, unselfconsciously using the French pronunciation though most New Yorkers called it Flam-burt.

Shauni's eyes turned in a demi-roll. "The school will lend you skis. Skates, too. That's how I learned hockey."

Peter imitated a documentary narrator, "And quickly she became a star, only to throw it all away."

Playing Switzerland to the hostile powers of Shauni and Peter grew tiresome and so Callie tried to change the subject. "Shauni,

do you often go into Flambert?"

"Shauni's got a sweetheart in town, don't you?" Peter tapped Shauni's knee. "Sadly, girls aren't allowed off campus without chaperones."

Shauni appraised him with cold green eyes but said nothing.

Peter went on, "It's a good policy. Terrible things can happen to girls."

CHAPTER 3

Callie was relieved when the train pulled into Flambert, a tiny Playskool depot, miniature and perfect. The three disembarked into an icy blast of wind. Scores of girls and a few adults piled off the train, their breath white as they shouted greetings.

Peter handed his bags to the lone station porter, pointing Callie toward the parking lot where the Cooper School bus would collect them. "I have to pick up some things I sent over the holidays. Ask Nora to wait, please." He trotted toward the brick station building.

A heavy young woman with dark curls lunged out of the station, almost colliding with Peter. Both stared for a moment and then moved on. Shauni ran to her and took her hand. Callie heard Shauni mutter, "Jerkorama sat with me." Shauni nudged her companion toward Callie, her words tumbling in a rush. "This is Alexis. Her mom's our art teacher. Callie's the new English teacher. Her dad was a draft resister."

"Cool." Alexis pulled her wool stocking cap over her ears and offered her free hand.

Callie wondered whether Alexis was mocking the word or acknowledging Callie's coolness. The wind bit into her and she turned toward the parking lot. When she looked back, Shauni and Alexis were gone. Shivering, even in her long wool coat and the hand knit sweater she'd inherited from Sophie, Callie slid along with the crowd, cursing her only boots, the skimpy high-heeled pair worn for the interview. The bus was easy to spot. **The Cooper School** was prominent among the erratic text and wild

colorful images inscribed across every inch of what looked to be an ancient Greyhound.

"State-of-the-art technology," Callie spoke aloud to no one in particular.

"Coop grouses about it all the time." A young woman joined Callie. "But the engine is sound and it runs like a charm. My senior art class turned it into the masterwork it is today."

"Nora Cooper?" 'Coop' rather than 'Dad' confused Callie.

"Yes. You must be Calinda Franklin. Welcome!"

"Callie." Two gloved hands met in a clumsy shake.

Cooper's daughter was a sturdy young woman with spiky, multi-colored hair and mismatched unisex clothing. Unlike her father, Nora chatted easily and smiled frequently. "You'll be happy to know your boxes came. I put them in your cabin. I'll show you when we get there. The ride's a little bumpy, so sit at the front."

"How did you know who I was?"

"World's greatest detective. Also I recognized the sheer terror when you made that crack about the bus." The black eyes Nora inherited from her father flickered as she giggled.

"Oh, dear. Did Mr. Cooper tell you I'm timid?" Callie revved up to a new fury.

"He didn't say much about you, just to make sure you got settled. I rely on my own keen deductive powers." Nora pointed to the envelope sticking out of Callie's bag. "To wit: You're carrying the Cooper info packet. You're too old to be—"

"Old? I'm thirty-one." *Paranoia is a poor map of the world.*

Nora shot Callie a look. "—to be a student. We only have two new teachers this semester and you're the only female. Plus I saw you talking to Peter."

"Who? Oh, the computer teacher. I almost forgot—he wants you to wait for him."

"I'm sure he does." Nora took Callie's carryall and jogged ahead to open the luggage compartment for a dozen passengers laden with suitcases and duffle bags. "This is Calinda Franklin, the new English teacher. Callie, some of our seniors. The underclasses came back last week."

One girl elbowed her companion. "Pity the poor teachers who lost a week of vacation to be on duty." Boisterous laughter and commentary followed.

Nora left the understorage door open for latecomers and offered Callie a strong hand up as girls and teachers clambered up the steps.

A wiry mid-thirties man with a camera case around his neck greeted Nora in French. Nora introduced him in English. "Jean Frière from Paris, Miss Franklin." She hissed a mock-whisper, "He's lived here since his teens so don't let him tell you he doesn't understand English."

"You give away all my little tricks." Jean smelled like strong tobacco as he bent toward Callie.

Nora raised an eyebrow. "*Oui, monsieur.* Jean's our French teacher and on-site car mechanic. He's kept this bus running long after it shoulda died."

Jean took Callie's hand. "A pleasure. We've been looking forward to your arrival. Nora does not mention that I also take the official school photos."

"The ones on the website?" Callie had pored over them for the past week. "Lovely."

"*Merçi, mademoiselle.*" He sat next to a student who didn't respond happily. Callie was grateful not to tax the remnants of her high school French.

Other teachers came aboard and were duly introduced, but Callie could barely hear their names above the clamor.

Shauni appeared, breathless, backpack slung over one shoulder. A chorus of "Hi," "Sit with me," "Nice jacket" greeted her. She leaned toward Nora and spoke softly. Callie heard only a worried fragment: "She said not to wait."

Nora did a quick head count. "Where the hell is Peter? Some people think they're royalty." The distinct sound of the understorage door slamming shut was barely audible.

"Kneel, my subjects."

Callie recognized that chocolate voice. The girls burst into laughter as Peter Guy hopped up the steps with a theatrical bow, sweeping an imaginary hat off his head.

Nora grabbed the gear shift with her fist. "Siddown Peter."

Ignoring Nora, Peter spoke to Jean in rapid French too low to hear. Jean's return quip set them both snickering. Peter dropped into the empty seat beside Callie. Perhaps because of the noisy bus, he leaned close to her ear. "You'll knock 'em dead." He took her hand in a gesture that was either flirtatious or paternal.

A voice yelled from a back seat. "Hey, coach. Did you see that Bruins game?"

Peter shrugged at Callie and ambled to the back, pushing past Shauni as she lifted her pack into the overhead rack. The students welcomed him noisily, all talking at once. He pinched one girl's cheek. "You'll have to run a few laps to roll off the Christmas cookies." To another: "Honey, you gotta stop letting your brother cut your hair." And a third: "Still listening to that wannabe?"

As Nora maneuvered the bus along a narrow snow-dusted road, Shauni slid into the seat Peter vacated. "I'm still not used to this. In Newark, the snow is gray. And yellow." At Callie's reassuring grin, Shauni turned to catch up with classmates.

Callie peered out the window and in the swipe of a gloved hand escaped into the dream sequence of a romantic 1940s movie. A multitude of evergreens, elegant in their white gossamer coats, climbed up the banks on both sides of the road. Two dozen voices rose, covering three million topics in thirty minutes. *Women come and go, talking of Michelangelo. Thank you, T. S. Eliot.* Callie wished she could call Sophie and brag about this fairytale come to life.

The bus turned onto a heavily wooded side road marked with a large sign reading: **The Cooper School.** Shortly, evidence of human life emerged. A gauzy white sheen softened the edges of angled roofs; the late afternoon sun splattered sequins across tidy, eco-friendly buildings and walkways.

Nora pulled to her first stop, yelling to be heard as she hopped down the steps. "Make sure you take all your stuff!" She looked around and shouted, "Incoming!" A volley of snowballs thudded against the bus, accompanied by happy shrieks and laughter. Girls in winter hats and scarves tumbled out of the bus to join the fray.

Other stops were less eventful. Nora dropped off passengers, helping them unload and talking nonstop to Callie. As the bus crisscrossed the main campus, Nora pointed out key buildings. Classrooms. Administration. Library. Gym and hockey rink. "Single teachers get cabins up in the woods. Married teachers get two floors right on campus in exchange for being house parents." She pointed toward several three-story Georgian structures. "Dining room and study hall on the ground floors, faculty apartment above, on the upper two floors." The girls, she explained, lived in adjoining cabins. At a nearby mansion, older and more elegant than the others, she paused to let students cross the road. "Coop and I live here."

"The palace." The words came from Peter who'd moved forward when the girls got off.

Nora's jaw tightened. "Used to be really fancy. Now it's set up exactly like the others, with cabins and everything. Old Gwen'd probably have a fit if she knew girls today use her drawing room as a cafeteria."

Peter lounged across two seats. "She'd probably think the cabins were servants' quarters."

"I thought she was egalitarian." Callie looked from Peter to Nora.

"She liked her luxuries." Peter unconsciously touched his cashmere coat.

Nora shook her head. "I think she figured out that rowdy teenagers and elegance can't cohabit. She entertained the smart set from the Upper East Side and collected large donations. The girls lived elsewhere."

Peter straightened, seemingly indignant at Nora's defense of privilege. "In those days, the students were the servants."

Callie chose to ease the tension by shifting into teacher mode. "Some philanthropists back then did a lot of good but also were snobs. For example, Gwendolyn's friend, Jane Addams, fought for laws to protect children, but she also distributed reproductions of famous European paintings to teach immigrants their own culture. Culture according to Jane."

"Some people just think they're superior." Nora shrugged.

The bus wound up a road dotted with faculty cabins. The last stop before Callie's was Peter's. Nora waited in the driver's seat, her face immobile, while he took several trips to unload his many belongings. Surprised that Nora didn't help him like the others, Callie offered a hand.

"On those boots? You'd be more trouble than help." He winked.

Gotta get new boots.

Nora barely waited for him to clear the bus before starting the engine. She turned to Callie. "Did Coop mention that you got a great cabin?"

"No." *Too busy making a fool of me.*

"You're lucky. Your place belonged to Hazel Landers. Art teacher. I took all her classes. Her home was her masterpiece."

"I think I met her daughter at the train station. Why did she leave?"

"Alexis? Graduated, like a good Cooper girl."

"She's not in college?"

"Taking a year off. Works at the police station in town."

"What about Hazel?"

"Oh, Hazel moved because she got married. Surprised everyone, including herself, I think." Gripping the steering wheel with one hand, Nora sliced the air with the side of her hand. "Felled by the Cooper tradition of great love."

"Tradition?"

"See that mountain? We call it Lover's Peak, though the mapmakers use some other less lyrical name. Tons of people got engaged up there in the last hundred years."

Callie found herself thinking like a chaperone. "But aren't the girls too young? And where do they meet boys?"

"Dances with other schools, visitor weekends, field trips to Flambert, whatever. Nowadays high school students are considered too young for true love. Just a few decades ago, though, more than one girl ended up walking down the aisle— and too often with some male teacher. In the twenty-first century, we frown upon student/faculty fraternization." Something lurked behind the formal language. Nora's wild hair

and youthful clothing made her look like the teenager she was, but she spoke like a seasoned adult. "The school doesn't judge consenting adults. Hazel and Craig had quite a long relationship before they married."

"So the school doesn't forbid 'fraternization' among faculty?" Callie watched the black silhouettes of bare trees against the sky but saw blue eyes and dimples.

Nora laughed aloud. "Sororization either—or whatever old-fashioned word means lesbians."

"Don't the parents object?" *The brochure left out some key information.*

"We don't ask. The girls don't tell. You know, like the military used to be." Nora's lips twitched playfully.

"I mean about girls having sex at all, with anyone." *Is Nora trying to say she prefers women?*

"Officially, nobody under eighteen sleeps with anybody. At the same time, we offer sex education and contraception, even though nobody needs it for nuttin'." Nora caught Callie's eye in the rearview mirror. "The faculty can fend for themselves. Now, if Coop got involved with someone—"

"I know it's hard to think of your father getting involved again—" Callie didn't say aloud that she thought it unlikely anyone would fall for Mr. Grumpy.

"Not because he's my father. Because he owns the school. You know—the boss."

Callie bristled at the word boss, but knew Nora was right. If Cooper got off his high horse long enough to date a teacher, it would set off cries of sexual harassment. She almost felt sorry for him. "Back up a second. Did Hazel marry a woman?"

"No, no, just a fr'instance. The school's lawyer. Great guy. You'll meet him. His office is in Flambert, so they live there and she commutes."

"Half-hour on mountain roads each way—must be a chore when the weather is bad."

Nora carefully maneuvered to avoid a deep rut. "Yeah. She drives like a logger, though, so she doesn't miss many classes."

"Why was she surprised to get married?"

"She's in her fifties. Alexis's father died ages ago. Long as I can remember, Hazel was single mom and teacher who gave a hundred and ten percent on both jobs. Never seemed sorry. Craig—that's her new husband—is ten years younger and was a confirmed bachelor 'til he figured out she's totally fabulous." Nora smiled. "I'm prejudiced. She's my godmother."

"Old family friend?" Callie felt the familiar pang. *What is it like to belong?*

"The only guest at my parents' wedding who wasn't a relative. They got married on top of Lover's Peak." Again Nora gestured toward the mountain.

"Your mother was a Cooper girl?"

Nora braked; they were at the end of the road. "Here it is. Your home, long as you stay at Cooper. Or marry."

"No danger of that." Callie lifted her heavy carryall and stared at the one-story wooden house emerging from evergreens probably there since the Mayflower.

Nora's breath was louder in the crackly air. "Hey, that's what Hazel thought. You never know when Prince Charming might show up—or in what guise. That's what my mom said. Too bad she didn't live to see Hazel marry Craig." She turned away from Callie. "I think Mom was their matchmaker."

"When did your mom die?" Callie knew too well the twin desire to put hurtful things out of your mind and simultaneously talk about them.

"Last winter. Almost a year ago. I was supposed to go to college this past fall but, well, er, I thought I should stay. I'll go next fall if Dad ..."

When Callie heard 'Dad' instead of 'Coop,' she felt Nora's heartache. "My mom died when I was eleven. Six months ago, I lost the aunt who raised me. My only family. It's hard enough to live with the grief—isn't it?—never mind planning for the future."

Nora cleared her throat. "Thank you. I mean it. Thanks." Shouldering one of Callie's bags, she led the way up a newly cleared walk. "You'll have to shovel on your own after today. The school hires a snowplow for the roads, but the walk is

yours." She crooked her head toward a shovel and neatly stacked firewood on the three-season porch. "The cabins use woodstoves for heat. This little stack will last you about a week. There's a huge communal woodpile out in the woods, about halfway between your cabin and Peter's. It's a bit of a trek—I'll show you. Not today, though. It's almost dark." Nora fished out a key and unlocked the door. "It can be treacherous at night, especially for a flatlander."

Callie tapped a foot, feigning affront. "What you must think of me."

"I think you're swell."

Callie started at the old-fashioned word until she realized she'd been out-mocked. Their laughter rang clear in the cold mountain air.

"Furnished but, you'll see, sparsely. We have pieces in storage if you need anything. Or you can be like coach and ship a lot of expensive designer furniture from New York. Alternately, Flambert has a couple of decent second hand places."

Flam-burt to Nora. "I'm certainly not in Peter's league financially." Callie's cold feet were making her teeth chatter. She hoped it was warm inside.

"He's rich but not …" Nora busied herself knocking snow off her boots.

Callie elbowed Nora. "Did you say he's hot?"

Nora did not smile. "Not hot. Never that." Nora pushed the door open and beckoned Callie inside.

'Cabin' was a misnomer. On three sides of the living/dining/kitchen open area, draped windows revealed snowy evergreens and mountains. Shards of sunlight disappeared into the gloom of late afternoon. A comfortable sofa, overstuffed wingbacks, bookcases, and bright rag rugs covered a golden hardwood floor. *Toasty warm.*

"You call this sparsely furnished?" Callie sank into the sofa and gestured to a generous oak-and-steel kitchenette and woodblock island. "Guess I should learn to cook."

"And to dress for the upstate area." Nora eyed Callie's footwear and clucked her tongue.

Callie unzipped the hated boots, which thudded to the floor. She lifted her chin toward a pair of snowshoes hanging on the wall. "Did Hazel leave those?"

"Standard issue. For the woodpile. That fireplace is a high-tech woodstove. It'll heat your whole place if you keep it full." Nora knelt to check yellow-orange flames.

A pedestal oak table with four pressed-back chairs created a dining area under a hanging lamp. Callie feared that any moment she'd wake to the stained linoleum and single gray window of her Troyville studio apartment.

Nora guided Callie through the rest of the rooms. "Hazel tiled the bathroom herself—gold and purple. Her colors." Nora ran a finger along the sink. "I helped. Grouted this whole wall."

Callie was stunned at what artists could make of ordinary fixtures. "Gorgeous. My last place didn't even have a tub, just a metal shower that trickled." Opaque glass blocks let in the last of the light.

The bedroom, with another window opening to the woodlands, offered a queen bed and matching dressers. The study was Callie's first proper office—her own bookshelves and filing cabinets. Each room had so many closets that Callie suspected she'd have only one piece of clothing for each.

Nora rattled off essential information while she helped Callie make up her bed from linens they unpacked. "Mail goes to the administration building. Most teachers put their assignments and reading lists on the Cooper School website."

Callie frowned. *Already lacking.* "My computer died months ago. I don't have a tablet. Aunt Sophie left me a boom box and her collection of jazz CDs. That's it."

Nora was unfazed. "I can fix you up with a computer and a sound system. We often make long-term loans to teachers." She and Callie returned to the main room. "I stocked your refrigerator and cupboards with some stuff but didn't know what you like."

Callie surveyed the supplies. Nora had provided enough for at least a week. "Oh, Nora, thank you. Tell me how much all this cost, and I'll reimburse you out of my first paycheck."

"Nope. This is the Cooper welcome wagon. After today you're on your own." Nora looked around, searching for another task and noticed the tiny silver dove on a chain at Callie's throat. "That's nice. Hand tooled?"

"Yeah, a gift from my Aunt Sophie." Callie smiled. "Let me make you a cup of tea." She set a kettle on the stove.

Nora hesitated. "No, I'd better have dinner with Coop. It's silly, really. He's a gourmet chef. But if I'm not there, he doesn't eat."

After a few more pointers about circuit breakers, plumbing, and wild creatures, Nora handed Callie the keys. "Keep the cabin locked. Sometimes townies come up—mostly out of curiosity about a school full of tough girls—but we don't want to encourage them to take souvenirs."

"After all these years?"

"New generations of horny teenage boys keep on coming."

Callie suddenly panicked. "Nora?"

"Sorry, did I scare you?"

"About teenage boys? No, I" *Still have a good right hook from juvie.*

"Spit it out."

"What should I wear?" Callie hoped she didn't sound pitiful.

Nora's laughter sounded relieved. "We don't have a dress code. But ..."

"But?"

"You'll break your neck on those boots."

The tone was hard to mistake. Callie's turn to express relief, if a bit rueful. "I thought they'd make a good impression but they're just trouble. I plan to buy useful ones soon as I can afford them."

Nora nodded. "I hoped you weren't a fashionista. Anything sturdy and flat. Oh yeah—your classes start at nine-thirty but you have an orientation meeting with Coop in the Admin building at eight-thirty. I'll see you then. And I know the perfect shoe store when you're ready." She grabbed her jacket and departed into the snow.

The cold night sky showered a million stars through Callie's

windows, more than she'd ever seen. She stood transfixed until her stomach informed her that the Grand Central croissant was long gone. After an easy meal from Nora's provisions, Callie read through her class notes, bookmarking passages she wanted the girls to tackle while fighting rising first-day jitters.

Sleep arrived on little cat feet worthy of Carl Sandburg. Her last words were mumbled aloud to Sophie, "Can I do this?"

CHAPTER 4

C allie awoke in confusion. Her partially functioning consciousness pieced together the data—comfortable bed, pile of boxes, view of luscious snow-covered pines and the half-hidden trail up Lover's Peak. The familiar photo of Mom and Aunt Sophie on the bedside table. Ignoring the insistent alarm clock, she slid back into a joyful half sleep. Instantly the mountain shook off its winter attire and blossomed into springtime festooned with aromatic multi-colored wild flowers. Dancers swirled about in gossamer clouds. She linked arms with a stranger ...

Unbidden, Harold Cooper crept into her consciousness. The meeting. She raised her head enough to see the clock and calculated that she could reach his office on time if she didn't dawdle. Still smarting from the interview, she worried whether another misstep might restore unemployment. She refocused on an imaginary post-Cooper moment, when she would triumphantly chalk, "English Literature. Ms. Franklin." *Or do the students use first names?* Hastily dressing, she followed the map to the central campus and climbed the wide steps of the administration building

Nora sat at the front desk, her workspace spilling over with colorful objects, windup toys, photos, candy in glittery glass jars, and extravagant plant life.

"Nice environment."

"Thanks. Someday I hope to do art installations for a living." Nora took Callie's coat and pointed her toward Harold Cooper's office. "He'll be back in five." Nora turned to her computer. "Go

on in."

Callie hoped Cooper's inner sanctum would reveal some fundamental character flaw. Instead, she found high ceilings lined with over-full bookcases, Mission furniture, and a stone fireplace alive with flames.

Several framed photographs of Nora and a woman Callie surmised was Nora's mother sat on the mantel. Miriam, far from the slender blonde Callie had conjured, was dark and roly-poly, with a vivaciousness that even a grainy snapshot couldn't suppress. *Why do great women so often end up with jerks?* When her own mother came to mind, Callie automatically touched the silver dove. Her gaze rose to the painting above the fireplace—a massive oil of a young woman in nineteenth century clothing dwarfed by mountains, trees, and a roiling stream. Callie searched her meager memory bank of art history. "Hudson School?" She wasn't fully aware that she spoke aloud.

"A little later, but you're right about the feel of the piece." Harold Cooper was immediately behind her. "That's my great-grandmother Gwendolyn, the school's founder. It was painted by her son, my grandfather, just before he went off to World War One. You can see he had great promise."

"Never fulfilled?" She knew about underachievers.

"He died in the trenches."

Do you offer condolences for someone he never met? "That's sad. Gwendolyn established peace studies here at Cooper, right? Because she lost her son?"

"Partly. Now we call it volunteer community service. But acting for the greater good is part of the Cooper mission. That's why your comments about teaching in an inner-city school so impressed me."

Impressed?

Cooper moved to his tidy oak desk, waving her to sit. He opened a file labeled **English, Spring** and extracted some notes. Talking her through her classes, he seldom made eye contact, yet she detected a man deeply saddened by students doing poorly, a cheerleader for those who met challenges. Abruptly he closed the file. "Questions?"

A sudden desire for connection startled her. "Can I borrow all your books?"

He chuckled, relaxing his face so it was almost handsome. Though in his early forties, his customary grouchy demeanor aged him. "This collection is only a fraction of the library, but I'll never say no to reading."

Outside his office she felt almost lightheaded.

"Did the boy genius wow you?" Nora handed over Callie's jacket.

"Terrifically productive meeting."

"I guess that Rhodes thing is useful for something, then." Nora winked.

"He was a Rhodes scholar?"

"Oh yeah. Speaks five languages. A trainer for the Olympic ski team in college. Has two PhDs, one in computer engineering, one in comparative literature. And here I am, his only offspring and a mere mortal."

"At least you have a sense of humor."

Nora looked at Callie with her father's piercing eyes. "He was more fun when my mother was alive."

"Oh, Nora, I'm sorry. I didn't mean ..."

"Yeah, you did. You're a bad liar. It's refreshing. We have some really good liars around here."

The arrival of a lanky, aging Chinese man interrupted them. "I have an appointment with Harold Cooper."

"Dr. Chen Hu-wei, right?" Nora introduced Callie. "Dr. Chen will be our campus physician and new vice principal."

A few social niceties later, Callie stepped carefully down the snowy Admin steps. Buoyed by Harold Cooper's encouragement, she nearly collided with Peter Guy.

"On your way to class?" He took her elbow to steady her and held it too long.

Dimples are excellent on a flirting man. Nod, you fool.

"Wait while I drop off my team requisition with Nora and I'll take you."

Watching her breath on the crisp morning air, she protested to the universe that the cold weather made her nose run and her

skin blotchy, while Peter could have just walked off the cover of a high-end winter sporting gear catalog.

"Our buildings are neighbors." He pointed across the maze of cleared walks and snowy lawns. Though Callie had studied the map, she let him guide her. She wasn't sure she liked him, but the attraction was unmistakable. Student after student greeted their celebrity-handsome teacher.

"Hey, coach!" Callie heard the staccato tones of the inner city, near-whispers from the shy and petite, incomprehensible consonant-free slang, rowdy sports lingo.

"Listen, I couldn't say this on the train in front of Shauni, but, Miriam Cooper was popular. Lots of students ate out of her hand." Peter spoke in undertones followed by a quick full-voiced exchange with a passing girl wearing a Nigerian patterned skirt and orange legwarmers. Turning back to Callie he spoke gravely. "Some kids will resent you replacing her." He pushed between two girls—Hispanic curls and Jewish curls in matching ear muffs—and walked arm in arm with them for a few paces, with Callie a few steps behind. Callie slid down a worry spiral, wanting more time to prepare, wishing she could consult Sophie. Peter sent the duo on their way and seemed to focus on Callie, but she only half-listened, confused by doubt and by how close he leaned in to her.

"Here it is." Maybe he'd said it twice. He bowed with the same flourish she'd seen on the bus.

With a quick—and she hoped professional—farewell, Callie found her classroom and unpacked her books and papers. The white dusty chalk squeaked as she printed the name of the class on the board and then "Ms. Callie Franklin."

"So glad you didn't write M I S S." Shauni stepped in, offering Callie a conspiratorial high five. "But we can call you Callie, right?"

Callie cursed herself for forgetting to ask Nora. "What did you call Mrs. Cooper?"

Shauni slung her jacket onto one of the pegs along the wall. "Miriam."

Callie gestured to a row of posters—Jane Austen, Emily

Dickinson, Amy Lowell, Lillian Hellmann, Nadine Gortimer, Toni Morrison. "Did Mrs., er, Miriam put those up?"

Shauni sat in the first row. "Yeah, we helped her choose and hang them the semester before she passed. No one's had the heart to take them down."

The arrival of other girls precluded further questions. As copies of *Jane Eyre* appeared on desktops, Callie searched fourteen pairs of eyes. "This novel was written more than a hundred and sixty years ago. Why study it today?"

"Torture?" A girl in the last row with a tattoo on her wrist twirled a pen through several fingers.

Callie tried to gauge whether she was under attack, as Peter intimated. Her juvie-trained instinct said no. The students were wary but not hostile. "Good. Now you know."

Most of the girls laughed. Silently thanking Sophie for teaching her to rely on humor in moments of uncertainty, Callie rocked her weight to her heels and held up her book. "Why does Charlotte Brontë call this an autobiography?"

Shauni raised her hand. "Because it was partly her own story."

Callie wrote Own Story on the board and turned to the class. "Good. Anyone else?"

The answers were thoughtful and plentiful. Even tattoo wrist jumped in. As the responses covered the board, Callie could feel tension ebb away with the girls' realization that she didn't espouse a particular 'right answer.'

Miraculously none of her classes grumbled over the homework Callie assigned. A few girls stopped by her desk after each class to welcome her. Just after the final bell, a short woman in her fifties appeared at the door, dressed almost as eccentrically as Nora, though her ensemble reflected a larger budget. "Hello, I'm Hazel Landers. Used to live in your cabin. I gather Nora did the honors." Her disheveled gray curls reminded Callie of Sophie. "How was your first day?"

"Perfect. Exhausting." Callie sank back into her desk chair.

"Everyone is really glad you're here. Coop taught English last semester even though he should have taken time off. It was grim." Hazel pressed her lips together.

"I heard the students might resent me taking Miriam's place."

"What troublemaker told you that? On the contrary, I heard all day that you're 'okay.' High praise from students. Are you up for a small faculty dinner? We're having a few people over. Sorry for the late notice." Hazel shook out a heavy wool coat she clutched under her arm. Purple, shot through with gold threads.

"Thanks for inviting me." *Don't let on that I don't quite belong.* "But I have to prep and—"

"It won't go late. Everyone teaches tomorrow. My classroom is just downstairs, if you ever need anything." Hazel pulled on purple leather gloves.

"What can I bring?" Callie mentally considered the supplies in her kitchen.

"Dom Perignon?"

"Oh, sorry, I don't have any wine at all." Another item for the shopping list. But not hundred dollar champagne.

"I'm kidding. You should see your face." Hazel smiled as if Callie were in on the joke. "Very informal. I think you've met Peter Guy, your neighbor down the road, right? I asked him to give you a ride." Hazel floated away on the same golden bubble she'd rode in.

Preparing to lock the building as per instructions, Callie noticed that a window on the first floor wasn't closed. As she struggled to budge the wooden frame, she heard Nora outside, just beyond her sightline. Callie almost called out but stopped when she heard angry words.

"Get away from me!" The young woman's voice was directed toward someone out of view. "A deal's a deal. I'm not doing another thing for you! Don't you threaten me!"

Callie froze, not wanting to embarrass Nora by interrupting a private argument. *Should I intervene?* She strained to hear but couldn't distinguish the words, nor identify the other person. Both voices moved away. *Deal? What deal? Could Nora be involved with drugs?* The thought struck like a physical blow.

Callie shut the window and exited Lang Arts, tensing against the cold. Neither Nora nor her mysterious companion was in sight. A low overcast sky grayed the snow-laden ancient firs.

Callie's thoughts ping-ponged in rhythm with her stride.

"Hey, neighbor." Peter had apparently overtaken her without setting off her internal alarm bells. "I hear we have a date for tonight." He grinned and bumped her with his elbow, his hands still his jacket pockets.

"Hazel said you have a car?"

"Yeah. Haven't driven it since before the holidays. Hope it starts." He flung an arm around her in a half hug. "Otherwise, it'll be a long walk."

The arm almost paralyzed Callie, who didn't know whether she should let him know she liked it. She decided to walk in step with him and pretend the arm was an extra appendage of her own. "I could bring brownies." She had a cookbook somewhere.

"You could also come empty handed. Hazel and Craig always put out mountains of food." He reclaimed his arm.

True, it had never been mine.

"See you at six-thirty."

Is it a date? No, of course not. Is it? Hurry. Her haste scuffed snow into her shoes, thoroughly drenching her socks. She threw the brownies together and into the oven, showered quickly, and swept her heavy wet hair into a faded towel.

While the brownies cooled, she padded around in comfortable garage-sale bedroom slippers and her ratty old bathrobe. She brewed herself a cup of tea and lounged with *Jane Eyre*, happy to review the next day's pages. The sound of an engine startled her. Peter wasn't due for another half-hour. At the sight of Nora's bus, Callie skittered to the door, eager to welcome equipment and supplies. Nora could tell her what to wear to Hazel's. Instead, there stood Harold Cooper, carrying a heavy box. She couldn't move.

"Mind if I bring this in?" His black eyes took in her bedraggled appearance.

"Oh … oh, yes, I mean no. I mean, thanks so much. Of course."

A wry smile carried him inside. After he set the box down, he sprinted back to the bus for several others. Callie threw a misshapen cardigan over her shoulders, which did not enhance

her attractiveness in the least, and pulled off the towel to reveal a mass of wet hair. *Gorgeous.* As Cooper placed the last item on the floor, Callie was struck again by the incongruence between his strength and his dancer's grace. Nora had mentioned his coaching an Olympic ski team. Perhaps that explained it. He stood to his full height, looking down at Callie.

Now what? You can't just tip him like a delivery boy. "Would you, er, like a cup of tea? Brownie?" The words popped out of her mouth under their own power.

For a moment he hesitated in the doorway, his eyes traveling from the matted wet snarls dripping along the curves of her skimpily covered breasts and hips, to her bare legs and up again. "Tempting." *Sarcasm or lust?* She blushed again. He raised a flat palm. "No brownies for me. I'm having dinner with my daughter. If I'm not there, she doesn't eat."

Beneath the relief, Callie felt a sensation rather like regret. *You can't be attracted to Harold Cooper. Out of the question.*

Almost out the door he turned. "Do you know how to set up the computer and the work table?"

"I can follow directions."

"Nora or I will come back later in the week and give you a hand." In the next instant he was driving down the road.

Callie somehow applied makeup, dried her hair, and donned gray wool slacks and a royal blue cashmere sweater she'd purchased on sale. *Presto, chango! From the melted mass of the Wicked Witch emerges the shiny specter of Wonder Woman! Why did Harold Cooper have to see the witch?* She feared he'd be among the people at Hazel's, regardless of what he said.

Or did she just hope?

CHAPTER 5

Callie scolded her dress boots for wobbling beyond the call of duty as she moved to answer Peter's knock. His smile, the one that no doubt had launched a thousand heartbreaks, supplanted all trace of Harold Cooper. Peter's late-model off-road Mercedes held two surprises. The first was an aromatic casserole dish. *He cooks.* The second was Jean Frière, riding shotgun and gripping a covered salad bowl, his ever-present camera around his neck. "*Bon soir, mademoiselle.*" He smelled of whiskey and strong cigarettes. He launched into French with Peter, apparently about sports, though Callie only caught snatches.

During the ride to Flambert, darkness and blowing snow obscured the view. They could have been flying in space or riding a train through Siberia. Had someone spoken in English? Alternating currents of desire for Peter, resentment toward Jean, and irritation with both distracted Callie through the entire drive.

Street lights through snow painted a romantic haze around Hazel and Craig's two-story Arts and Crafts bungalow. The three entered through a glassed-in front porch where a graceful wooden swing signaled easy summer afternoons of iced tea and novels. A distant universe of happy, comfortable families.

A heavy-set African-American man met them at the door wearing a sea green chef's apron. "You must be Callie Franklin. I'm Hazel's husband, Craig."

Peter winked at Callie. "Trust Craig to lead with his wife. Hello, counselor."

"Speak of the devil." Craig slid his arm around his wife's waist

as she appeared and started collecting coats, starting slightly when she saw Jean. Callie guessed he'd invited himself. In the dining room a gleaming oak table was set with one-of-a-kind ceramic plates and flatware. Candles glittered off cut-glass goblets.

The only other guest was the new vice principal, Dr. Chen Hu-wei. His tweed jacket and bulky sweater layered over a turtleneck overwhelmed his slight frame.

Hazel explained that Miriam had been Vice Principal but never liked it. "After Coop met Dr. Chen at an education conference, he said he'd finally found a good replacement."

Dr. Chen raised his palms, warding off the compliment. "I am a poor substitute." He also demurred at her praise of the expensive wine, though he'd brought it. "Even one sip of alcohol turns my face scarlet. A genetic peculiarity among some Asians. I rely on merchants to recommend a label."

Jean passed the bottle to Peter. "French. Good choice." He raised his camera and snapped a few photos of his colleagues.

Peter caught Callie's eye, perhaps to apologize for Jean. To change the subject, he turned to Dr. Chen. "You taught at medical school, didn't you? The Cooper School must be less challenging."

Dr. Chen shook his head. "I grew up in China at a time of great chaos. My parents were doctors not allowed to practice, condemned for having Western skills. I was fortunate to have a long and fruitful career. Now that I'm retired, I welcome the chance to be useful." He passed the warm homemade bread.

Callie smiled at him. "So we're both Miriam's replacements."

"Successors, dear. Not replacements." Hazel leaned toward Callie conspiratorially. "Nora likes you and she's an astute observer. I'm sure we'll be fast friends."

Hazel's eyes traveled from Callie to Peter, perhaps to condone Callie's attraction. *Is it that obvious?*

Craig patted his new wife's shoulder. "Yes, Nora's judgment is impeccable. Evidence her close friendship with Hazel's daughter."

Callie had noticed the girl's police station ID badge hanging in the front hall with the coats. "Is Alexis joining us?"

Hazel poured sparkling water for Dr. Chen. "She was planning to but at the last minute she had to go out."

Dr. Chen looked around as if noticing for the first time that all the chairs at the table were filled. "And the Coopers?"

Hazel sighed. "They don't socialize much these days."

Jean nodded. "*Bien sûr.*" His pronouncement was hard to read.

Dr. Chen continued, "Mr. Cooper is a very troubled man, is he not?"

"Coop lost his wife around this time last year." Hazel framed her words with practiced composure. "An auto accident." She ladled soup with a demeanor suggesting the conversation was finished.

Attention turned to dinner. Though Callie had attended countless potlucks among Sophie's friends, they usually featured pasta with steamed vegetables. Craig and Hazel had created onion soup and duck à l'orange in the time it took Callie to bake brownies and be embarrassed by Harold Cooper. Peter's contribution was gourmet mushrooms in garlic sauce while Jean's salad boasted walnuts and imported goat cheese. Callie's box-and-water dessert wasn't in the same culinary class.

Jean interrupted the happy camaraderie, ignoring both Hazel's tacit plea for a change in topic and the evident discomfort of others. "Auto accident, yes, but that doesn't tell the whole story, *oui*? She was out in the storm to meet a man."

Craig gripped his fork. "The Coopers are our friends."

"That's just one theory." Hazel moved the wine bottle away from her French colleague. He responded by taking her photo.

Peter's blue eyes narrowed. "It's the police theory."

"Was Mrs. Cooper's lover in the car?" Dr. Chen seemed oblivious to the growing discomfort.

Hazel appeared to focus on the insistent snow beyond the dark windows. "Miriam was alone. It was an awful night, a blizzard. Worse than tonight."

Craig seemed reluctant as he joined the discussion. "She apparently lost control and slid into the path of a semi. The trucker didn't see her until too late."

"Where was this?" Dr. Chen reminded Callie of kids in juvie

who had no idea when to leave something alone.

"They were both in the parking lot of a motel just outside town. The truck was pulling in, she was pulling out." Peter knocked his fists together. "The motel personnel did everything they could to save Miriam but it was too late. The trucker survived."

Dr. Chen cocked his head to the side. "Maybe she was just turning around?"

Peter touched Callie's arm apologetically. "She'd rented a room."

Craig raised his litigator's voice. "There's no proof she made the reservation."

Jean sounded almost sober. "The room was rented on Cooper's credit card. Yet he knew nothing about it."

"I don't want to talk about this anymore." Hazel rose abruptly and began clearing the table.

Jean raised his camera.

Hazel looked ready to crush the thing. "Stop it, Jean."

Jean let the camera slide down its strap around his neck. "In France we know how to have affairs. Miriam should have been more discreet."

For the millionth time Callie thought of her mother. "Maybe Miriam just wanted to escape." *From what? Please, not an abusive husband.*

"The police found men's underwear in the room and bodily fluids ..." Peter cleared his throat. "Forgive the graphic details."

Craig disappeared into the kitchen. Hazel followed.

"At first the police thought it was a homicide—that someone tampered with her brakes." Peter didn't help collect dishes. "But they found no evidence."

"Peter's a crime nut." Jean yawned. "Few of us read the *Flambert Courier*."

Hazel returned with Callie's inferior brownies, Craig on her heels with coffee. Both praised Callie's dessert, offered cream and sugar and generally seemed determined to change the tone.

Callie cast about for a new topic. "Do you see much drug use at school?"

Hazel nodded as if grateful for the diversion. "Now and then. But the consequence for drugs in any amount is expulsion."

"Isn't that a little Draconian?" Callie read the policy and was eager to debate it, having served in juvie with kids who'd smoked pot but didn't deserve jail.

Hazel shook her head. "Most of the girls support it. They want the drug culture out of the school."

"For some girls this here age, drugs are their her-i-tage," Peter awkwardly rapped a hip hop rhythm.

The muscles in Craig's face tightened visibly. "Not every poor kid is a criminal."

Peter responded with gentlemanly calm. "No offense, Craig. You're right, of course. Cooper is full of students who prove your point. I know from my prep school days that it's privileged kids who tend to think the rules don't apply to them. Like Nora Cooper. I sometimes wonder whether she's on drugs."

Callie's breath caught.

Hazel's open hand hit the table, rippling everyone's wine. "I've known her since she was born. She was always my best student, responsible beyond her years. Not druggie characteristics. And I wouldn't call her entitled."

Peter's voice was velvet—more sorrowful than accusatory. "You're describing the girl we knew before her mother died. Now she's moody, difficult. Doing menial work for her father, treading water instead of going to college. It's sad to see potential go down the drain."

Hazel practically hissed, "For God's sake, Peter! She just lost her mother."

Peter seemed genuinely contrite. "A year ago. Isn't it time to move on? I worry for her."

Callie chose not to mention the conversation she'd overheard. Maybe the 'deal' had nothing to do with drugs. Maybe these weren't the people to ask.

Soon they headed home. Jean flopped into the front seat without glancing at Callie. Peter and Jean's French murmur became white noise as she mulled over the evening.

When the car neared the Cooper School, Peter raised his

voice and spoke in English. "What an annoying evening. Jean's coming over for a nightcap. Will you join us?"

"No thanks." *Please insist.* "I have to prep for tomorrow." Callie was still waiting for him to insist long after he'd dropped her off.

During the following weeks, she didn't let thoughts of Peter—not the perfect smile, blue-blue eyes, dimples, skater's muscles—interfere with teaching, going to the gym, prepping and grading, or sleep. Disappointment in a nonexistent love was not her chief worry. What if a boisterous student or better-trained teacher unmasked her as an imposter? She worked harder and trained harder, but the mob bearing torches and scythes always seemed just beyond her peripheral vision.

Weeks passed without incident. Nora stopped by Lang Arts one day with a phone message. "Some guy says he's Blake somebody's lawyer. He said you'd know and left his number."

"Thanks Nora. I already called him. You can toss that." Callie hated lying but had no intention of explaining Blake.

Shauni, lingering in the classroom, smiled at Nora. "Don't forget the meeting." Nora waved a noncommittal assent and departed. Shauni continued, "Uh, Callie, er, we were wondering, I mean I was hoping—"

"Yes?" Impatient with the girl's hesitation, Callie wanted to evoke Sophie's mystical power to simultaneously encourage and demand. Absentmindedly she caressed the silver dove at her throat.

"We need a faculty sponsor for our community service group. Would you do it?"

The Cooper School required everyone—students, faculty, and staff—to participate in community service. Some sang Christmas carols at retirement homes or distributed tee-shirts at a charity run.

Shauni spoke with her usual confidence. "We want to educate the whole school about sexual assault and safe sex."

"Together? Rape isn't sex. It's violence." *Do I sound like a public service announcement?*

Shauni batted her eyelashes in exaggerated shock. "No!

Really?" She resumed her normal voice, the gold flecks in her green eyes aglitter. "Seriously, some girls don't know the difference. That's what we want to talk about."

Callie longed to say no. Any subject but sexual assault. But Sophie's wisdom rang in her ears: "Running isn't a solution, it's a new problem." *Go on the offensive.* "I'm not crazy about Cooper School girls being sexually active."

"Wow, never pegged you as a prude." Shauni giggled a little nervous cascade. "But, well, the girls are going to have sex whether you want them to or not. Don'tcha think?"

"Premature sexual contact can be—" *A prude. Really?*

"I was kinda teasing. We know you're okay. We figure you won't push chastity pledges. Right?"

"Of course not, but …" Callie knew plenty about sex but not in ways she wanted to share—or see adolescent girls experience.

"So let's bring this up at the meeting, where you can really get made fun of."

Callie handed Shauni a pen. "Write down the details."

Over the next few days, Callie did her best to put the meeting out of her head. After all, she'd just chaperone. Unfortunately, she found it impossible to block out bloody fragments of her past. Her personal black hole. Childhood memories of her mother's rape and murder.

Despite years of therapy and support groups Callie still half believed she could've prevented it. Blake's shouted accusations still resounded like physical blows. Blake told her to shut up about her mother's frequent injuries, usually attributed to Cecilia's purported clumsiness. *Should I have told someone?* Protectively, Cecilia dispatched Callie to lessons and to her friends' houses—and to Sophie's when they could keep the visit secret.

On that horrible day, the other child's mother dropped Callie off early. The terrified eleven-year-old usually crept inside, hurrying toward the safe haven of her room. But this afternoon was different. The foyer was all wrong—paintings awry, vases in shards, flowers and plants upended. Her mother's screams from the floor above tore her eardrums. Callie assumed her mother

was fighting an intruder.

She flew to Blake's desk, where she'd seen his revolver. When he bought it, he'd boasted about his expensive firearm, a "four-inch Colt Python with a Royal Blue finish." He'd slapped Cecilia when she protested having a gun in the house, while Callie'd cried silently in the next room. Finding the drawer locked constricted Callie's breathing—a new experience for the girl who effortlessly ran six blocks from school. Cecilia's screams continued and a man's voice joined the fray. Later Callie couldn't explain why she didn't recognize Blake's voice.

Callie grasped his heavy antique silver letter opener, the one he commanded her mother to shine daily. At eleven, Callie had only TV knowledge about how to jimmy a lock and it seemed to take forever. The wood shredded under her frenzied blows. At last the drawer fell open and she threw open the revolver case. She didn't consider whether the weapon was loaded or whether she could fire it. As she sprinted up to her mother's bedroom, she heard a fist thud against skin. Slap. Scream. Slap. Smash. Callie silently turned the doorknob and peeked in. Usually tidy as a museum, the room was unrecognizable. Curtains shredded. Furniture broken. Mirrors shattered. At the center, Cecilia's blood dyed the jumble of white silk bedding custom-made for Blake's king-size bed. The screaming stopped. Blake, naked, his penis still inside Callie's dead mother, continued to pound her lifeless body. Chilled and feverish simultaneously, Callie grasped the gun. She didn't know when Blake saw her. But she remembered his eyes, red like the devil's in movies. He must have lunged toward her because she shot him in the chest. She could never recall the exact moment he fell. Only the blood. Pools of blood. And then the screams that were hers.

Twenty years ago.

The cold and snow, the lights along the walkways, the stars, the millions of stars, and finally the dormitory entrance forced Callie back to the present.

Shauni's cheerful freckled face greeted her. "Hope you're hungry. The house parents are out so we made pizza."

The aroma of tomatoes and garlic filled the air. A dozen girls

sprawled on the floor and furniture, laughing and talking and eating, sometimes all at once. Nora, recruited as culinary advisor, handed a plate to Callie, grunted a hello and sat apart, with a sullenness Callie hadn't seen before.

Shauni called the meeting to order and explained the project. "A lot of girls, er, women, get raped. Sometimes they can't do anything to stop it, but if we talk about it openly, we can figure out how to take care of ourselves better—self-defense, stuff like that." She handed around copies of an informational pamphlet and waited a few minutes while everyone looked through it.

"Why rape? I mean, shouldn't we be talking about the glass ceiling or something?" The quiet girl who spoke was from Racine, Wisconsin, where, in her words, "Nobody's had a job for generations."

A South Asian junior with wide black eyes looked around. "In your country one of every six women is assaulted. That's two of us right here."

"Get this—almost half are younger than eighteen. Our age." A plump girl with blue streaks in her hair pointed to a chart in the pamphlet.

A sophomore who'd volunteered to take notes spoke next. "Maybe we should pick something different. Easy to say talk about rape, but we don't want the whole school to gossip about us."

Shauni nodded. "Right. First we need to be safe right here." Everyone started to speak at once.

Shauni raised her hand for silence. "First, everyone say, 'I swear anything said here stays here.'" She repeated it as everyone said it along with her. "Now, anybody who still doesn't want this topic can leave. This committee is about sexual assault. And the other kind of sex, too. The good kind."

Callie admired Shauni's confidence. Nobody budged.

A blonde girl wearing a tee-shirt that read Adam was a First Draft spoke too loudly as she read the pamphlet. "I don't like the word victim."

"Well they aren't exactly participants, are they? It's not like the next day the girl just resumes her normal life." The speaker

turned out to be Hazel's daughter, Alexis, the group's community liaison. She spoke authoritatively. "Victims of rape are more likely to be suicidal or drink or take drugs."

The blonde protester looked to Callie for approval. "I just don't like the word." She raised her voice. "I'm not a victim. I'm a survivor." The room quieted, waiting to hear, while wanting it not to be true. "Like Shauni says, talking about it helps. I was eight. My family was homeless. We moved into my uncle's basement. He waited 'til my parents were out." The girl picked at the carpet by her feet. "He hurt me so bad I went to the hospital. They told the doctors some kind of lie, I don't know what. Nobody will talk about it."

Words of support and anger rang from all sides.

"That man took a part of me, but he didn't wreck me. I fought to get out. I did good. I got into Cooper. Someday I'll put men like him in jail."

"A lawyer?" The blue streaks girl stabbed at her pizza with a plastic fork.

The blonde nodded. "Or a cop."

Amid murmurs and side conversations, another girl's whispers took over the room.

"Tell them. Please." She stroked the arm of the girl next to her.

Her companion slowly looked around the room, perhaps assessing her risk. Surprisingly, nobody spoke while she made her judgment. A glance to her friend seemed to bolster her courage. "Last summer vacation my brother's friends got drunk. At first it was fun. They were laughing and watching TV and teasing me. Then one guy grabbed me. I thought they were just, y'know, tickling me, until another one joined and then another tore off my clothes. They burned me with cigarettes and, y'know, had sex on me." She clutched her friend like a life raft. "I couldn't get away. I guess the neighbors heard and called the cops. All the boys went to jail, even my brother. They all hate me now. I didn't go home for Christmas. I don't know if I can ever go back."

"Your brother? Gross."

"Step-brother. He only came to live with us last spring." She hugged herself, covering the heavy sweatshirt over her breasts. "Everybody thinks I'm horrible. Like a slut."

"Bullshit." Callie and Alexis spoke simultaneously. The shock of adults cursing set off hysterical laughter among tears. The floodgates opened. Stories of 'my sister,' 'my mother,' 'my cousin.'

Alexis spoke above the fray. "It's really important to hear this. **It wasn't your fault.**" She looked at each girl in turn. "Rape is caused by rapists. Not by what a woman wore or didn't wear, not because you had fun or your mother went out to a bar. The blame goes on the perpetrators. Not the victims." She exchanged a glance with Shauni.

Shauni rose to the unspoken challenge. "Maybe we should say survivor."

"Not everyone survives." Callie heard the words after she'd spoken them. No one questioned how she knew. Teachers know things.

"So what do we do? Stay inside away from boys?" The senior who spoke was eighteen. "I like boys. I like, y'know, kissing and …" As she trailed off, she got a chorus of uh-huhs.

Shauni shook her head. "Not every guy's a rapist. Next time let's talk about what's okay. I mean they tell you about boys' sex urges, but we have 'em, too." Another chorus of assent. "So let's talk about sex." Accompanied by giggles, Shauni adjourned the meeting.

Several girls huddled around the two who'd told their stories, offering hugs and chatter. In the bustle that followed, Nora grabbed her coat and left without saying goodbye.

Callie wanted to run after her and find out why she was in such a dark mood, but couldn't leave her post as chaperone until the house parents relieved her. Her dilemma was interrupted when a CD player came alive with pop music. Instant mood change. Girls sang along or danced, dragging Callie along. While she tried to figure out what a chaperone should do, Callie heard Shauni holding forth on addiction.

"I was born a crack baby and raised in foster care. I don't even

know whether Rodriguez is my real name. I'm lucky I wasn't brain damaged. And I'm super lucky I got into Cooper. Lots of kids I knew are dead."

A few others told harrowing stories about their neighborhoods. Callie decided to add autobiographies to her writing assignments. "What if someone offered you drugs here at school?" *Maybe one of these girls knows about that conversation outside Lang Arts.*

"Turn their ass in. Oh, I'm sorry, Callie, er, Miss Franklin. I didn't mean to curse." The girl covered her mouth.

Shauni sprawled on the floor. "I don't believe in ratting. Get someone kicked out? I couldn't."

Callie pressed on. "What if you knew someone was using here at school—not trying to recruit anybody, just getting high?"

The girls had a dozen opinions, all theoretical.

Callie wanted to be sure. "Without naming names, tell me truthfully—do you know anyone at all at Cooper who is using or dealing?"

Most girls said no. Shauni spoke louder than the others. "Not the kids. I don't know any kids who're using."

The statement took a minute to sink in. While Callie was deciding her next question, an exuberant dancer, apparently tired of the drug talk, plopped down next to Callie. "Hey Ms. Franklin, Callie, are you going to the ski lessons tomorrow?"

"Ski lessons?"

"Coop teaches cross-country the second Saturday of spring semester to anybody who wants to learn. Teachers, too. You should come."

Callie vaguely remembered the announcement on the Lang Arts bulletin board. "I don't know." *Great, another opportunity to embarrass myself in front of my boss.*

"The school provides skis. Just show up on the central quad at noon tomorrow. It's really fun."

As Callie considered possible excuses, Shauni announced she needed help with the dishes. "I'll do it." Callie wanted to speak with Shauni alone. The two washed and dried in rhythm. "What did you mean? Someone on staff does drugs?"

Long silence. "I have no proof. But I know a user when I see one. And I'm pretty sure I've seen one."

"Who?"

Shauni shook her head.

"If I guess the person's name will you nod?" Shauni didn't look up.

"Is it Nora Cooper?"

Shauni burst into laughter. "Nora? You've got to be kidding. Miss too-clean-for-words? She won't even get a fake ID even though she could easily pass for twenty-one. She's never tried anything, not even pot. I'm telling you. I'd know."

Relief flooded Callie.

"She doesn't do boys, either."

"Do you mean she's a lesbian?" Callie didn't like prejudices of any sort. She was prepared to defend Nora's right to her own sexual orientation.

"No, no. I'm the lesbian. Nora's no dyke. I mean she doesn't date at all. Not girls, not boys, not little green aliens. If the Coopers were Catholic, she'd probably end up a nun."

"Maybe she's focusing on her art."

"Maybe." Shauni formed a handful of soap bubbles into a makeshift sculpture. "Her work's changed a lot since her mom died. Darker. More complex. Nora's a genius, you know. She does everything—paint, sculpture, design. She costumed all the school plays. She's already had a piece in a New York gallery and…"

Very much later Callie remembered that Shauni never revealed the user.

CHAPTER 6

Shauni's cryptic accusations nagged at Callie all morning until the irritating prospect of ski lessons in front of the entire school drowned them out. She was a good athlete who'd taken years of martial arts, but never while her employer watched. In lieu of sleek microfibers she didn't own, she assembled random layers of cotton and wool concealed by her baggiest jeans, intensifying her resemblance to the Michelin tire guy. She crabbed at the midmorning sky—fingerpaint blue with clean cottonball clouds. "Don't be so darned cheerful."

She stopped for coffee at the campus commissary which bustled with students stocking up on snacks for the outing. Nora, sitting at a table, moved a pile of gear and waved Callie over.

"Isn't this Saturday?" Callie gestured to a clipboard of tasks at Nora's elbow.

"Are you asking if Simon Legree, I mean Coop, is driving me across the ice floes?"

"We do have child labor laws in this country." Callie set her coffee on the small table.

"That would be ever so much more helpful if I were a child." Her intense Cooper eyes shifted from her checklist to Callie. "Seriously, it's my choice. Since I was about ten, on ski day I volunteer to organize the equipment, find boots, everything. One year I forgot to count poles and someone used a broomstick. Pretty funny. A witch on skis."

"Big job." Out the window Callie saw a parade of students and faculty on their way to the lessons.

"I hope you're coming."

"Wouldn't miss it." *Liar. I'd rather be home with a good book. Or at the dentist.* "How many people do you expect?"

"Usually twenty or thirty newbies—mostly freshmen, some teachers. Another couple dozen already ski. A lot of ages. A lot of sizes." She clapped the clipboard against her head. "Oh, whine, whine, whine. My mom used to say I complain just to complain." She blinked back tears.

Callie offered Nora a napkin. "You must miss her."

Nora collected her gear in little jerks. "For my mom, ski day was more fun than any holiday. She liked introducing the girls to something new, something they wouldn't learn without the Cooper School." Her voice was small and strained. "My dad is great, but, well, you saw—not exactly Mr. Demonstrative. Mom was the hugger."

"My Aunt Sophie—the one who gave me the dove necklace?—same thing."

Nora wiped her eyes. "Talk about something else."

"Okay. Um—"

"The new snow is perfect for cross-country." Nora pulled on a bright magenta ski hat covered with handmade off-kilter snowflake appliqués.

"If you say so."

"Coop told me you need help setting up the computer desk. If you survive this, maybe I can come over later."

"I wish you hadn't said if." The extra desk was still in boxes, insisting that Callie admit she was powerless over it. "How long will the skiing go?"

"As long as the weather holds. It's nice now, but a storm's coming in. We teach the basics, then take an easy trail. The whole thing takes three or four weeks."

"And me with no change of underwear."

"Hours. Just testing."

Callie and Nora joined the crowd at the gathering place, marked by a perfectly formed snowman holding a well-worn sign: **Ski Today.** As Nora, Coop, and Jean Frière helped match skiers to equipment, Callie peered around the bustling crowd, not admitting she was searching for Peter. As cover, she sat on a

frozen bench next to Dr. Chen who shivered in the single-digit mercury reading. Enveloped in layers of puffy down, the doctor seemed a size larger than his skinny frame. "I'm in snow for the first time and I find it very cold."

"You're brave."

"Maybe I'm foolish." He shook his head slightly. "And you? Brave or foolish?"

Callie considered. "Definitely both."

"Definitely." Coop stood in front of them, offering skis.

"And you, Mr. Cooper, which are you?" Callie couldn't halt her impertinence.

"More foolish than I should be." He helped her secure her boots to her skis while Dr. Chen imitated the process. Coop raised his eyes to Callie's as he finished. Something fiery and unspoken sparked between them. She reached for her poles as if they were fencing swords.

The lessons began. Despite numerous flubs and spills, within a very short time even the most timid girl was in motion. Callie took mental notes as the Coopers teased, babied, or challenged; their teaching methods tailored to each girl.

Jean Frière directed the adults, frequently dismissing them all as uniformly idiotic. He snapped in exasperation as they tentatively slid on the path, falling and standing again with less agility than the students. "*Mais non. C'est* impossible. *Encore.* Again. *Encore.*"

His vitriol reached new bilingual heights while the Coopers organized a buddy system with each seasoned skier responsible for keeping a learner in sight. Coop assigned Jean to Callie, causing an angry conversation. Callie could see Jean pointing at his camera but could only make out his occasional French invective about *noir*. As Nora led the group toward the woods, Jean snapped pictures and gestured with his camera for the adults to follow.

Callie concentrated on the rhythm of her movement, swinging her arms and legs, pushing and gliding past frozen streams, in and out of the mottled sunlight, under the muffled canopy of mountain evergreens. While the girls exchanged

shouted conversations over the swishing of many skis, Callie was most exhilarated by the silences, the sleek quiet of the winter. Silence was safe.

The group spread out, the more confident skiers moving ever more quickly. Callie found herself at the rear. She could hear girls in the distance, but only Jean was in view. Despite the buddy system, he shot on ahead. "You're a natural." His Parisian accent slid over the words with honeyed disdain as he zipped away.

Callie's legs were strong from her exercise regimen, but balancing and maintaining the rhythm undermined her speed. *Right, a natural.* She reveled in the smell of clean air, so different from the grimy years in a dying industrial town. Anything seemed possible. Jean's bright yellow jacket flashed between the trees.

Gray clouds pressed across the sky with sudden violence. Snow began to fall in crisp little sheets that obscured vision. Callie noticed a black diamond trail marker. *Weren't the earlier markers green? Do the colors mean something?* She hurried after the yellow jacket, beginning to suspect that she'd lost the group. The trail grew increasingly steep, narrow, and poorly groomed. She watched Jean's ski tracks filling with new snow in front of her.

Callie wanted to stop, turn back—anything to halt the fear of being alone in the cold twilight. But to one side of the trail the mountain fell sharply into dark woods. *Can I safely reverse direction?* Her fingers ached in the inadequate gloves.

Miscalculating how to negotiate a difficult slope, she lost her balance and fell. Though she pushed herself upright as taught, somehow in the tangle of feet and skis, one pole sailed off the trail. Inadvertently, her body jerked after it, her hand grasping only air.

That awkward lurch sent one ski-clad foot over the side of the embankment, the other dragging behind. Callie's arms flailed. The struggle for balance sent her down a long, steep embankment. She stabbed at the snow, succeeding only in increasing her velocity. A duet of cursing and moaning rose from her chest. The deep snow and a heavily laden fir tree conspired to break her fall. Her shoulder thudded against a large hidden branch, sending her sprawling backward. Excruciating spasms

pounded over her arm and shoulder with a ferocity she had never felt, not even in fistfights. The trail was now some distance away.

"Help!" Callie shouted at regular intervals. No answer. She used her good arm to release the skis and stand them upright in the snow. She clutched her enemy, the tree, trying to haul herself up. Despite her best efforts, however, she slid further from the trail, each time deeper into the snow. The trembling from the cold and her throbbing shoulder made her dizzy. *Don't pass out. Think warm and safe. Keep your wits. You're a survivor. This is bad.* She barely heard her own screams.

Callie clung to the tree, terrified that moving her legs would plunge her further down the mountain. The snowfall intensified. Time elongated in pace with the afternoon shadows. Heavy snow soaked her jeans and then her long underwear. Her teeth chattered until her jaw hurt. Her wet clothing weighed her down. *This is how people die.*

"Anybody there?" The sound from her throat was not the intended greeting of an adult, but an untamed cascade of frantic tears. Dusky mirages pulsed in the gray-white murk. Nothing. No one. When a large shadow shifted to solid, Callie couldn't tell if it was real. *Rescuer? Angel of death?* Regardless, she had to try and called out again.

The shadow sharpened into a breathing, earth-bound man. Harold Cooper. He might have shouted her name while he climbed down to her. She could only sense one thing at a time. At that moment, it was rejuvenating warmth as he wrapped his arms around her and held her while she cried. He pressed his warm cheek against her cold one, murmuring reassuring sounds into her frozen ears. She couldn't distinguish the words.

Arm around her waist, he guided her toward a toboggan. He pressed her hurt arm and the jolt caused the kind of scream she hadn't uttered since her mother died.

"Hold still." He slid his hands inside her jacket and carefully felt her shoulder and arm as she winced and moaned. "Thank god, probably a dislocated shoulder."

"Yeah. Thank god, indeed." Neither throbbing, freezing, nor near-death could keep her fresh mouth at bay.

He grunted. "Sense of humor intact. I meant that Dr. Chen can fix this. Tough to airlift you to Albany or Montreal in this storm." He strapped her into the toboggan and negotiated the embankment like a polar bear.

"Am I the last one?" Hearing no other voices, she wondered again if she was in the final delirium of death, imagining her cruel boss as a knight.

"Yep. We missed you at the head count." He pointed the sled toward campus, kneeling to secure her for the ride. His visible breath and the musty smell of ski wax suggested that she was, indeed, alive.

"How long was I down there?"

"Forty or fifty minutes. Damned dangerous to go off the trail. It'll be dark in less than a half hour. What if you'd been unconscious? What if we hadn't found you? People die from this kind of stupidity!"

"I'm sorry, I ..."

Once again, his arms were around her, stroking and holding her with unexpected gentleness. "No, no, it's not your fault. I'm furious with Jean, but I'm not angry with you, sweetheart. Just letting off steam."

Sweetheart?

Coop pulled the sled along the trail, speaking into a cell phone to call off the search party. As they reached the edge of the woods, a cheer erupted among the posse of searchers. Many girls, already out of their ski gear, raced to the toboggan, jostling one another to see Callie, wish her well, offer a hot drink.

Dr. Chen knelt beside her. "Are you injured? I have my medical bag."

"I think her shoulder is dislocated. You can examine her at our place." Coop waved away the students and steered Callie toward the dorm, a few yards away on another planet.

They passed Nora and Jean in intense conversation. Callie hoped, uncharitably, that Nora was telling off that skinny jerk. She overheard only raised voices. Nora shook a finger at Jean and he moved toward her, poking her with his gloved finger. She looked ready to slap him, but Callie saw no more as Coop hurried

heralong.

Arriving at Gwendolyn's former mansion, Coop supported Callie up the steps from the first-floor student common room into the private residence. Easing her onto his neatly made bed, he took off her ski boots and covered her with a heavy blanket.

Dr. Chen followed, sending Coop to another room. He gently helped Callie shed her wet jacket and sweaters, leaving her sopping long underwear and bra in place. Callie grasped the bedding with her good arm, straining against the pain.

The doctor looked closely at her shoulder, prodding and pushing in small, gentle movements. "Mr. Cooper was right, it's dislocated. For a moment, it will be worse. Then it will be better." After a searing, breath-defying flash, the pain subsided.

Callie lifted her arm by inches and gingerly rolled her shoulder. "Wow. How? It doesn't hurt!"

"I think it's only comparative. You may feel sore for a few days." Dr. Chen examined her hands and feet, asked her some other questions, then called to Coop. "She needs rest and a change of clothing and—"

Distance, or possibly relief, muffled Coop's voice. "All covered, doc. I'm cooking. Would you like to stay?"

Dr. Chen politely refused.

Callie wondered if the doctor thought he was doing her a favor by leaving her alone with Coop. She decided to follow the doctor. Pushing up on her good arm, she wondered how she'd manage to get into the wet jeans and sweaters piled on the floor. "I should—"

Coop called through the French doors, "Stay where you are. I'll find you something to wear." He clattered up to the third floor where Callie could hear him opening drawers and cabinets.

She sank back on the bed in full-fledged self-castigation. "Wimp."

Coop returned with a thick terrycloth bathrobe. Judging by its size, it belonged to neither Coop nor Nora. He took in Callie's stare. "Miriam's. Sit by the fire a minute." A teakettle whistle called him away.

Shivering, Callie put Miriam's robe over her wet long

underwear and stumbled to the living room chair next to the fire, clutching the blanket like a toddler.

Coop brought a tray with a cup of tea and a plate of gingerbread. "Are you up to a bath? That's probably the fastest way to get warm." He opened a door into a large bathroom, turning the faucets on a double-sized tub. "Can you move okay?"

"My shoulder's sore. But I'm fine. This gingerbread's heavenly. Did you make it?"

He shrugged an assent, offering the same enigmatic expression she'd seen in Troyville. *How does he see so much without giving away anything about himself?* As her insides began to thaw, the seriousness of the day bubbled back up. "You saved my life!" She felt weepy. Again.

"You weren't close to dying." He held each foot, scrutinizing it carefully like Dr. Chen before him. "You don't even have frostbite. Lucky."

"Yeah."

Only the faintest tightening of Coop's jaw suggested his touch was more than clinical. He hurried into the bathroom and turned off the water. "Ready."

Callie dragged after him, steadying herself against the counter. He moved behind to support her. Through the robe and the damp long underwear, she felt the warmth of his hand against her spine. A hot and cold shudder moved through her.

He turned her to face him. "Definitely foolish." He leaned in, just slowly enough to allow her to say no if she wanted.

No wasn't in her vocabulary just then. She arched her neck, lifting off her heels and pulling him toward her.

He kissed her.

She kissed back.

CHAPTER 7

allie floated alone with Coop in a terrifying alternative reality in which some men could be trusted.

"Where is everybody?"

That's Nora! Callie had completely forgotten the girl. Apparently she wasn't the only one. Coop shot out of the bathroom with a finalizing click of the door. In a moment, Callie heard a singer who could only be Ella Fitzgerald, one of Aunt Sophie's favorites. Humming the notes helped drown out complications.

Nora called through the door. "Coop forgot to tell you that those knobs are for the Jacuzzi. Help yourself to the bath stuff."

"Thanks." A twist of the good wrist and pressurized jets kneaded her with pulsing hot water. Callie chose the green-grey gray bath salts called Seafoam Surrender. Its scent called up an amniotic ocean—familiar and ever so slightly assaultive. The large tub let her float into the night sky beyond the windows, back to her own solitary, protected world. Later, in Miriam Cooper's periwinkle sweats, Callie considered herself in the mirror. The clothing was too large, but nice quality and comfortable.

Lured by the scent of sizzling garlic and spices, she padded into the kitchen. Nora and Coop, backs to one another at opposing counters, were at war. Callie halted, not sure whether to make her presence known.

"I don't see the point of punishment." Nora was stirring a large metal soup pot, her wooden spoon punctuating her words.

"Jean was supposed to be Callie's buddy, not off shooting

pictures. It's not like you to interfere." Coop looked up from the *New York Times* cookbook, his finger marking a page.

"He said he didn't know Callie would follow. I doubt he could feel worse than he already does."

"He didn't know? She was his responsibility." Coop, perhaps aware that he was shouting, chopped vigorously. A moment later he was calm. "The point isn't to make him feel bad. It's to reassure the girls that behavior has consequences, that adults have to be accountable."

A spoon hit the floor and all three of them jumped.

"Don't be an——" Nora noticed Callie and motioned her forward. "Hey. I hope you're hungry. Coop's fixing a major feast."

"Great. I'm starved. How can I help?"

Nora pointed to an overstuffed chair. "Sit. Put your feet up. We're almost ready. I'm throwing your long johns in the washer and dryer with the rest of your clothes, so you're our prisoner for at least another forty-eight minutes. That means when I say sit, you sit."

From Callie's perch on the plush chair, she watched Coop butter phyllo dough, his stiff back suggesting he hadn't settled his argument with Nora. Callie surveyed the home full of artifacts—Nora's childhood drawings, photos, souvenirs from family trips. Callie ached for such things. Her few pre-Sophie belongings were a garbage bag of private items allowed in juvie, now mostly consigned to the dustbin of history. She somehow knew the Coopers' antiques, silk rugs, crystal, and china were just set dressing. Until it all came crashing down, this family would have been happy in a trailer.

And now, in their own Katrina rubble, they pieced together dinner—whether by habit or respect for the past, Callie didn't know. She found it curative: homemade mushroom soup, lemon chicken, rice pilaf, a Greek salad, and baklava. The dinner conversation was lively and surprisingly relaxed given whatever remained in mid-air.

Nora acted both adult and child—fully engaging in the conversation, yet from time to time dismissing both Callie and

Coop as impossible. "The older generation!" Nora poured coffee. "That's why we're drinking decaf, right?"

"We're really three generations here. I'm about halfway between you and your dad."

Nora teased. "Great, now you expect me to do fractions."

"You're right." Cooper pushed himself away from the table. "I'm the old fogy here."

"I didn't mean . . ." *Is Coop insulted? Kissing confuses things.*

Nora brought Callie's clothing from the dryer. "You can change in my room."

"First let me help with the dishes."

"No, no. Go ahead." Coop may have meant to offer a kindly release from duty, but it sounded like a rejection.

Callie felt relieved, or was it disappointed, as she and Nora mounted the stairs to the third story of the old house—two long attic rooms where servants once bunked. Nora's multi-media projects hung on every wall and lay in heaps across tables and easels.

"Is this whole floor yours?" Callie observed another modern bathroom at the end of the hallway. "Did they retrofit it for you?"

"Yeah. There's some attic space under the eaves but unless Coop wants something from storage, he almost never comes up here. Good thing, too. You see what a neat freak he is."

Atop Nora's rainbow-hued jungle were twenty-first century skylights, where moon and stars illuminated hand-painted wall hangings and sculptures of found objects. The art was not the scribbling of a child. Skilled craftsmanship conveyed a dark message Callie couldn't decipher. She was almost too distracted to change clothes.

Callie watched Nora idly straighten a photo of her mother wearing the same periwinkle sweatshirt Callie was removing. "Seeing me in your mom's clothes—did it bother you?"

Nora watched while Callie folded the sweats. "No, it really doesn't. Wow. That's a surprise. We're coming up on the anniversary of her death and it's been hard on us both. We've avoided so many things we used to do with her."

"Like Hazel's dinner?"

"Like any dinner. You're the first guest we've had in a year and you weren't invited."

"Sorry." *How would Nora feel about the kiss?*

"Don't be dumb. Mom was the most generous person on earth. If she were here, she'd give you her clothes herself. Tonight reminded me of her in a good way."

Callie tried to reconcile Nora's vision of Miriam Cooper with the gossip at Hazel's.

In that moment, the quasi-grownup Nora melted to reveal the girl who'd lost her mother too young. Unaccustomed to physical closeness with anyone but Sophie and occasional inconsequential lovers, Callie hesitated. When she patted Nora's hand, the young woman fell against her, sobbing into her sore shoulder until the tears wet her shirt.

"I don't care what those jerks think." Nora muffled her cries in the jumble of decorative pillows on the bed.

Callie knew this terrain. "I lost my mother when I was young. It's hard not to blame yourself. But it wasn't your fault."

"You don't know." Nora's whisper was almost inaudible. She covered her face with both hands and rocked. "I never should have gone to that meeting. I had everything under control."

Callie searched for some appropriate Sophie magic. "Nora, control isn't always best. Please don't try to grieve alone. Should I call your dad?"

Nora spoke in a whisper but with the energy of a shout. "No! No! Don't tell him I freaked out. Please, promise me. Please!" Nora took short breaths through her nose, her chest and shoulders trembling.

"You both lost her." Without Sophie, Callie couldn't have survived her mother's murder.

"You don't understand. My mom died because of me." Nora gripped the photo of her mother so tightly her knuckles strained white. "I killed my mother."

Callie cupped her hand over Nora's like a cocoon. "It was an accident."

"They say she was out meeting a man." Nora's words were barely audible.

"You don't need to listen." Callie's shoulder hurt and she wanted to get away. Sleep. Read. Anything.

"But he wasn't after her." Callie's solar plexus tightened. "He was after me."

Callie could hear the shushing hum of the dishwasher in the kitchen and Chet Baker's mellow tenor on the stereo downstairs. *Is life normal somewhere?*

Nora ran a finger along the photo. "She was going to confront him because ... he raped me."

The pieces realigned. Nora's talkativeness versus sullenness at the meeting. The recurring themes in her art. Darkness punctuated with crimson and ivory. Callie kicked herself for not seeing it earlier. "That little bastard." A desire to kick the boy bloody supplanted the urge to leave.

"Dad doesn't know. Promise you'll never tell him."

"Why not?" Callie looked over Nora's shoulder at Miriam's kind face, wishing the dead woman could provide a clue.

"The last thing Mom said before she went out that night was, 'Thank God your father's out of town.' See? It was her dying wish for me not to tell him." Tears dripped off Nora's chin.

"Oh, Nora, I'm sure she didn't mean—"

"No. I can't tell him." Nora's face was red and puffy but her voice was fierce.

"Instead you let him think your mother was having an affair?" Callie wondered if that explained Coop's reserve.

"He knew she wasn't."

"I know he believed in your mom, but—"

Nora shook her head emphatically. "No, I mean it was impossible. Most people don't know this, but he called just as she was leaving. I listened, 'cause I wondered if she'd breakdown and tell him. But she didn't. The last words I ever heard her say were, 'Honey I have a quick errand. I'll phone after I'm back. Love you.'" Nora now cried out, heaved and shuddered. "The police were called thirty- five minutes later, exactly the amount of time it takes to get from here to the motel in icy conditions. That means she drove straight to her ... death."

"But the room was rented on Coop's credit card."

"Dad had the card. The motel clerk told the cops that a man phoned in the reservations. The police figured someone else made that call. I couldn't say that I knew who."

Callie pictured guys she'd bedded in her teens. "Why not? How do you know this boy?"

"Don't call him that!" Nora hugged a pillow to her. "He's a monster." Her voice croaked, choking for air. "I'm sorry, I'm sorry. I've never told anyone. Except Mom."

Callie flashed on Nora's artwork. Abstract blood and snow. "Sometimes it's good to talk."

Nora was silent for a long time and when she spoke she stared vacantly at the wall. "You look like a younger, skinnier version of her—your hair is almost exactly like hers. For a minute it was like having her back."

Callie usually fled from offers of friendship. Here, in the makeshift gallery where Nora had told her secret over and over with canvas and sculpture, the girl's revelations resembled something else. A responsibility. A mission. "Nobody can replace your mother. But I know it helps to talk. It helped me." Sophie said this day would come, a day her shell would crack open. *Why fight the oracle?*

"He said he'd give me a ride to town but had to stop off at the motel and get something. I shoulda wondered, but I trusted him." Nora looked to her mother's photo for permission to continue. "I don't remember how he talked me into going inside. I was so stupid. Next thing I knew he was calling me pretty and I was screaming. The motel was almost empty so no one heard me."

"Oh Nora, I'm so sorry. The boy, the monster, should be in prison!"

"I fought but he was too strong. When he was done, he called me names, like I'd brought it on myself. I ran for the door. He didn't even try to stop me. Like he dared me to call my mother."

Callie searched her memory for facts—*do rapists want to get caught or not?*

"She came for me. Drove me home."

"Did you go to the police?"

"She wanted me to but I said no. She brought me home,

stayed with me until I calmed down. Then she left. Then she died."

"I'm so sorry, Nora."

"And the worst is, that night I lost a ring Mom gave me for my eighteenth birthday. It was her last gift to me." Nora rubbed the empty finger.

"Please tell your dad. If your mother wanted to call the police, she knew he'd find out. It's not too late to prosecute." Callie inched toward the stairs.

"No! No! You don't understand. Everything would be ruined."

"I'm sure Coop'll be mad." Callie considered his thunderous anger at Jean. "But not at you."

"I can't. I can't. Promise you'll never tell anyone. Anyone." Nora clutched Callie's arm.

The pain in Callie's shoulder crept to her head. "Nora, you can get help. Call a rape hotline—they won't ask your name." She didn't believe Nora had told her the whole truth about the secret, but right now Nora just needed an ear.

"Promise."

Such a silence rankled every moral principle Sophie'd ever taught. "I can only promise that I won't say anything without talking to you first."

"Good enough." Nora pushed herself up. "Cover for me while I wash my face."

Making small talk with Harold Cooper offered its own challenges, but Callie agreed. Downstairs she found him reading. The music had shifted to Charlie Parker, another troubled teenager. Callie sought a neutral topic. "Nora's quite a talented artist."

"Yes, she is." Coop looked up at her briefly, then back down at his book.

Callie sank into the other chair. The charged moment of intimacy was gone. His own daughter couldn't tell him the truth. "Nora will be a few minutes. Then she'll take me home."

Coop nodded and again looked down at his book, though Callie was almost certain he wasn't reading. Then he snapped it

closed and was on his feet. He called up the stairs to Nora. "I'll take Callie."

A muffled assent came from Nora's room. Coop and Callie silently donned their coats and made their way down through the student dining room, now populated with girls poring over books and notes.

"I'm glad you're okay, Miss Franklin," said one. "Me, too," came a chorus.

She waved and smiled, still brooding inside. As Coop guided her to the parking garage, scarves conveniently prevented speech. The structure held a few dozen vehicles. Coop unlocked the door of a late-model off-road vehicle, handing her in with easy gallantry. For a disconnected second after his touch, Callie forgot the tension between them.

The glittery trees and spangle of late night constellations cruelly promised romance they couldn't deliver.

"It'll be a few minutes. The engine needs to warm up."

No hurry. But once the clock strikes midnight, no glass slipper can fix this.

The soft moonlight didn't illuminate Coop's expression. He spoke in fits and starts, covering more distance than words. "My wife died almost a year ago."

Callie knew how conversations ended that started with 'my ex,' and waited silently for the inevitable rejection. The car climbed the road toward her cabin.

"I met Miriam in high school. Love at first sight."

Never count on anyone. Callie knew that and silently kicked herself for succumbing even for the length of a kiss. He was silent so long she wondered if he felt he'd said it all. *Men.*

"Miriam was the smartest, most compassionate person I ever met. She was my bedrock, my touchstone for more than twenty years. When she died, only two things kept me going—Nora and the Cooper School. My child and my calling. This past year I have been neither the best father nor the best principal—but without them I couldn't have survived." He pulled up in front of her cabin. "I haven't been with a woman since. I haven't wanted … Kissing you tonight was … a surprise. I don't …"

"Don't worry about it." Callie climbed out of the car and ran for her door as if pursued. She longed for yesterday, when her worst problem was how best to teach nineteenth century novels.

CHAPTER 8

Callie blinked, cursing the sun and Nora for waking her too early. "What's up?"

"My weekly run into Flambert. Wanna go? You need boots."

Only the promise of warm, dry feet enticed Callie onto a bus full of inquisitive colleagues and students exchanging fact and rumor about her accident. She said very little through the half hour ride except that she was fine, just tired. Both true, both not.

Nora parked the bus, joking about Sunday afternoon blue laws as a way to remind the group of the return time. The Nora of last night was buried under an extravagant sunny repartee. She pointed at Callie's boots. "I'll show you a shop where they know me. Course, it's a small town. They all know me."

A tiny bell attached to the door signaled their entrance. The remnant of a bygone era reminded Callie of listening to the radio with Sophie, who refused to own a television. "Won't catch on" was one of Sophie's many anti-technology jokes. She'd have liked this cramped little shop—shoe boxes piled high, chairs as old as the brick storefront itself, no advertising logos or designer handbags. For Callie, a veteran of thrift stores and sales, the smell of new leather and shoe polish was ambrosial.

"Hey, Jerry?" Nora yelled through a curtained doorway.

A young man appeared from the stockroom. "Hey, Nora." About Nora's age, skinny, unruly long hair grazing a hemp shirt, Jerry looked like he'd be more at home in a yoga studio.

"Can you help my friend? She needs boots." Both young people glanced at Callie's footwear and snickered.

The young man fitted Callie with wool-lined flat boots. As he rang them up at a healthy discount, he and Nora exchanged friendly barbs.

Callie could barely wait until they got outside. "How do you know Jerry?"

"We grew up together." Nora put her hand firmly on Callie's good shoulder. "You can't look at every boy and wonder if he's the one. Way too cynical." She held Callie's old useless boots over the Flambert Goodwill box with a question in her eyes.

"Yes, dump those like a bad boyfriend." Callie immediately regretted the words as Nora blanched.

A shivery silence covered several blocks to a small diner where they could see the bus from their plastic booth. "Your dad told me he met your mom in high school. Where?"

"He went to Cooper." Nora watched the street.

"I thought no boys were allowed."

"Only one. And only his senior year." Nora ordered a coke and sandwich, then excused herself.

While Callie watched Nora talking outside on a cell, she squeezed her injured shoulder. *Is this trip to Flambert a mistake?*

Nora returned. "Almost forgot to get the supermarket order delivered to the bus—I'll have to run out when they get here."

"Sorry I distracted you."

"I needed distracting."

They ate silently. Callie was grateful when she saw the art teacher, burdened with several large bags, elbowing her way to their table.

"Hello ladies." Hazel sat with a flourish, shrugging off purple coat and scarf and plopping her burdens beside her. "Callie, dear, I heard about your fall. Are you okay? Should you be in bed?"

For the dozenth time, Callie explained that she was ready for class tomorrow.

"That Jean!" Hazel smiled and rummaged through a gargantuan purse. "Pretty self-centered for a ski buddy." Her search produced a business card. "Seriously, call me if you need anything."

Callie marveled at Hazel's unremitting honesty, so like

Sophie's. "But you invited Jean to dinner."

Hazel half-smiled. "A mitzvah. Yiddish for blessing. I didn't really invite him, so I guess I can't take credit. I invited Peter to drive you. I should have known he'd bring Jean. Peter takes Jean and that damned camera everywhere. If I didn't know better, I'd say they were gay. But Peter's a skirt chaser and Jean brags about his prowess with women."

Callie and Nora rolled their eyes in unison.

Hazel wriggled her fingers like a fortune teller over an invisible ball. "Yes my dears, it's truly a mystery." She assessed a spoonful of watery soup. "And here's another—how can they call this food? You know, Jean was different when he first came. Charming, funny. Beautiful photos for the website. But he's deteriorating. He drinks too much, or some horrible secret is eating away at him. I credit Peter for sticking by him."

Nora spoke without humor. "Jean's a jerk. Everyone knows it. Coop knows it."

Hazel agreed. "Yeah, but Coop's honorable about his mistakes. Now, anyway."

"What do you mean?" Callie signaled to the waitress for the bill.

"He won't fire anyone except for cause. Being a jerk isn't cause. Killing another teacher is, though, so maybe now——"

"Like Mark Twain, reports of my death are greatly exaggerated. Really, I'm okay. I don't want anyone fired because of me, not even a jerk." Callie chose not to pursue Coop's change from—what?—to honorable behavior.

Hazel's mouth twitched. "Maybe Jean wasn't always a jerk. Maybe he really was a lady killer back in his heyday on the racing circuit."

"Like Dad." When both women looked at her, Nora giggled. "Joking. Coop married his first love and now he's trying to be as dead as she is."

Hazel gave Nora a little one-armed hug. "It's a tough time for your dad. But he'll recover. Honor the God within and all that."

Callie could tell that Hazel and Nora took some comfort in those words. "Excuse me?"

Nora explained, "My dad went to a Quaker academy near New York City."

"Are you Quaker?"

"No." Nora craned her neck to look farther down the street.

Hazel picked up the story. "It's an excellent school, just a few hours away. Coop came home weekends. Only child, close to his parents. They were good people who embraced many Quaker tenets. Peace. Love. Simplicity. Care of the earth."

Nora turned from the road to Callie. "They were great. I wish you could've met them."

"That's a lovely thing to say." Callie flushed but something nagged at her. "How did Coop end up at Cooper?"

Nora thought for a minute. "It was about money. My grandfather got into a big legal fight that took all his savings. No money to pay tuition elsewhere. Don't know why Coop didn't go to public school in Flambert."

Hazel mused aloud, "Flambert natives can be hostile to people associated with the school. Given the fragile times, maybe it was easier on the family for him to be home."

Callie grabbed on to the word hostile. "What do they have against the school?"

Hazel shook her head. "A dazzling panoply of racism toward our students of colors, distrust of people who want our kind of demanding education, and wariness about them perceiving us as a bunch of liberals."

"Oh, is that all?" Callie chuckled.

Hazel patted Nora's hand. "Coop was the first and last boy at Cooper. He's a little ashamed of it. Nowadays he's fierce about honoring Gwendolyn Cooper's intentions."

Nora fluffed up her multi-colored hair. "If he told you about him going to Cooper—"

"He didn't exactly tell me. I put it together because he said he'd met your mother in high school." Callie sipped tea, entertaining the rare wish that it was whiskey and that these complicated emotions were where they belonged, in someone else's life.

Nora squeezed a napkin in her fist. "Dad never talks about

Mom, not even to me."

Dad again. Callie rarely asked how people felt. She rarely wanted to know. Now she surprised herself. "Do you mind?"

"S'okay." Nora's attention shifted to outside. "Grocery van." She wolfed down the remains of her lunch and rushed outside.

Surely Coop's private life wasn't appropriate talk with another teacher, even Nora's godmother. Callie smiled, hoping to seem unperturbed. "What brings you here?"

Hazel aimed a thumb at an overnight bag. "Another storm's coming in. I'm letting Craig and Alexis fend for themselves while I stay over at school."

"Where do you stay on campus?"

"Depends. Sometimes at Mir ... Nora's. Sometimes the school guesthouse. Sometimes with other faculty. I'm a vagabond." Her laugh sounded like the little bell at the shoe shop—familiar and musical.

"Stay with me." Callie gulped. Hosting was new territory, but Sophie training wouldn't let her renege once Hazel said yes.

During the entire ride back to school, Callie fought misgivings. At Nora's last stop in front of Callie's cabin, Callie found herself inviting Nora to come in and share a mocktail with them. This new territory—having friends—felt good, as good as the warm new boots, as the great new job. As confusing as kissing your boss.

"I don't have any liquor." Callie opened a cabinet and was happy to hit on hot chocolate as a reasonable substitute. "Meant to buy wine today but I was too—"

Hazel stroked Callie's good shoulder. "Tired, I'm sure. Oh you poor thing. What can I do to help?"

No one had has taken care of me since Sophie died. Now two days in a row? "Nothing, really. It's just good to have you both here." Callie gratefully watched Nora tend the woodstove, deftly arranging the logs. "I see I have a few north woods skills to learn when my shoulder gets better."

"My mother believed every girl needed to know how to take care of herself." Nora turned to Hazel. "Tell Callie about Mom."

"Miriam and I were in the same class." Hazel bustled about, a

woman who couldn't be in a kitchen without something to do. "High school, teachers' college, and back to Cooper. The ultimate Cooper girls. Somewhere in the middle we both got married, had kids."

"Not necessarily in that order." Nora grinned.

Hazel set out mugs and spoons. "We were bohemians and proud of it. Not so Nora's grandparents. Very proper. Letting Coop into the school was tough for them, but they had no choice. Gwendolyn left her fortune to the school, not the family. They got her personal belongings and furniture but not sums you need for a legal battle."

"Yeah. Our house is a lot more elegant than we are." Nora lifted her pinky off her mug as if to illustrate.

"Legal battle?" Callie's shoulder ached and she had lessons to plan, but she couldn't quell her curiosity.

Nora shrugged. "The school's been sued every few years by some rich girl or even a boy—someone who doesn't qualify under Gwendolyn's mission."

Sophie's activist training prompted Callie. "Doesn't it just figure? Privileged people trying extend their privilege." *Great. A civics lesson. To the choir.*

"Cooper isn't legally required to admit anyone—the school doesn't accept government money." Hazel opened her briefcase, apparently in search of calorie-free sweetener. "But those suits are problematic." She extracted notebooks from her bag, slapping each onto a table in rhythm with her words. "Legal fees. Bad publicity."

Nora crossed her arms, covering breasts already hidden under a heavy sweater. "That one was a real ugly. A brother and sister from some elite family applied and, of course, were turned down. Then they made up a disgusting, gross story about my grandfather touching them, y'know, sexually."

"What happened?"

"I don't know exactly. It was before I was born." Nora turned to Hazel.

The older woman seemed to be dredging up a half-memory. "I think they threatened to go public with their lies and your

grandfather was afraid the scandal would ruin the school. Appearance of impropriety can be as bad as the real thing. He made some sort of settlement. Very hush-hush. Coop knows the details but never discusses it."

So many secrets.

The phone rang as Hazel was re-filling the cups. Fearing that somehow Blake's lawyer had found her number, Callie growled a little on her greeting. "Hello?"

Coop growled back. "Harold Cooper here. How long ago did Nora leave?"

"She's still here. So's Hazel. You want to come?" *What will I do if he says yes?*

"Um. Sorry, no. May I speak with Nora?"

Nora took the phone and listened. "Be right there." Hanging up, she pulled on her jacket. "Coop wants me to garage the bus before the storm. Bye girls."

Within the hour, Hazel and Callie settled in front of the fire with omelets and salad. Outside, the snow became more insistent, adding weight to tree limbs, obscuring the stars.

"I'm happy Nora's taken to you. She's been fairly solitary since Miriam died. My daughter, Alexis, is really worried."

"Are they close?"

"Like cousins. Miriam was my best friend. We're godparents to each others' kids. They grew up together." Hazel seemed eager to offer personal details.

"What's different about Nora now?"

"She was always outgoing, sociable, funny. Now her joviality seems forced, a front. I get the feeling something troubles her more than losing her mother."

Callie longed to confirm Hazel's intuition, but she'd given her word. She shifted the icepack on her shoulder, which set off a cascade of memories from the accident to the rescue to Coop's declarations of the night before. "Was Nora born before her parents were married?"

"Does that bother you?"

"Not at all. I don't care about social conventions. I just—"

Hazel pointed a spoon at Callie. "You just secretly like gossip

as much as the rest of us." Hazel laughed her inclusive laugh. "Miriam found out she was pregnant after Coop left for the Rhodes program. Didn't tell him because she was afraid he'd give up his studies and come back. I argued with her but she could be so stubborn." Hazel's mouth flickered from smile to sad frown. "I knew his ego couldn't take it. Idiot. He has two PhDs, for heaven's sakes. Instead of thanking her for giving him time to study, he went postal when he found out about the baby. Washed his hands of the whole family. Moved to New York City. Took a fancy engineering job."

Callie dropped all pretense at disinterest. "Wow. How'd he get back here?"

"He was a workaholic even then—rose through the ranks like a shot. Made piles of money." Hazel deposited their dishes on the kitchen counter.

"Were you in touch with him?"

"My first husband and I saw Coop when we went to the city, but it was hard. He drank too much, exercised like a maniac, slept rarely. And his dates! Nora's right that he married his first love, but it wasn't a straight line from cupid to altar. In New York, he slept with one brainless anorexic after the next. Worse, he despised those women more than we did. But at least he was good to them. Showered them with jewelry, hired limousines. One time he bought out a whole restaurant for the four of us. Work was the opposite. He constantly belittled the people he supervised, firing or demoting them arbitrarily. Forced older folks out early so they couldn't collect pensions. Truly despicable."

The high wind battered snow against Callie's windows. "Would he be okay with you telling me?"

Hazel waved away the question. "Yes, yes. He offers it at key moments as a cautionary tale—something Nora has heard but overlooks in her version of him. But the story has a happy ending. Or it did. Until last year." She tightened the afghan around her. "While Coop was in New York City, his parents told him to stop acting like a spoiled brat. But he thought as a Rhodes Scholar he knew everything."

"Where's the happy part?"

"His dad had a heart attack."

"Now that's happy."

"But it was, in a weird way. Coop left his dissolute life, came back here, and sat at his father's bedside, learning how to be principal of the school. When Miriam saw that, she took him back and taught him to love again. He even made reparations to people he'd hurt, paying out thousands of dollars. It was a miracle." Hazel's eyes glistened.

Callie didn't mention the kiss. Nor her own past. She tried to put Coop out of her mind as she organized her classroom materials. The girls would want to talk about the skiing accident and Coop was a key player.

The high-pitched wind followed an erratic musical scale, ever louder, pressing under the door and across the sills. Darkness, snow, and the late hour conspired to drive the women to the privacy of their own beds. After Callie and Hazel turned off lights, Callie remembered that she'd never asked Nora about the conversation outside of Lang Arts. It already had an aura of unreality. Maybe she'd imagined it.

* * *

All day Monday Callie wished she could imagine herself somewhere else. The repeated questioning about her health felt invasive, though she knew most people meant well. She felt less benignly toward Jean Frière, who arrived in her classroom bearing a box of Belgian chocolates. Unshaven and stinking of smoke, he needed only a beret to play a stereotype. A gaggle of girls hovered in the doorway, perhaps hoping for fireworks. Callie shooed them away. Jean stood next to Callie's desk, knees locked, like a teenage boy waiting to have his knuckles rapped. "I want to apologize for *l'accident*. I was taking photographs for the website and didn't notice that you followed me onto the black trail. *Je suis desolée.*" The French softened all the consonants to

silk. He drifted into the chair next to Callie's desk where students often related their own tales. "I know this is just a small token." He placed a long finger on the box of chocolates. "I should have come to see you yesterday. But you were in Flambert." His palms rose in the air, revealing bony shoulders under his wool sweater. "Are you well?"

"Recovering." She looked out at the new-fallen snow across the mountains, blurring all edges.

"So you would agree that it wasn't serious." The reason for the visit began to dawn. "Harold Cooper is being very difficult." Jean flicked an invisible speck from Callie's desk. Odd for a man so fundamentally unkempt. "Because of Miriam."

"I don't follow." Callie wanted to throw him out. His faint odor of alcohol made her slightly queasy. But despite her revulsion, his last sentence hooked her.

"He wants *de trop*." His gesture suggested he was guiding a person with insufficient brain cells.

"I mean about Miriam."

"He is more sensitive since she died."

Callie wanted to slap Jean, screaming that he could use some sensitivity himself.

"Cooper expects me to publicly apologize. When we met this morning, he dared threaten me with firing." Jean's gaze surveyed the display of writers, as if each of them was to blame. "But since you are fine, you will speak with him?" He barely placed a question mark on his sentence. "I have races."

"Races?"

Jean narrowed his eyes, apparently offended by her ignorance. "I race cars. Who can live on a teacher's salary?" He left without saying goodbye.

Adieu, jackass.

Callie felt like dashing to the gym and pounding a punching bag. But Dr. Chen's warning to avoid exercise for a few days, together with the ache in her shoulder, argued for caution. Muted sounds signaled someone in the hall. "Who's there?"

CHAPTER 9

Callie started at the creaky footfalls outside her door. "Hello?" She grasped the dictionary on her desk, weighing its value as a weapon, more from habit than an actual sense of danger.

Nora, cheeks red from the cold, pushed through the door. "Hey. I passed Jean swearing in French. What a dork." Seeing Callie's grip on the dictionary, she laughed. "I got rid of mine 'cause of the online one. Guess I missed its true use."

"Weapon of Mass Instruction." Callie put the book down.

"I'm on my way to the gym but you got another phone call from that Blake guy's lawyer. He didn't seem to have your number. I wasn't sure you wanted him to." Nora handed Callie the While You Were Out note. She heralded a new arrival. "Hey, Shauni. We gotta stop meeting like this." Nora shared a smirk with the student. "Gotta book."

The student clumped into the room on heavy boots and waved to Nora's back. She eyed the Belgian truffles with unconcealed relish.

Callie handed over the sweets. "Use them wisely."

"Wow, thanks. Yum." Shauni tucked the chocolates into her backpack. "About my paper."

The paper wasn't due for weeks, but Shauni's discipline no longer surprised Callie.

"I want to combine my paper with research for our committee. I thought I could look at how newspapers cover sexual assault today compared with the past. But I'm not sure where to start."

"Maybe focus on Flambert, so you aren't overwhelmed. Analyze police reports and newspaper coverage. But remember, this is English class. I want you to focus on language and storytelling."

"Great! I think the *Courier*'s online. Maybe the police data, too. And I bet Alexis can help."

"Make sure you do more than internet research." Callie made a mental note to look at the *Courier* herself. Miriam's death raised many questions. Perhaps Peter could help, though he'd expressed distaste for Miriam. As Callie left Lang Arts, she looked for him, knowing he often headed home around the time she did. Spotting his familiar green muffler, she raised her voice to a flirty lilt. "Howdy stranger. Can you show a girl how to negotiate the online *Flambert Courier*? I need to search ... the classifieds."

"Sure, no problem." He fell into step with her on her walk home. "I've been away. I only just heard. It's a shame you got hurt your first time on skis."

"Trial by fire. But I'm getting back on the horse, pardon the mixed metaphor. I'm going skiing soon as I get Dr. Chen's okay." *Next time with someone besides Jean. Peter?*

"Good for you! Let me know if I can help. I'm a decent skier." *Now he offers.*

At his cabin, he touched her arm. "Busy tonight?"

"Tonight?" She needed time to unpack the day's zig-zagging emotions.

"My website design class is doing a Shakespeare project. Could you take a look? I'll swap for searching the *Courier*."

"Well, maybe for an hour."

His muffler covered his mouth, muting his words. "I'll cook. Six o'clock?" He ambled backward toward his cabin, like a teenager unwilling to let his date out of his sight.

Is this a date? Am I even attracted to him? Cute, yeah, and a great flirt, but the focus of those sapphire eyes is a little off, somehow. Callie sifted the inconclusive evidence and finally focused on grading quizzes. When she next looked at the clock, it was a few minutes before six. The phone rang just as she was closing the porch door. *Ignore it. No, it might be Peter.* She dashed back. "Hello?"

"Was there something you wanted to tell me?" Harold Cooper's staccato voice held menace.

Hello to you, too. Quite well, thanks—almost no pain. Doing fine until someone started shouting for no reason. "Excuse me?"

Coop apparently missed the unspoken message, judging by his failure to change his tone. "Did you tell Frière you thought punishment was inappropriate?"

"As a matter of fact, I did not. But even if I did, as I recall ..." she drew out the word 'recall' "free speech is still part of the First Amendment to the U.S. Constitution. Why are you yelling at me?" The other end of the phone offered only silence. *Did Coop hang up?* She considered hanging up herself. *Men!*

"I owe you an apology."

"I'm hanging up now. Call me back and let's take this from the top." She slammed the receiver into its cradle, tempted to walk out and let the phone ring in an empty house. She could almost hear the excuses, the tiresome defensiveness, the 'It wasn't my fault. I have a short fuse. I am an important man and needn't bother with social niceties.' She paced a few minutes, listening to the silence that should have been the phone. *If he doesn't call right this second—*

The phone rang.

"Hello?" She congratulated herself for keeping her voice calm.

"Callie. I've been trying to imagine a scenario in which you would forgive me for being such an ass."

"Why would I tell Jean to speak for me?"

He didn't answer right away. "You're right. I shouldn't have jumped to conclusions. This is no excuse, but Nora's been pestering me since Saturday. When Jean waltzed into my office and announced you were backing him, I just saw red. I felt that all the women in my life were ganging up on me."

*The women in **what?*** "For the record, I never agreed to 'back him.' Nor would I tell you how to do your job. Have a little more faith."

"You're right."

Those few words were rarely said to Callie. Now, twice. By her boss. The outerwear she hadn't removed heated her like a

sauna. "I'm off to Peter's to talk about Shakespeare."

"A lean and hungry man."

Cassius or Peter? "I think he just wants Cliff Notes." She wasn't being completely honest about what Peter might be after, but why discuss that with Harold Cooper?

"Good night then." The dial tone sounded and she once again left the house. This time, her thoughts of Shakespeare drifted to comedy.

Sounds of a shouting match on the other side of Peter's door interrupted the Elizabethan jokes. Nora banged out, practically running Callie down, her raised voice directed at Peter. "I hate you." Nora took off without greeting Callie.

Peter stood in the doorway, welcoming his guest with a hand gloved in an oven mitt. "Nora's upset." He sounded kind. "Poor kid. She's having a terrible time."

Though she agreed, Callie said nothing. Dismissing her offer of help, Peter handed her a delicate wine goblet. The exterior of Peter's cabin was almost identical to hers, but it was as if he'd taken the same outline and written a different story. His main open concept room offered a sleek GQ steel-and-glass study in geometry. A few original modern prints were the only decoration—no photos, memorabilia, or personal touches.

Callie spotted a for-dummies book that might help her with the internet. She waved it at him. "Can I borrow this?"

He didn't look up, apparently concentrating on culinary arts. "What?"

"Computer how-to book."

"Sure, whatever."

Unlike the room, the food was warm and exotic, a Moroccan stew of lamb, olives, and apricots in tantalizing spices. "Do you always eat like this?" This plus Coop's meal spurred Callie's fear that her two-dish repertory —spaghetti and chili—wouldn't do here.

"My sister died quite young. She wanted to be a chef. It's my private tribute to her." His blue eyes flitted to a tiny faded school photo Callie hadn't noticed earlier.

"I'm so sorry."

"It was a long time ago." He asked about the skiing accident, listening with respectful attention as she imparted the details.

Most of them.

"Delighted you're unharmed. Some of my players've dislocated shoulders. I can show you some gentle stretches."

"Wonderful. After Dr. Chen says I can go back to the gym, I could come to team practice one day." A twinge in Callie's shoulder reminded her to take it easy.

Peter topped off her almost full glass. "Or I could meet you at the gym one-on-one." He paused as if he knew that would need to sink in. He laid a hand over hers. "But I think Coop's overreacting, don't you?"

Creepy. She wriggled away, plates in hand, toward the state-of-the-art dishwasher. "I have no opinion. It's Coop's call."

"Don't be a child. Obviously, you have an opinion. You mean you don't want to share."

She hadn't heard that hard edge before, but he was right. She thought Jean should stand up in front of the girls and explain. "If I'm unhappy with how things end up, I'll say something. But I won't interfere before I see what Coop does." She carefully rinsed the hand-blown water glasses that would cost a fortune to replace.

Peter's velvety tones returned. "Nothing you say could interfere. You, more than anyone, have the right to speak. But—" He slung his arm around her waist. "Shouldn't you stand up for what's right? Don't let Coop turn this into a vendetta just because you're the purported victim."

He couldn't know that his choice of words would harden her position. "I'm no victim. Ever." She hated the squeak in her voice. "Coop wants to show the kids that behavior has consequences. Isn't that 'what's right?'" She lifted his arm from her waist and resumed clearing the dishes.

"Coop's using you." Peter gathered study materials, setting marked-up printouts on the table. "It isn't the first time. He has an ugly past of manipulation and meanness."

Her stomach soured from the smell of the leftovers she spooned into covered containers. "What do you mean?"

"Callie, I know you like to think the best of people. It's one of your loveliest qualities."

The untrue compliment boosted her wariness. "Peter——"

"Coop always has an agenda. He's the principal because he inherited it, not because he earned it. They say his father was worse—preying on kids or something." Peter shook his head sorrowfully, suggesting deep regret over the existence of child molesters.

"If you believe ugly rumors."

"I went to private school, Callie. Forgive me for pulling rank, but I know how easily good lawyers and better money can spin a whole range of misdeeds."

He sounded like the narrator of a documentary. *Could Nora be wrong?* She'd admitted the events occurred before she was born.

Peter turned on his laptop as if the little screen would back his story. "I know people who worked with Cooper in New York. They hate his guts. No integrity at all. He was one of the top guys at a Fortune Five Hundred firm in Manhattan—until he left under a cloud. I don't remember the details—just that Coop left in a hurry and grabbed control of the Cooper School." His hand grazed hers. "I hope this isn't upsetting."

Callie, half-expecting Peter to pinch her cheek like a schoolgirl, jerked away. "I've seen worse." Like Blake betraying everyone from his business partners to his family. "Let's get started on Shakespeare or I'll be here all night." *Bad choice of words.*

"I apologize for getting us off track." He arched an eyebrow. "Let's close our eyes and think of England." He smiled his sexy smile. "Literature, I mean." He brewed espresso.

The cymbal-brush shhhh of water boiling and the clink of tiny Italian demitasse cups accompanied their talk as they sorted through student designs for the Shakespeare site. Peter seemed so well-versed on the bard that Callie had little to contribute.

Marc Antony's duplicitous speech, "I've come to bury Caesar, not to praise him," reminded her of something Peter said earlier. "You said Coop always has an agenda?"

"Always." Peter brought up the *Flambert Courier* on his screen,

pointing to the search box. "Here's the url for the classifieds." He emailed her the link.

She refused to be deterred. "What's Coop's agenda about my accident?"

"Everyone at Cooper has to do community work, put in volunteer time."

"Ye-e-e-es, and?"

"I coach hockey. Hazel organizes art shows. You know, the Cooper Mission." His voice coaxed her closer. "Jean's an auto mechanic. He takes care of the school vehicles. Tune ups, oil changes—"

Callie widened her eyes in exaggerated interest. "Fascinating. The point?"

"'How poor are they that have not patience.' Jean was in charge of Miriam's car. Coop all but accused him of negligence in her death. Public humiliation is payback." He spoke with gentle authority.

"Maybe Jean really did screw up?"

"Only Coop thinks so. He was angry at his wife sleeping around and wanted someone to blame."

"That makes no sense—unless he thinks Jean was sleeping with Miriam."

"Don't be ludicrous. Jean would never be attracted to her. He likes them pretty. And thin."

Callie had an urge to punch him but didn't want to injure her arm further.

He took her silence as agreement. "Right. Disgusting. A mechanic in Flambert looked at that car a day or two before the accident. Even if Jean did miss something, the second mechanic didn't find it, either."

He changed the subject. Again. Callie tried not to yell. "Jean endangered my life. Doesn't that deserve a response?"

"That's a tad overdramatic." Peter squared his shoulders.

"Jean hasn't suffered at all."

"Coop wants to humiliate him in public."

"Public? A school assembly is only public in the narrowest sense." Callie considered returning the computer book, now

lodged in her backpack. *Best not to owe Peter a thing.* He didn't seem to read her hostility.

"Coop demands that Jean write a piece for the *Flambert Courier* about proper ski practices, using himself as an example of bad judgment."

Her voice rose. "Sounds like a good idea to me, though the paper has a readership of what? Thirty-eight farmers and twelve cows?"

His words overlapped hers. "The paper's online. Jean Frière's a minor celebrity on the racetrack circuit. The international wire services will pick up the story. You're fine."

For a moment Peter's eyes held Callie's and she wasn't sure what she saw—persuasion? Seduction? Anger? Maybe Coop did hold a grudge. How could she know? "My shoulder is sore. Even after it heals, I could always dislocate it again. Fine isn't quite true."

"What's an occasional inconvenience compared with ruining a man's career?" Peter stood tall, almost menacing.

Callie was ready to crown him with the closest blunt object, shoulder or no shoulder. Her eyes roamed the room, lighting on a shelf of books. Shocked, she read the titles aloud. "*The Complete Shakespeare. Annotated Shakespeare. Elizabethan Culture and ...* You didn't need my help."

Peter's voice was steely. "Of course not. Do you think I need insight from someone who went to Podunk Teacher's College? I have an Ivy League degree. I spent a year studying Shakespeare in London. You're hardly my muse."

The sound of someone walking across the porch dissuaded her from landing a punch. Jean Frière entered without knocking. He seemed immediately aware of the tension. "What's wrong?"

"I hate liars." The flat soles of Callie's new boots were ideal for stomping. She put them to good use on the road home.

CHAPTER 10

Callie's chorus of swear words—aimed against Peter's manhood, heritage, and all rich people—halted at the sight of a human silhouette huddled on her porch.

"I'm sorry to bother you." Nora's breath glistened wispy gray, ghost-like in the starlight.

The familiar inner scaredy-cat insisted Callie had her own shadows to chase. A newer voice pushed her to usher Nora inside. "What happened?"

"You know that guy I told you about?"

"The rapist?"

"I don't know what to do."

"Come sit by the fire." Callie put the kettle on. "Do about what?"

Nora flopped onto the floor, pushing her boots off, wiggling toes and fingers for warmth. "He has pictures. Video. You can see my face but not his and that I'm, um, naked and he's, um," Nora hesitated. "You know."

"It's sexually explicit but he can't be identified?" Callie remembered bloody courtroom photos. The past may fade but photos are forever.

"That isn't even the worst." The colors in Nora's sweater blended with Callie's rag rug like a rainbow camouflage. "He has video of my dad."

"Coop?" Callie almost dropped the teapot.

"With a teenage girl." Her words came out one by one in uncertain succession. "But it's a lie. My dad never—"

Or at least that's what he said. Callie considered all the lies men

had told her. "Start from the beginning."

"What P-P-P—that creep—did to me? Wasn't his first time." Nora avoided the guy's name as if she could barely form her mouth around it.

The teakettle rattled and whistled. Callie silenced its screech and doused the leaves, silently calling on the tea to heal them both.

"Before me, he attacked another Cooper girl."

"Who?"

"Dunno."

"How does your dad fit into this?"

"I think she fought more than me. She was all bleeding and bruised up."

"Fought who?"

"That asshole. Who do you think? Did you think Coop? The girl called Coop because she needed help and trusted him. He went there, to the motel. To get her. But someone rigged up a camera. Like he did with me, I guess. You can see Coop's face but not hers."

Callie couldn't sit still. She jumped up in search of a treat and settled for graham crackers. Nora dunked one in her tea. A corner mushed off and floated like a forlorn raft.

"It all looks pretty convincing—Dad right next to the bed with a half-naked girl, and then carrying her with her clothes all ripped. It looks like, like—" Nora stuck a spoon into her tea, a life line for the disintegrating cracker.

"Like he attacked her."

"Yeah."

The two women slumped at the table, hands wrapped around the warm mugs. Only Nora's stifled sobs broke the silence.

"Do you know for a fact that Coop wasn't the girl's lover?" Callie wished she didn't have to ask.

Nora looked stunned but stopped crying and yelled. "Yes! I know it for a fact. Because I know my dad. But also 'cause both my parents were home when the call came. While Dad was being videoed, Mom was in the car keeping it warm so they could rush the girl to the emergency room."

"Where were you?"

"I slept through the whole thing." Nora slapped the table as if that could retroactively wake her. "If I'd gone with them, if I'd known who he was—"

"If you were asleep, how do you know what happened?"

"Mom told me when she heard my story. I think she planned to scare him into giving her the photos of me."

On the windows, frost created lacy patterns too delicate for these realities.

Callie focused back on Nora. "Why didn't the police prosecute the first time?"

"The girl never told who it was. I think Mom figured it out the night it happened to me." Nora's face tightened. "You didn't really think my dad would do something like that, did you?"

"I honestly don't know."

"Even you!" Nora sobbed. "See? That jackass said if I ratted, he'd give the pictures to the papers. Put 'em online. We'd look like a family of perverts."

"But none of it's true."

"Like Hazel said, appearance of impropriety can ruin the school as fast as the real thing. That's why Grandpa was scared of the kids who accused him, and why Mom was scared of this."

Callie reeled as the full meaning of Nora's dilemma hit her. If the girl remained silent, it could scar her for life. If she spoke, she could kill the school and her father's reputation. "Listen to me. Listen! None of this was your fault. You didn't choose to be raped. Nor did you pose for porn. You certainly did not knowingly put your mother in danger." She reached for the telephone. "Let me call Coop."

"No. No. Don't you see?" Nora's voice rose. "That's why Mom went out that night. She knew that if Dad found out what happened, he'd do anything to get justice for me. Let the school fold. I can't let him. He lost her because of this. He can't lose the school, too."

They sat silently for several minutes. Then Callie remembered. "You said something happened. What was it?"

"Up to now, the guy and I had a deal. He kept the pictures to

himself and I kept his identity to myself."

A deal? Callie was beginning to understand the conversation outside of Lang Arts and Nora's promise. It wasn't about drugs at all.

"But it turns out someone else took the pictures. And now they're threatening me, too." Nora's entire body shook.

"Threatening how?"

"If I don't do stuff for them——" Nora looked sick to her stomach.

"Sexual stuff?"

"No, worse. Much worse."

"What?" Her imagination, the one she so lately lamented as too narrow, now ran amok with the sickening bloody images from her own mother's deathbed.

"I can't tell you."

Callie set the phone next to Nora. "You can't let these bullies control you."

Nora shrank from the phone like an instrument of torture. "I have no choice."

"Everyone always has a choice." Callie paced, considering various options. She needed information. "Did you keep your mom's papers, scrapbooks, and stuff?"

"Yes, of course. And all the articles about the accident." Nora drank the tea as if she'd just noticed she was thirsty.

"Can I see them?" Callie had been a good researcher in her college days.

Nora looked at Callie as if she had changed the subject. "Um. Okay, I guess. Why?"

When the telephone rang, they both jumped. Callie grabbed the receiver. "Hello?"

"Coop here."

Callie tried to sound casual. "Hang on a sec." She covered the mouthpiece and whispered. "It's your dad. May I tell him you're here?"

"No, no. He thinks I'm out with friends."

His voice moved about a county away. "I'm sorry, am I interrupting something?"

"Just had to turn off the kettle."

"I know it's late but I need to speak with you." He sounded both formal and hesitant.

Not another drama. "Can it wait until tomorrow?"

"Unfortunately, several events may occur first thing in the morning. I'm sorry to impose but could I come over? I want to discuss this in person. Won't take long."

"Alright, but I'm beat. I'll hold you to just a few minutes." Ironic to accuse the world's tersest man of taking too long.

If Coop found it funny, he didn't let on. "I'll be there in ten minutes."

Callie turned to Nora. "He's on his way. Stay and talk with him."

"I can't." Nora threw on her coat and ran out into the snow.

In deference to Nora's desire that her father find no trace of her, Callie washed and dried the teacups and put away the graham crackers. Noticing that the fire was low, she opened the front door to grab firewood from the porch. *No logs. What else could go wrong?*

Callie scribbled a note. **Gone to the woodpile. Back in a minute.** She slung a carrier under her arm, flashlight in hand. She'd become accustomed to snowshoes on other forays through the hip-deep drift behind her cabin. Usually she liked this chore, the opportunity for a hike through the trees, mysterious in the winter quiet. Tonight, pulling the logs from the pile and dragging the full carrier wearied her. Pulling with both hands, she tucked the flashlight under one arm. Every few yards it slipped against the fabric of her jacket and plopped into the snow. Her sore shoulder smarted each time she reached for it.

During one of the dark retrievals, she heard a man say her name. She aimed the beam toward the voice, ready to accept help from her boss. The figure in the light, however, was Jean. Arms flailing as his legs sank into the snow, he resembled an out-of-season scarecrow.

"What do you want?" Callie pushed past him on the trail, trying to shut off little alarms in her head.

"To apologize." He raised an arm and snow fell from his coat.

"Apology accepted. Please go home. I'm exhausted. We'll talk some other time." Callie moved as swiftly as she could manage.

Jean kept pace despite sinking into the snow with each step. At the cabin, he seemed to remember his manners and helped her haul the wood onto the porch. Neither spoke until they finished.

Callie kicked her door open with her heel and elbowed through with an armful of logs. "Thanks for the help. Good night."

He pulled the note off her door and followed her in. "This is why I came to the woodpile. This invitation."

Callie longed to rebuild the fire and tend to her shoulder but had to get rid of Jean first. Arms still full, she leaned back against the kitchen island. "I'm sorry you misunderstood. Go home."

"*Le livre.* I need the book." His bloodshot eyes surveyed the room, widening when they found the backpack she'd flung onto the kitchen island. He reached for it.

Clutching the wood, Callie jumped at him. "What do you think you're doing?"

Jean halted, seemingly exchanging one strategy for another. "*Ooh la. Jolie.* So pretty." He slurred his words. "*Je voudrais* ... I want ..." He threw off his coat, closing the gap between them in short, rapid steps, knocking the firewood from her arms. It crashed to the floor and skittered in all directions.

He trapped her before she could stop him. Up close, his inebriation was unmistakable. He slobbered on her cheek and lips as if groping for the target. She squirmed and wriggled, protests muffled by his mouth over hers.

Wedged between him and the kitchen island, she couldn't back up. "Stop!" She yanked her face from his acrid breath and pushed against him. He was uncannily strong. She groped behind her for anything to use as a weapon. Nothing. But years of self-defense training paid off. She stomped Jean's instep with all her weight. He growled in pain, clawing at her shirt, ripping it away.

He emitted a mean little laugh. "*Bon.*" He pressed himself against her harder, one hand pinning her sore arm, the other tearing at her bra.

When his weight shifted, she inched sideways, kneeing him in the groin. This time his moan was pure animal. He slapped her and twisted her bad arm, his legs clamped around hers. She cried out in pain. He clutched an exposed breast, fingernails gouging her flesh.

Callie screamed. "You motherfucking sunnovabitch. Get off me, get the hell *off* me." She threw her head forward, aiming to break his nose. She missed. Crammed against the kitchen island, his weight heavy against hers, she succeeded only in jerking them both to the side.

It was a lucky break. Jean's balance had depended on flattening her against the anchored counter, and that tiny movement undid him. His feet, still wet with snow, slid apart as he tripped over a piece of firewood. He held on but pitched downward, pulling her and twisting her under him. His head hit the edge of the island as he fell. Blood poured from a gash above his eyebrow.

Callie bucked and thrashed like a captured wild horse.

"*Cochon.*" When Jean pinched her arms behind her, she bashed him with her forehead.

This time she heard a bone break. *Good.*

Icy air blasted across her bare shoulders and breasts.

"Am I interrupting something?" The voice was hard and familiar.

CHAPTER 11

Jean struggled to his knees, blood rivulets diverted by the stubble of his beard. He twisted toward Coop glowering in the doorway. Callie fled to her bedroom, vestiges of propriety falling with the shreds of her shirt. Behind the closed door she could hear Jean thundering after, banging on the wood.

"The note was for him." Jean sounded hoarse.

No shit, Sherlock.

He became soberly analytical as only drunks can be. "This is why you back him—*tu le baises*—he is your lover!" He continued, childish and sing-songy. "Our principal seduces his employees. *La réputation, Monsieur Cooper.*"

"Shut up, Frière." Coop's words punctuated the scuffling of two men nearing fisticuffs.

Callie threw on a sweatshirt and slung back her good arm, ready to punch as she opened the door. "Get out of my house, Jean."

"As you wish. But first I must have ..." Jean swayed, perhaps realizing that he was in no position to make demands. "*Eh bien, un autre fois.*" He leapt back, swept his coat and hat off the floor and banged out. Gusts of cold pushed inside the cabin, already cooling for lack of a fire.

Coop followed Jean.

"Don't." Callie touched his arm.

Coop shrugged her off but stayed in the doorway. "At first I didn't see who it was. Just you."

"Without benefit of clothing."

Coop offered a sheepish grin. "And for an irrational split

second I thought you were a willing participant. Are you alright?"

Callie wanted to erase all signs of Jean. "Yeah, fine." She grabbed a sponge, kneeling to scrub the blood off the floor. Aware of the absurdity of her actions, she tilted her head in Coop's direction without looking up. "Out damned spot and all that."

"What can I do?" Coop remained by the door, as if seeking permission to breach her space.

"The fire. I think it went out when J-J-J ..." Callie felt a jolt as she recalled Nora's P-P-P. Some pieces of a puzzle fell into place.

"What is it?"

Damn Coop for reading people so well. "I'm a little spooked."

Coop gathered wood from the floor where it had fallen. "Call the cops. It was sexual assault. I'm a witness." He rebuilt the fire as he spoke.

"What a mess! You didn't actually see him go after me. Like you said, it looked to you like a tryst. He'll say I was willing and you're insanely jealous." She stopped scrubbing and stared blankly ahead. The impending disaster she'd somehow caused overwhelmed her.

"Our word against his."

The 'our' distracted her.

He thrust a leg over the chair and sat astride it, dwarfing the table in front of him. "Nothing improper has happened between us. Truth is a powerful weapon."

Callie sighed. "But it's the appearance of impropriety, isn't it? If he says we're lovers, it doesn't matter that we're not."

"I apologize for coming over so late. That won't help."

Callie offered Coop a pursed smile. "You probably stopped me from going to jail for kicking his ass." Only she knew how little mirth underlay her words.

"I like a woman who expects the outcome of attempted rape to be 'kicking his ass.'"

Callie imagined what Coop had seen. A half-naked woman sprawled on the floor among scattered pieces of firewood, squirming under a man bleeding all over her. She couldn't stop hysterical laughter. "I was just getting my second wind. I could

have taken him. I could have. I know it." And then unfamiliar tears. She sat at the table, dropped her head on her crossed arms, and sobbed. She felt only the smallest shift in air temperature, but Coop stood behind her, caressing her hair and murmuring reassurances.

After a while he brought her a glass of milk. "Drink this. Do you have any cookies or crackers? Carb loading will help offset the shock."

She remembered he'd trained Olympic skiers. "Graham crackers." She waved at the cabinets.

She dunked one in the milk. Sophie would be mortified. "Awful manners, I know."

"I think you're getting your land legs back." He hurried down the hall to the bathroom, returning with a wet washcloth and a towel, talking as he moved, his voice a lifeline. "You have blood on your face." He gently wiped away the remnants of Jean.

Callie closed her eyes while he washed her, never once considering that she could do it herself.

"I shouldn't have hired him. Peter Guy charmed me into it and I'm not easily charmed."

Callie, eyes now open, found it oddly comforting that he didn't read everyone as well as he read her. "Do you trust Peter?"

Coop hesitated, as if considering what was appropriate. "I did, but I shouldn't have. There were enough red flags."

"Like what?"

"For one thing, he didn't need the job—Master's in English Lit from Oxford and cooking school in France. Computer technology is his third profession. He's lived all over the world. Independently wealthy."

"So why'd you hire him?"

Coop tossed the soiled towel and washcloth onto the washing machine. "Convinced me he'd be good for the school—he could help girls learn social skills. Parents always liked him—you've seen how he is. Said he needed a break and he'd always wanted to 'give back.' Too good to be true. He made no demands on school resources—funds the soccer uniforms and equipment himself. Another red flag."

"Why Jean?"

Coop manipulated a broom and dustpan to gather shards and splinters as if they were the evidence he'd missed. "Minutes after the previous French teacher told me she was going back to grad school, Guy was in my office with Frière's resume. Sometimes I wonder if he convinced Ms. Fleur to get a PhD. Of course, I didn't just hand over the job. The Jean Frière who applied not only had good credentials but was competent and pleasant. The best of good candidates. Not the difficult drunk we know today."

Callie watched Coop sweep up the debris from the fallen firewood. For a man in his early forties, he seemed awfully like a boy scout. She nodded. "Yes, the thing about con artists is, well, they're artists. If they're good at what they do, no one knows 'til it's too late."

Coop's black eyes, unrevealing as usual, appraised her. "Direct personal experience?"

"Long story." Callie sighed. This home of hardwood and bright colors had seemed so perfect only a few weeks earlier. *How soon until it feels safe again?* Safety meant silence. "Look, I'm dead tired. Why're you here?"

He offered one of his enigmatic stares that could mean anything from sympathy to wrath. "Ironically, it's about Jean."

Callie leapt. "He thinks you're persecuting him because you blame Jean for Miriam's death? You think he screwed up her car?"

Coop looked genuinely puzzled. "No. I mean, I don't. Miriam's car was at the garage in Flambert just before she died. That mechanic is top notch. If the car were dangerous, he'd have found it." He took Callie's hand, usually such a normal size, now so small in his. "I'm here because the school's lawyer—Craig, Hazel's husband—called to say that Jean's applied for a restraining order."

"To restrain what?"

"To stop so-called unlawful disciplinary action and to prevent the school, including you, from speaking publicly about the accident. His lawyer filed late today. The hearing is first thing tomorrow. I don't know why Jean came here. His lawyer no doubt told him to stay away from you. I can't imagine it will go

well for him if the judge knows he attacked you."

Callie interrupted with her own private restraining order. "I've seen it before." In juvie. "People can't get out of their own way." She rose from the table, meaning to signal being back to business. "How does this affect me?"

"Craig thinks you should come, though he may not ask for more than your presence."

"You couldn't say that on the phone?" She was profoundly grateful he hadn't.

"I needed to see your face. Frière suggested you'd defend him."

"What a jerk. Jean—and Peter, too, for that matter—can go to hell." She made up her mind as she spoke. "Of course I'll go."

Coop curled his fingers around the collar of his jacket, slinging it over his shoulder. The finely woven wool of his sweater clung to his chest and the flex of his arm.

Callie's fatigue receded behind longing and she focused on the colorful rug.

"Thank you." Coop stumbled over his words. "I appreciate your support. I need …"

Callie spoke at exactly the same instant. "I need …"

For a moment the only sound was the timpani of the fire settling in the grate. Callie's chest tightened. "Yes?"

"You first."

"I need …" For a split second she had no idea. Then she knew. Then retreated. "I need someone to cover my class." She wound a lock of hair around her finger and focused on breathing.

He must have stepped toward her but it felt like a jump cut from a nineteen sixties French movie. His hand found the same strand of hair she clung to for dear life. "I wanted to kill Jean."

He kissed her. A short emphatic symphony, every sense in concert.

Callie saw Coop wait through the million-year moment while she decided between slapping him and welcoming him. "Me, too." A lone finger reached for his hand, entangling their joined fingers in her lock of hair. She returned the kiss, and then another.

The crackling rat-a-tat of a log settling into the fire startled both of them. Coop stepped away. "I'll get a sub for you. You must be exhausted. We have a long day tomorrow."

"And we'll never mention that kissing thing, right?"

"I was hoping not. Once was an impulse. Two impulses make a ..." He moved toward the door.

Callie spoke to his back. "You know we can't get involved. You're my boss. Think of the students. The parents. The board of directors. Nora." Her voice softened. "Miriam." She remained rooted, on guard. *Was his kiss another lie?* Nora said there were good liars around. Including Coop?

He didn't turn toward her when he spoke. "Miriam would want this for me more than anyone except maybe my mother. Both of them believed in love."

"I don't."

He faced her, for the first time without the usual cloaking. "I was a confirmed nonbeliever, too, after Miriam died. Love demanded too much. I promised myself I'd never let anyone in again. I assiduously avoided revealing anything about myself to anyone, even Nora."

"Don't I know it." She replayed the first interview.

"That day in Troyville was unusual. I'm usually taciturn, not oblique."

She was almost used to how easily he followed her unspoken thoughts. "Not sure I really know the difference."

"And yet you teach English." He winked.

"I don't think a dictionary would help."

"You have a disconcerting gut spilling effect on me. The hazel eyes do it, I think, or the—"

Callie interrupted. "Gut spilling. Professional jargon?"

"More of a technical term." His hand found the doorknob behind him as his eyes on hers opened channels she'd wanted closed forever. "What do you want, Callie?"

Desire could be the enemy. Tiny snapshots of past partners popped into her mind like stills from a Viewmaster. Until now, Callie had generally found men puzzling, though desire sometimes overrode reason. Ergo Peter. At fourteen, she slipped

off her panties for a gang banger in juvie who knew only one thing about a woman's body and could barely find that thing before ejaculating. It left her wondering why she wanted sex. Yet want it she did, following that boy with several equally inept others. In college, she found feminism and began to teach her lovers what to do, with predictable missteps. Into her mind swam the scraggly bearded face of a sweet poet whose idea of foreplay was to read Collette aloud in French. Her most recent conquest was an athletic orderly with whom she sullied unoccupied hospital rooms while Sophie slept. He found every hot, wet place on her body and none in her mind. Fortunately.

Honesty was hard. Lies were hateful. Silence usually triumphed. But now the words insisted on a hearing. "What do I want? I want to drag you to my bed. I want you to erase Jean, make sex okay for me again. I want your love to be the real thing, not just another ploy from another guy with another con. But mostly I want to keep my job, Boss."

His eyes traveled to the ceiling, the window, the moon, the universe. "Wait, who's going to fire you? Not me. The students love you. I hear them talking about your assignments with the same gusto as, oh, YouTube videos. Nora thinks you're great. So does Hazel. The board has never initiated a firing in its entire existence, more than a century."

"A century? They must be really old." Callie leaned against the kitchen island, exhausted from her evening of encounters and secrets, yet not wanting Coop to go. "Look, I'm trying to play by the rules here. Not easy for me."

"Me, neither. I have a checkered history with women."

"So I've heard." Callie silently thanked Hazel.

"The rules and I were always a bit at odds. I, the stalwart defender of the Cooper mission, am the only male who ever defied the mission and attended the school."

Callie shrugged. "Heard that, too."

"Miriam and I weren't married when Nora was born."

"Your point is?"

He flicked his hand toward the computer in her study. "You Googled me."

"Nora told me."

"Ah ha. Betrayed by the progeny again." He ran fingers through his hair exactly as Nora did, creating greater disarray.

"If that's your idea of a horrible past, you're a rank amateur." Her titter fooled neither of them.

"It's not a contest. And if it were, I'd win." His athlete's body, unmoving, filled the doorway with the unsaid question: stay or go?

"How so?"

"You shot your mother's killer. I betrayed the people I loved. You were eleven. I was twenty-two."

Callie clung to the edge of the counter. "How could you know? The records are sealed. I changed my name back to Franklin." Her thoughts tried to catch up.

Now Coop moved to her, catching her as she lost her footing in absurd imitation of Jean only a short while earlier. "I've known since before I met you. Court records of juveniles are sealed, not name changes of adults. Once I knew you weren't always Franklin ..."

"I was always Franklin. Blake never really adopted me. Just made me use his name."

"... It was easy to Google the newspaper coverage."

How many circles of Hell are there? Review Dante sometime. As dizziness overtook her, Callie let Coop support her to the bedroom. "Didn't it scare you?" Her injured shoulder ached, her head ached, her desire for Sophie ached. "Hiring a felon?"

He tucked her in, looking around as if checking for a child's comfort item—a stuffed animal, perhaps, or a blankie. "I consider you a hero."

"And the board?" *So tired. So sore.* She couldn't believe she was still talking. *And such nonsense.*

"What the board doesn't know won't hurt ..." His words became white noise, then silence.

CHAPTER 12

Everything was just a bit off. Callie had slept in her clothes. It was too early to get up. Yet she smelled coffee—not stale leftover dregs but something hot and delicious. What an unwelcome dream for an injured woman who needed to wake and brew her own. The phone rang. A man's voice answered. She was awake.

She reached for the bedside phone extension. Nora's voice was off, too. "Dad?"

Callie blushed.

His two voices, one from the other room and one through the phone, sounded equally uncomfortable. "Not a tryst, Nora. Callie was attacked—"

Nora didn't let him finish. "The police just called. With a warrant for your arrest. Did you beat up Jean Frière?"

Callie and Coop spoke simultaneously. "What?"

Nora didn't stop to breathe. "The cops are on their way."

Coop snapped into military leadership mode. "Call Craig and have him meet us at the police station. Tell Dr. Chen that Callie can't teach today and he needs to find a sub."

Callie remembered Dr. Chen being the assistant principal. *So that's what they do.* She struggled out of bed, still clutching the phone.

Nora's nineteen-year-old irritation was evident. "Done. Get your ass down here. You, too, Callie."

Callie hung up while Coop and Nora were still on the phone. She moved down the hall to the kitchen, noticing items out of place, tiny—not totally unwelcome—invasions of her space:

blankets and a pillow on her couch, Coop's boots by the door, Coop extending a cup of coffee. She drank. "Do I have time for a five minute shower?"

"Five minutes. I'll start the car."

Hair still wet, Callie was grateful for the car's heater and an insulated cup with a lid. Coop explained that Jean had left Callie and gone to Peter's where the two buddies apparently concocted the idea of assault. "Nora said, 'Remain silent until you talk to a lawyer.' I knew that girl was watching too much TV." His humor fell flat.

"If I don't tell my side, it could have terrible consequences for you." She knew he knew that.

"Seriously, Callie." Coop's voice rose to a command. "Say nothing without Craig's okay. Promise me. Promise."

She stared out at the snow-clad evergreens. "I can't promise until I know what the stakes are."

A police car idled in front of the Admin building. Despite the predawn darkness, dozens of students and faculty were gathered, breathing visibly in the dawn.

Nora, eyes swollen and red, coat flapping open in the cold, ran to meet them. She barely waited for the car to stop before she yanked Coop's door open and fell into his arms. "Dad!"

He hugged her tightly. "Nora, you and Callie follow us to Flambert." He left the keys in the ignition and extricated himself from his daughter's embrace as two young men in police uniforms approached. Coop greeted each by their first name.

"Sorry, Coop. We have to take you in." They led him to the squad car and drove away, lights flashing, sirens screaming.

Shauni emerged from the crowd and ran to Callie's side, talking non-stop. "I know that cop. What a jerk." She jerked a thumb toward the retreating squad car. "They're not supposed to run their lights and sirens. He just likes to show off. Alexis works at the police station. Is there anything we can do?"

Callie kept her voice as adult as possible. "Tell the girls that Coop did nothing wrong. I'm the one who injured Jean—in self-defense." Too late Callie remembered Coop's warning about speaking without a lawyer. She didn't care.

"And you and Coop?" Shauni's red curls shook, matted from lack of comb. Pajamas with little red devils peeked from under her coat.

Nora leaned closer.

Callie looked at each girl with as much directness as the darkness allowed. "There is no me and Coop. Coop happened upon Jean attacking me and stayed afterward to help." Callie hoped the girls believed her. She tried to believe herself.

Nora waved Shauni away and opened the car door. "We gotta go." As Callie snapped on her seatbelt, Nora started the ignition and swung the car in a careful arc to avoid the crowd. "I was afraid maybe it was true."

"What?"

"Coop found you in bed with Jean and beat him up."

"Jean? Give me a little credit." Callie's stomach churned with disgust. "Yuck. He was drunk. Grabbed me. We fought." Callie wished she didn't sound so defensive. *How false the truth could can sound.*

"Okay." Nora kept her eyes on the road and her voice steady.

Callie watched as Nora followed the police car's track on the new-fallen snow. "What do you want to know?"

Nora shivered and turned up the car's heat. "Did you sleep with my dad?"

"No." *No time for lies.* "But I wanted to." Callie cast about for a way to change the subject.

"Do you love him?" Nora's question sounded like an accusation.

"I don't know." Callie knew. She just wasn't ready to say.

"What about Peter? Everyone thought you two—"

Callie wondered how much to reveal as she peered at the flashing lights of the cop car disappearing into the snow. "I had kind of a crush on him for a while. Not now. He's—"

"A total jerk. And a good liar."

"You're so right." Callie had the feeling anything she said to Nora would ring off key, no matter how heartfelt. "I mean it. Really." *God, that didn't help. Holy moly. No wonder.* "Your rapist. It was Peter." Callie hadn't known—not completely—until she

spoke.

Long breath. "Yes." Nora pulled off her a glove with her teeth and swiped at a tear on her face. "Oh, crap. Everything is going to hell. What if I have to tell what I know to get the cops to believe Dad? What if you do?"

Callie searched her purse and then the glove box for a tissue. *Nothing.* "Coop isn't guilty, Nora. Everything will be alright." *Will it? Innocent people go to jail every day.* "It must have killed you to think I was seeing Peter."

Nora leaned over the steering wheel as if that would improve her vision despite the tears. "I knew someone as cool as you would never really fall for him. And I thought he was just play-acting because he told me he only likes really young girls. Underage."

"Bastard." Callie wanted to touch Nora, to hug her, but didn't want to interfere with the treacherous driving. "Listen to me, Nora. I want you to turn him in, you know that. But, I promise. I will never betray your trust."

"Then why does that lawyer keep calling you? And why don't you ever call him back?"

Callie started. "What lawyer?"

"Says he's the attorney for your father. I figured that was a lie. Your last living relative was Sophie, right?" Incongruously, Nora seemed proud to have remembered Callie's details.

"My father? Long dead. Oh, wait. Maybe my stepfather. He probably wants me to testify at his parole hearing. Fat chance."

Nora raised an eyebrow. "You weren't kidding when you told Shauni about family in jail."

Damn the school gossip tree. "Nope."

"Why don't you ever mention him?"

"He killed my mother."

Nora gripped the steering wheel a little too tightly. "Holy shit." Nora nodded as if finally accepting that Callie understood her, then tuned the radio loud enough to preclude more conversation.

The streetlights flickered out just as they arrived in Flambert. They passed an occasional early-morning delivery truck but

otherwise the snowy streets and sidewalks were quiet. Callie knew from earlier trips that this squat nondescript brick building marked only by a flag and a blue mailbox housed the police station, jail, courthouse, and post office. Nora peered through the windshield, first one direction, then the other.

A middle-aged, heavy-set African American man in earmuffs and a gray overcoat stood on the wide cement steps, slapping gloved hands together against the cold. As soon as Nora parked, she pushed open the door and ran to him. "It'll be okay, Nora." He put an arm around Nora's shoulder and extended the other hand toward Callie. "We met at dinner. Craig Landers. Hazel's husband? Alexis' stepfather."

Callie knew who he was, of course, but appreciated his polished manners and felt somehow reassured by a voice like James Earl Jones.

Inside, Alexis rose from behind the receptionist desk. The plump dark-haired young woman hugged Nora and Craig and directed the three to a waiting room. She explained that Coop would be charged shortly. Someone was getting the local judge out of bed.

Nora gestured to the door after Alexis left. "Another Cooper graduate with an illustrious career path like mine."

Craig smiled at Callie. "Young people are always in such a hurry. Alexis is just taking some time off. Both of you will go back to school when you're ready." He pulled a legal pad out of his briefcase. "Now, tell me what happened." He crooked his head to dismiss Nora.

"No, I want Nora to hear." Callie recounted the evening up to the moment Jean stormed out. Her story wasn't credible to her own ears, each detail sounding more like a made-for-TV movie.

Craig took careful notes, then looked her in the eye. "Are you having an affair with Coop?"

Reality returned. Callie stared at the walls of the police conference room, dotted with irregular black spots suggesting that an army of smokers had used it as an ashtray. "Pardon?"

Craig set his pen down with great precision. "I'm only asking what the police will ask."

Callie's mind connected the cigarette spots into a hitherto unknown constellation. "No."

Craig drummed neatly manicured hands on the table. His voice was velvety, soothing. "Callie, if I am going to protect you and Coop, I need to know."

Callie was acutely aware of Nora sitting two chairs away. "He stayed the night." She saw two faces try not to react. "On the couch. He was there to help me, and instead it hurt him." *Do. Not. Cry.*

Craig reached inside his suit jacket and pulled out a packet of tissues.

Callie remembered Sophie offering her tissues through her dry-eyed recounting of Blake's attack, the gory gross details she couldn't say aloud to anyone else. Callie hadn't been near a courthouse in twenty years. Now vivid memories of Blake's trial flooded her.

Craig spoke softly but with great firmness. "Alright. The police will be in here shortly. Don't speak to anyone without consulting me."

A moment later, Alexis ushered two detectives, a court stenographer, and Coop into the room. While the others got settled, Callie overheard Alexis whisper to Coop. "I'll speak up if it will help."

Out of earshot of the others, Coop patted Alexis' shoulder and walked her out. "Your call."

Callie had no time to figure that out.

A detective asked for Callie's version. She told it, watching for Craig's nod sentence by sentence, until the stenographer produced her statement for her signature. After the police and court personnel left, Craig outlined the legal options. "It would probably be best to settle out of court. It's a he said/she said, but he's the one with bandages."

Coop's voice was steely. "Under no circumstances. We've never settled before."

Callie recalled that most legal cases against the Cooper School involved wealthy people suing the school to get their children admitted. "Coop wasn't at fault. Jean attacked me."

"I believe you. I don't know if the judge will." Craig slid his copy of Callie's statement into a folder.

Nora squeezed Callie's hand.

When the judge arrived, they trooped through the building to a miniature courtroom with golden oak paneling and fading black-and-white photos of the Adirondacks. Jean limped in, leaning on Peter. His face was elaborately bandaged, the visible part blue with bruising. Peter, his imperious manner enhanced by a designer leather duster, appeared to be issuing orders to the prosecuting attorney. Following Craig's instructions, Callie sat immediately behind Coop. Nora and Alexis whispered at the back of the room. Unlike Blake's trial, it felt like a meeting of the Flambert Social Club. The judge wore no robes, pounded no gavel, called everyone by their first names, barely listened to the charges, set a trial date, and released Coop without bail. He overruled objections about Coop's violent temper.

Peter, with Jean still leaning on him, halted in front of Callie, his blue eyes frosted expanses of tundra. "I'll thank you to return my computer book." His demeanor implied that she'd stolen it.

Callie wanted either to taunt him with something childish about his stupid cootie-infested book or 'accidentally' drop it in the toilet. Before she could reply, Coop was on his feet, large and menacing, towering over Peter and Jean, arms half an inch from fight position.

"Get away from her, Guy."

An uproar followed. Nora and Alexis, the courtroom personnel, even the judge swarmed the two men, shouting, yanking, pushing them apart.

"Coop." Craig's shouted word and hand on Coop's shoulder possibly stopped an all-out melee. The lawyer herded Coop, Nora, and Callie to a far corner. "You can't lose your temper in front of the judge and the DA. Think about it. Guy deliberately pushed your buttons. Get hold of yourself."

Held back by a bailiff, a cop, and Alexis, Peter stopped struggling and stalked away, dragging Jean, whose limp decreased as he trotted to keep up.

Hazel was waiting in the corridor in a flowing purple coat

buttoned askew over purple flannel pajamas. "Come to our place. I'll feed you. You can talk." She saw Coop frown. "Don't worry, one of the seniors is teaching my class. Callie's too. Good thing our schedules don't conflict." She responded to his quizzical raise of an eyebrow. "Shauni Rodriguez. Good kid. Smart, too." She winked at Alexis, who had returned from escorting Peter out of the building.

Alexis reassured Callie. "Mom's a great cook. Her food got me through some really hard times."

"Yeah, my aunt Sophie was like that. She had great survivor skills—and cooking was one. Only she didn't teach me, unfortunately."

Alexis spoke again, in a low tone that only Callie could hear. "Tell Coop I meant what I said. He'll know what I mean. I gotta stay at work."

"Okay." *Does everyone have to keep secrets?*

As they shed coats and boots in the Landers' homey front entrance then filled the dining room, Callie felt out of place. *Dumb to expect a new community. Some people don't belong anywhere.*

Hazel, her purple pajamas now covered with a bright orange apron from a New York museum, brought a plate of warm muffins and another piled with scrambled eggs. Callie knew the food would quell some of the ping-ponging emotions, but she could barely swallow. Amid the din of multiple voices, Coop spoke to Callie for the first time since his arrest. "I know this is tough. We'll talk about it when we get home."

Callie wondered for the umpteenth time whether he could read her mind. Afraid of her own response, she managed only a nod. But that word 'home' was good.

Nora scraped her fork on her plate, like a small child using cacophony to get attention. It worked. Coop stopped Nora's hand. "This isn't helping. We have things to discuss."

"Like how you'll go to jail and I'll be an orphan?" Nora frowned as Hazel deftly cleared her plate and flatware.

"That won't happen. I *meant*, like how you'd feel about me dating Callie." Coop faced Nora as if the others were just background noise.

Callie's eyes flicked from one to the other in time with her heartbeat, suddenly excruciatingly loud. "Excuse me?"

Nora picked at an invisible flaw in the sleeve of her sweatshirt. "I guess it's good. I mean, it's good. Really. I'm good with it. It will just take some getting used to."

Coop nodded. His eyes flashed at Callie, with the slightest wink. "Easier than visiting me in prison."

Nora snickered, her impish good humor returning. "Yeah, baking files into cakes could be time consuming. Callie might have to learn to cook."

Callie watched Nora balancing a knife at the end of her finger. "Do I get a say in this?"

"No." Nora dropped the knife. "Cooking is an essential life skill."

Coop held Callie's hand. "Of course."

Callie took comfort in their search for equilibrium, their effort to include her, and comfort in the room's square oak-and-glass cabinets which hid decades of other families' histories. "Maybe we should deal with the legal stuff." She didn't really want to—privately she hoped everything would settle into an effortless dreamy confection. Somehow the signs weren't good.

Craig sat, again with legal pad in hand. "I think we can safely assume that Frière's ploy is to counter charges arising from his negligence in the ski accident. But I find it a little hard to understand why that's such a big deal. Or why Guy's involved. Or their antipathy toward Callie."

Nora spoke sullenly. "I told you not to go after Jean. Now it's totally backfired. That's why they hate Callie. They think she started the whole thing."

Callie gave up on her uneaten muffin. "If I'd just stayed home from the ski day, Jean wouldn't have gone for the restraining order and I wouldn't have made Peter so mad." She couldn't stop herself. "Coop wouldn't have come to my place. Jean wouldn't have come to my place." *What, in fact, was Jean doing there?*

Coop, Nora, Craig, and Hazel all spoke at once, pointing out the flaws in her argument: Yes, Jean was a jerk but nobody could predict he'd assault anyone, and Peter—

Craig finally got the floor. "I can't remember the term in formal logic when you attribute causality falsely, but these events started with Jean, not you. He didn't do his job, he caused you harm. Then he tried to escape the consequences."

Coop ran his fingers through his hair, ineffectively making up for the comb he hadn't used. "Yesterday Jean was arguing to keep the accident quiet. Now he's escalating the confrontation. Why did he go up to Callie's? He never showed interest in her before. And Peter's usually all good manners but today he lost the veneer. Something's up."

Craig made a couple of notes. "I'll have my investigator sniff around. Let's see what she comes up with. Meanwhile, say nothing to anyone at the school. Anyone. I'll call you in a day or two. Oh yes, one more thing. Callie, what did Guy mean about his computer book?"

Callie jerked a thumb toward her backpack. "I borrowed one of those computer instruction books from him. Should I have given it back right in the courthouse?"

Craig plucked her backpack from the floor and handed it to her. "It's probably completely irrelevant, but I want you to avoid contact with him. Give me the book. If he asks for it, tell him to call your lawyer." Craig's dark face crinkled into an expression suggesting he'd made a joke.

Callie watched Craig drop the book into his briefcase. Another task for a man who already seemed too busy.

On the ride back, she felt no less guilty. Coop drove. Nora sat in the front seat, still arguing with him that she was right about his action against Jean. In the backseat, Callie massaged her sore shoulder, staring at the sequins of sun on snow.

The hours of stress and sleeplessness caught up to her and she dozed, dreaming murky, threatening shadows that took no solid form.

CHAPTER 13

ilence woke Callie—the engine cutting off and with it the radio Nora evidently used to drown out her father.

Coop helped Callie out, noticing her wince as he inadvertently touched her sore arm. "Do you need to see Dr. Chen?"

"No, I'm fine. I just need a cup of coffee and a couple gallons of morphine."

Nora searched in her pocket for her cell to play some music, as if music-to- drown-you-out was a lifeline. "I can take you up to your cabin."

Callie laughed to cover her hurt and fatigue. "No, just kidding."

Coop let go of her hand. "For the sake of appearances, I'm going to work. I think you should, too, if you can manage it. I'll call you later."

Callie nodded and tried to shut out the past twelve hours or so as she trudged toward Lang Arts. The crowd from hours earlier had dispersed, though a few stragglers late for afternoon science labs looked at Callie with emotion she couldn't identify—fear of discipline or curiosity about their teacher's love life? She noticed a new student-built snow fort that all but called to her to crawl in and forget it all.

The sun was setting. Callie quietly rejoiced that her classes were finished for the day, since she had no idea how she would respond to questions, never mind focus on the lessons of literature from another time and place. She heard voices around the building but was grateful that late afternoon at Lang Arts was

mainly office hours and prep. She rifled through the notes Shauni had left, along with a pile of student work. Most of it made only passing sense.

Just as Callie was about to give up, Shauni appeared. She leaned against the door frame, panting, her brown cheeks bright pink from running in the cold weather. "Callie, you need to see this."

"Thanks for teaching today. Looks like a lot got done." *Now, please go away.*

Shauni was apparently impervious to ESP. Instead, she pulled fistfuls of disheveled papers from her backpack, unloading them onto every available surface.

Callie didn't look at the pages, unwilling to decipher anything that didn't involve a hot drink and a warm bed. "For your paper? Too much material. You need to focus."

Shauni shook her head. "Not for my paper." She peeled off her jacket like a boxer discarding a robe, hopping from desk to desk as she flopped the piles into categories. "When Nora left you last night, she came to me. That's why I was with her this morning. She was shaken about something—she wouldn't say what—so I hung out with her 'til Coop got home. Ended up sleeping there."

"And?"

"She mentioned you wanted to see her files on her mother's death."

Callie stifled a yawn. "Still not following."

"I had an idea that might be connected. I asked if I could bring them to you, which gave me a chance to look through them. Then my girlfriend helped get to sites I couldn't have accessed on my own. Lexis. Nexus. Police records."

"Alexis?"

Shauni flushed a darker pink-and-gold. "Yeah, she's way older than me. Like three years. I thought you might not approve so I didn't mention her."

"Is it legal?"

Shauni spoke like the forensics star she was. "I'm eighteen. I can vote. I could be drafted. Surely I can have a girlfriend."

Callie rubbed her sore shoulder. "I don't mean you and

Alexis. Far be it from me to judge. Look at the mess I'm in." *To a student? All my censors seem to be asleep.* "I mean, did you acquire these materials legally?"

"Sorta." Shauni evidenced her usual ear-to-the-ground school savvy without looking up from the task at hand. "Hey, you and Coop. That's somethin'. I like him. Way better than Peter. That guy's scary."

Callie groaned. "Does everyone know?"

"Pretty much. Maybe someone was out sick today, but otherwise, yeah, everyone."

Callie felt in turns physically ill and relieved. "I don't have to figure out what to say, then. Except I guess I'll have to write a helluva good resignation letter."

Shauni stopped paper sorting. "No, no you can't quit. You're the best teacher I ever had. I don't care who you sleep with. Nobody does." She flicked her hand at the piles. "You have to see this stuff. Alexis is a whiz at legal research. Should go to law school. Anyway, I wanted to do my paper on the language of sexual assault, remember?"

Callie responded to Shauni's statements in order. "Thanks. Good. Okay. Yes."

"Not sure how she limited her search terms." Shauni flipped through the papers. "Here it is." She handed Callie a grainy photograph accompanied by a private detective's report. A handwritten note attached to the photo read, "Subjects leaving closed hearing Wednesday." The date was fourteen years earlier. Shauni's green eyes flashed. "Smoking gun."

Callie peered at the picture. Surely it was a teenage Peter and a younger girl. Callie couldn't make the pieces fit.

Shauni sifted through the piles until she unearthed her own notebook and turned to a page of bulleted scribbles. "Here's what we put together. Peter and his sister, super duper rich kids, sued the school to get in, maybe twenty years ago? That photo is them coming out of some kind of closed hearing. Then we found hospital records—"

Callie raised an eyebrow.

"You don't want to know how. Just after this hearing, the girl

committed suicide."

Callie recalled the photograph at Peter's cabin. Peter's sister. His only personal item. "He blames the Coopers for—?"

"Killing her. Yeah, I'm pretty sure he does. He's famous for telling the team that the Cooper School drives girls to suicide. Everyone always thought it was some kind of weird motivational thing." Shauni nodded, perhaps seeing the past for the first time.

Peter. The rapist. Callie had a horrified thought about why the girl died, and it had nothing to do with the Coopers. "Sorry?"

"You know us teenagers. We kill ourselves all the time over crap. The death rate among lesbians is particularly high."

Callie had flown too close to telling Shauni about Nora and Peter. She was glad to be on new ground.

Shauni looked again at the detective's report. "But if this was a civil suit, why a closed hearing? What were they after?"

Callie sat up, no longer tired, or even sore, her mind suddenly working overtime. "A settlement. They got a settlement from Coop's father. They accused him of sexual harassment or something. Nora once told me about the suit without knowing who it was. The details fit. And the timing."

"Makes sense. Coach always talked about Coop like he seemed to be saying good stuff but sneaking in something negative. You know that thing you say—'damn with faint praise.'"

Callie corrected Shauni without thinking. "Not me. Alexander Pope."

"Whatever." Shauni consulted her notes and then moved to a different pile, apparently looking for something. "Anyway, I bet Peter was looking for revenge."

Callie nodded. "I wonder how Jean got involved."

Shauni tossed pages on the floor as she shuffled through the remaining pile. "Look at this." She handed Callie another smudged detective report about two teenagers getting a slap on the wrist for an unnamed crime. Stapled to it was a photo of two boys. Peter and Jean.

"Where did you get this?"

"Alexis found it a long time ago when she was looking for ... something else." Shauni hid her hands in the pockets of her jeans.

Callie reread the report. "I can't imagine that Coop would hire Peter if he knew about this. Or Jean. Or if he knew that Peter sued his father."

Shauni picked at the edge of the pile. "These were in sealed files. Some people can find things."

Callie mused aloud, "But Coop found other stuff. Why not this? I guess Jean and Peter were rich enough to keep their story out of the papers."

Shauni looked over Callie's shoulder at the report, pointing to the date. "This happened right around the same time as Peter and his sister's suit. They were all still minors. Maybe he and his buddy acted out after she died."

"Or maybe they acted out and that's what drove her to suicide." Callie time-traveled out the classroom windows, past the picture-perfect mountains and trees cloaked in heavy white snow, back to irrational acts by people who should have loved her.

Shauni stopped fiddling with the papers and looked up. "What did you mean about Coop finding other stuff? About Peter and Jean?"

"No, about me." Twenty years of keeping the story secret, spoken only to Sophie behind locked doors, left Callie almost unable to find the place where it began. But on this day of all hell breaking loose she suddenly stopped needing secrecy and silence. "My stepfather murdered my mother. I was there. I shot him. I was eleven." *Was that all there really was to it?*

"Holy shit, Callie." Shauni bashed her knee into the desk. "Ow ouch. Fuck. Did he die?"

Callie turned away from the window and no longer avoided Shauni's eyes. "No. Ironically they spent hours saving his life, just to put him in prison." The story, so long shelved, arrived as a whole.

Callie's earliest memory of Blake was his courtship of her mother. Callie's father died three years earlier. Eight-year-old Callie shared a small apartment with her mother and Aunt Sophie. The two women mourned husband and friend differently. Sophie threw herself into work and volunteering. Cecilia

struggled out of bed once or twice a week. Little Callie cried herself to sleep, begging anyone who'd listen to bring her daddy back. Callie recalled only single moments. Sophie holding Cecilia and rocking her. "He'd want you to live, honey." Cecilia circling want ads in the paper with a red marker. Sophie driving Callie to school. Cecilia dressing in heels and blood red lipstick for an interview as a secretary at Blake's company. Dressed up like a Barbie doll, Cecilia was a knockout. Callie occasionally cursed the vagaries of genetics that meant she'd inherited none of her mother's delicate beauty except for thick dark hair. Raised in a modest but educated household, Cecilia and Sophie were chameleons of class identity—seemingly at home in corporate board rooms and waitress bowling tournaments alike. Blake misread Cecilia as the trophy she worked so hard to imitate. He was in the market for a wife right then and deemed the new girl perfect.

Like mother like daughter. Dating the boss. Callie coughed and leaned on the windowsill, pressing her burning forehead against the cold glass.

Shauni jumped toward the door. "I'll get you a drink." Before Callie could protest, Shauni was gone and back with bottled water from the vending machine.

Callie fumbled in her pocket for a dollar to repay the student. "Thanks." She wanted to beg Shauni never to say a word. She wanted her own words unsaid. She wanted to rewind to the morning before, say no to Peter, no to Jean, no to Coop. But all she could manage was to unscrew the bottle top and swallow.

Shauni hitched up her belt as she stuffed the dollar in her backpack. "I bet he had it coming."

Callie returned to the present and her desk. "Who?"

"Your stepfather."

"Yep."

Blake's courtship of Cecilia manifested itself to little Callie as the arrival of presents. Flowers, candy, stuffed animals, a trip to Chicago to visit American Girl. Callie disliked him all the same. He looked too much like a Ken doll, even to her child's eyes. Not very tall, hair plastered to his perfectly shaped head, he wore

pressed white shirts with gold cufflinks. Washed and overly coiffed, smelling like fancy aftershave. And always, always, some undercurrent, something mean, something shifty.

Within months of his marriage, his Dr. Jekyll was gone. Supposedly the trigger for his hundred and eighty degree turn was the 'discovery' that Cecilia wasn't the aristocrat he'd mistaken her for. Blake's fury at having acquired a 'lying bitch' took the form of shouting and beatings.

Shauni's voice wobbled a little. "Does anyone else know about this?"

Callie straightened papers on her desk, items on the windowsill, Miriam's posters. "Coop. He told me last night that he's known all along."

Shauni watched her teacher, perhaps wondering if she should help in the frenetic cleaning. "So, promise me, the thing with Coop isn't, like, sexual harassment? You had to sleep with him or he'd fire you or something?"

Callie stopped, the blackboard half-erased, and laughed aloud. It felt good. "I didn't have sex with Coop. He slept on the couch. I'm against getting involved with the boss. But—"

Shauni let out a breath she must have been holding.

"Shit happens." *Exactly*.

Shauni looked energized. "I like Coop. I'd hate him to be a jerk. Peter, though, he's like that Cassius guy in *Julius Caesar*. A lean and hungry man, an asshole. Did Jean hurt you bad?"

Callie continued tidying the room, hoping square piles would engender psychic order. "I'm okay. I can't really talk about it. Lawyer's orders."

Shauni went back to her pile. "This info's gotta help. Doesn't it prove Peter has a grudge against Coop and a nasty partnership with Jean?"

"I don't know. Craig can tell us. But I don't think it's the smoking gun. I doubt Peter or Jean care what the world thinks of their youthful foibles. Something else is going on. Something about public exposure that freaked them out enough to go on the attack."

"Miriam's accident? I've been over and over Nora's files and

can't find anything, but maybe you can." She handed the relevant stack to Callie. "I wasn't supposed to tell about me and Alexis. But, well, Coop's older than you, too."

"Yes. Ten years. But nothing has happened between us." Except Coop asking his daughter permission to date Callie. Callie remembered Alexis' message.

"The lady doth protest too much, methinks." Shauni struck a pose reminiscent of a Shakespearean actor. And smirked.

"Shauni, Alexis said she would help Coop if he needed it. Is this what she was talking about?"

Shauni stared at Callie for a long time. "No, it's something else. Something she's never told anyone but me. If I tell you, you have to keep it to yourself."

Callie touched Shauni's arm. "Of course."

Long silence, no eye contact, quiet voice. "Peter raped her." Callie sat with a thud.

"Does Coop know?"

"He knows about the rape. But I'm the only one who knows it was Peter. 'Til now."

Callie's headache came back with a vengeance. She drank water, hoping hydration would be a cure. A story was forming. Nora had described her parents rescuing a girl. "Did she call the Coopers for help?"

"Yeah. How did you know?"

"Wouldn't they automatically call Hazel?"

Shauni crossed her arms across her chest, warding off the evils of the past. "She was away at some art teachers' conference. Alexis had just turned eighteen. She insisted it was her private business and never told anyone except me."

"Why? Hazel would have supported her."

"Yeah, Hazel's the greatest. That makes it even harder for Alexis. She got snookered by Peter's sweet talk and couldn't fight him off. She's afraid Hazel'll feel like she'd failed as a mother." Shauni stood still, not clearly coming or going.

Callie's mind raced back Sophie's encouragement through her own ordeals. "Alexis works for the cops. Surely she sees that victims need to come forward?"

Shauni snorted. "Surely she sees how cops treat victims. But I still want her to tell. We've argued about this a million times. Her mom's, like, her idol. Mrs. Truth-in-All-Things, like Miriam was. In my opinion, Alexis would feel better if her mom knew. But she thinks her mom would feel worse. I think it's worth it. I'm sure that rat would lose his job, even if it's too late to put him in jail."

"Too late?"

"Statute of limitations."

Callie handed the girl her jacket and backpack and donned her own. "Maybe not too late. C'mon. Do you have a cell phone?"

"Not allowed on campus. You know that."

Callie was tired of subterfuge. "Do you have one or not?"

Shauni shrugged. "Yeah." She pulled the contraband instrument from her pocket and punched in a code. Callie grabbed the phone.

Alexis answered immediately. "Hey, Babe."

Unwilling to wait, Callie pushed Shauni out the door, talking into the phone. "Alexis, this is Callie Franklin. Come to the Cooper School. Now!"

CHAPTER 14

lexis cleared her throat, not revealing whatever shock she might be feeling at hearing Callie's voice. "I can send an officer if you need one." Then her voice changed. "Is something wrong with Shauni?"

"Not with Shauni." Callie was talking fast and loud. "You offered to help Coop. Now's the time." She clicked the phone off and handed it to Shauni. It immediately blared a popular song.

As they sprinted across sidewalks clear of snow, zipping by the students en route to after-class activities, Shauni answered her cell. "Yeah. I don't exactly know. Just come."

They took the stairs to Admin two at a time. Nora wasn't at her desk. They could hear voices through Coop's door. Callie knocked hard, knuckles on wood.

Nora cracked opened the door. Her face, framed between the heavy oak door and its equally majestic frame, was a moving panorama of emotions—fatigue, happiness at seeing Callie, then surprise at Shauni's presence. Callie could hear Coop and Peter arguing inside. Nora pulled the door open and Shauni followed Callie in.

"The whole world is watching, Cooper." Peter's Cheshire Cat smile broadened to reveal shark teeth. "I need your answer."

"Get out of my office." Coop stood behind his desk, torso thrust forward, arms straight down, weight on his fingertips.

Peter thrust his chin toward Coop daring him to throw the first punch. "I'm telling you, I can make this all go away." Like powerful bulls with horns lowered, both men breathed audibly. Peter straightened and charged toward the door, brushing against

Callie, his open palm grazing the soft fleshy part of her behind.

The room exploded with noise. Callie slapped Peter's face, Shauni swore, Cooper roared, Nora screamed, Peter laughed. Everyone moved toward Peter except Callie, who jerked away.

The deep creases next to Peter's smile became disfiguring crevices, no longer handsome dimples. "You are all my witnesses. A further assault." In an almost invisible motion, he kissed Callie on the cheek and left, door slamming behind him.

Ashamed she hadn't moved away fast enough, Callie grabbed her cheek.

Still growling without words, Coop leapt toward the door. Callie and Nora grabbed Cooper yelling, "Stop!" and "He's not worth it."

Silence. Shauni moved first. "I'll meet Alexis outside." The door closed behind her.

"I need a drink." Cooper relaxed his fighting stance.

Callie guided him to an overstuffed wing chair. "What is this, forties film noir? You don't need a drink. You need to think clearly. We're counting on you not to go all hot-headed."

Both Cooper and Nora turned to Callie, amusement crinkling their faces in identical muscle patterns. DNA at work. Cooper sat, grasped both arms of the chair, but instead of pushing himself back to standing, he sank into the upholstery. "You're right, of course. I need to call Craig. Give me a minute to regroup."

Nora opened a closet, revealing a small refrigerator. She pulled out three cans of cola and handed one to each. Callie sat on the arm of Coop's chair. "What the hell was Peter doing here?"

Coop countered, "What the hell was Shauni doing here?"

Callie opened her can. "You first."

"Get this," Nora sat on the Persian rug at her father's feet, carefully popping the top so the soda wouldn't fizz onto the carpet, "Peter said he'd tell the cops he knew Jean lied if Coop would drop his so called persecution of Jean. No punishment. No public statement. Oh yeah, and shut you up about last night."

"Like you can control me." Callie jumped to her feet, wishing for her own chance to punch Peter.

Nora traced the complex pattern on the rug with her finger.

"Like Coop'd drop the whole Jean thing."

Setting his unopened can on a table covered with legal texts and reference books, Cooper rubbed a thumb against his temple. "And Shauni?"

"Alexis is her——" Callie searched for the right word across the room.

Nora stretched out on the rug, speaking with tired acceptance of adult stupidity. "Yeah, whatever, they've been dating for months. Everyone in school knows."

Coop's double take was deliberately exaggerated. "Everyone?"

Nora sat up. "All the girls." She poked her father's toe. "It's not against the rules. I mean, it's her business, right?"

Ruffling Nora's hair, Coop sat back. "Darlin', I don't care who anyone dates except the people in this room. I'm just not sure I want a student involved in our legal troubles." The sound of a motor on the usually vehicle free campus propelled him to the window. "Now what?"

Callie followed his gaze to a weathered jeep occupying the No Parking Zone in front of the building. "I think that's Alexis." Sure enough, Hazel's daughter got out of the car.

When the two young women entered the office, Coop spoke decisively. "Shauni, it's not my choice to include you in this discussion. I like to keep students away from the business end of the school in the best of times. But it seems I have no choice."

"You won't be sorry, Coop."

"I hope you're right." Coop phoned Craig, who was already on his way. "Alexis is here with Shauni ... Yes, I just heard that ... OK, will do."

To Callie, Shauni seemed incongruously eighteen, a child playing cops and robbers in the middle of a major crime spree. But she knew that adulthood was around a short corner. "I think it's okay if Shauni stays. She and Alexis collected a lot of good material."

Coop shrugged. "Craig said something similar."

Nora exchanged glances with Alexis and Shauni that were just short of eye rolling.

In the next few hours, the six of them sifted through materials

and talked through a hundred different scenarios. They divided tasks. Coop phoned reporters who had covered stories about the school. The three younger women huddled around Alexis' laptop on the coffee table, entering internet search terms and taking notes. At Coop's desk, Callie showed Craig the material Shauni and Alexis' had uncovered.

Alexis didn't offer her story and Callie began to wonder whether she'd misunderstood. Her growling stomach gave her an idea. "Alexis, getting snacks and could use a hand."

If Alexis was surprised, she hid it. "Sure." Outside, Callie broached the subject of Peter.

The younger woman, short like her mother, trotted to keep up with Callie. "I wasn't always the fat, happy lesbian you see today. In school I was a skinny little runt with neither self-confidence nor sexual identity. Perfect target for Peter. Maybe I was bowled over that anybody, guy or girl, who looked and dressed like a movie star would single me out."

Callie stopped to let Alexis catch her breath. "I fell for him, too. Me, the big feminist, always on about how men judge women on looks. I did the same thing. I think it was the dimples." Callie noticed that the student snow fort, so pristine earlier, had collapsed.

Alexis gulped for air but didn't stop. "That black hair and blue eyes, the Irish thing, they got me. And his command of nineteenth century bullshit romanticism. If he'd actually stayed nice to me, I'd have robbed banks for him. At least until I figured out I wanted to kiss girls."

Students and teachers on their way to dinner waved and smiled companionably at Callie. Everyone seemed to be rooting for her. In her memory, every adult but Sophie had ganged up on her. The change gave her courage. "Do you mind talking about the assault?"

Alexis slowly turned in a circle, checking the snowy campus of trees and girls and late afternoon shadows on dimming buildings. "I don't mind telling you. Shauni thinks you're the greatest so it's fine that you know. By now I've worked through a lot with my shrink and with Shauni. The thing is, I've never told

my mother, so I'm nervous about Craig being here. He's a great guy, don't get me wrong. And I love that he and my mother found one another at their age, but I can't tell him before I tell her."

"How about just telling me, now, away from the others?"

The two women arrived at the commissary and Callie reached for the door. Alexis hesitated. "Okay, but not in there. News travels fast."

Callie remembered Shauni's assertion that everyone on campus knew about her and Coop. She was glad Alexis couldn't see her blush. "Okay, let's plan to meet later. Do you mind Nora joining us?"

Alexis cocked her head to one side in a slow gesture of realization. "Oh, no."

Callie felt guilty at asking Alexis to reveal more than she was ready to. "Okay, not Nora."

"That isn't what I meant." Emitting an angry guttural sound, Alexis kicked and stamped a snow bank. "*Aaargh.* I should have known he'd do it again. Why her?"

Callie's guilt doubled as she realized Alexis just guessed Nora's long-held secret. "I suspect you were, well, practice. I don't mean he was practicing rape—I'm pretty sure he's preyed on young women for ages. I mean he was perfecting his Cooper school strategy. Heaven knows how many others he attacked, but his ultimate goal was Nora. He wanted to hit the Coopers where it hurt."

"So fucking sick." Alexis formed a snowball, aimed it at a tree, and threw hard. "I believe you. I saw the reports on his suit against the school and his sister's suicide. But I don't know whether it's worse to be a rape victim or a second-choice rape victim."

Callie shivered. "Sorry." Guilt usually annoyed her. Today it was an icy winter wind cutting through layers of clothing and soul. She started when lights came on along the campus walks, marking the official start of evening.

"Only one person owes me an apology, and he owes me a lot more." Alexis's next snowball disappeared into the dusk. "Shit, I

can't see a fucking thing. And I'm freezing. Let's go in."

Inside, student workers were wiping tables and sweeping the floor. "Sorry, we're closing, but if it's something simple—"

Callie and Alexis soon returned to the Admin building with pre-wrapped sandwiches, fruit, and drinks. Craig had gone home for supper but everyone else ate voraciously.

Without preamble, Alexis spoke. "I need to say something." Quietly, holding Shauni's hand, she told Nora about Peter. Coop looked on, nodding while she explained how he and Miriam had rescued her. Nora sat without moving. Alexis ended with a simple statement. "I want to get that bastard for every single crime he's committed, starting with the one against me."

Nora bolted from the room. Coop followed. When Alexis moved to join them, Callie motioned her to stop. "Let her talk with her father."

"Yeah. I need to talk to my mother." Alexis nodded. "Callie, I know you're probably wondering if you shoulda opened this can of worms. But all this truth is for the best." She and Shauni hugged Callie then departed in the jeep.

Callie picked up her jacket and left Admin. No sign of Coop or Nora. If they'd gone home, good.

The walk to her cabin had never seemed so long. It was now fully dark and the wind had come up. Callie shivered as the trees dribbled bits of snow, dusting the road with a barely visible white haze. Oddly, bone tired as she was, she felt no fear. She passed Peter's darkened cabin without pause. Once home she stoked the fire and fell into bed, stopping only to remove her boots and outerwear. Later the phone rang but she didn't answer. She slept without dreaming.

What woke me? The lighted dial on her clock showed a few minutes past eleven. Then she heard the noise—not the usual creaking of a lone cabin shifting with a high wind. A small bump. A footfall. Scratching. Someone inside! Callie slid her legs from under the quilt, feeling for the floor in her stocking feet, wracking her brain for something to use as a weapon.

Whoever it was didn't seem intent on the bedroom. She found a textbook on her bedside table, grateful it was large and

hardcover. She slid heel to toe along the wall toward the open bedroom door, trying to see in the dark. The scratching got louder. *Cheeky bastard.* She sniffed, hoping for a telltale odor. The faint scent was earthy, unfamiliar.

Callie considered the possibilities. *Coop or Nora? They'd knock. Peter. No. Shauni? Probably not.* Each thought propelled her a bit farther along the wall. Through the bedroom door, toward the great room. **Snap.** Lights on. She mustered her fiercest voice. "What do you want?"

No answer.

The rustling intensified, more insistent, her ear drawing her to its source. When she saw her visitor, she nearly dropped her book.

There, on her kitchen island, snacking on a bowl of fruit was a large raccoon. Only then did she notice the cold. The animal had apparently pushed its way through an incompletely closed door. It wasn't like her to forget to lock the door.

"Shoo, shoo. Beat it." She summoned all the volume that sleepiness and relief allowed. Waggling her book, she lunged toward the raccoon, not wanting to hurt the creature, but not wanting to share her cabin, either. It casually lumbered toward a chair left next to the kitchen island and scampered down to the floor.

Callie opened the broom closet to search out a more appropriate tool for chasing the raccoon and found herself face-to-face with Jean.

CHAPTER 15

Yowling, Callie swung her body in a circle like a shot putter and smashed into his abdomen.

"*Va t'faire foutre, salope!*" His bony chin quivered.

Callie registered peculiar details—his slim body crammed into the closet, elbow between the mop handle and the broom. His face, free of bandages. Her backpack dangling from his left wrist. And his other hand. The one with the gun. "Get out! What the hell are you doing in my house? Out. Out. Out." She batted the book repeatedly against all available surfaces of his body.

Dodging her blows, Jean wriggled out of the closet. He raised his revolver to her eye level, where it would register. His words were cold and even. "You will pay for that."

Callie clutched the book against her heart, wondering if it would save her like the Bible in an old Western. "What do you want?"

In his casual Parisian way, Jean sighted along the steady gun hand to parts of her body. "I am an excellent marksman. I can shoot so you will die a painful death over many hours." A scratching noise distracted his gaze as he noticed their companion, the raccoon was groping its way out of evil human land. Jean clutched Callie's backpack and gestured toward the creature. "The raccoon will eat away your flesh."

Fighting nausea, Callie forced herself to keep her eyes on Jean's, mentally scanning the room for escape routes. "I have nothing that would interest you."

A mean-spirited laugh. "You are correct about your body." He trained the gun on her while dumping the contents of her

backpack on the floor. "Not of interest." His booted foot kicked aside student papers, uncovering a scattering of textbooks. He squinted briefly at each, grinding a wet heel into one, toeing open another and adding his full weight to break its spine.

Callie needed to move to keep from fainting but feared setting him off. She surreptitiously shifted her weight to each bone in her feet, one by one. "Stop! What are you looking for?" A kaleidoscope of images flitted through Callie's brain—a knife holder on the kitchen island, a poker by the fireplace, a letter opener on her desk in the study. Behind the practical came the emotional. Coop's face. Sophie's. Blake's wrath. Peter's cold civility.

Jean's frenzied destruction became a demented dance of anger and frustration. "Where is it?"

"What?" Self-defense lessons popped into Callie's brain: Remind the abuser that you're human. "Jean, I have everything to live for. I love teaching. I love this cabin. Take what you need and leave." She knew she sounded like a movie of the week and wondered if any words would deter him.

Jean no longer appeared to be listening. His eyes darted about the room much like the raccoon's. With his free hand, he clutched the toast Callie and Coop had abandoned that morning, showering dry crumbs over the student papers, then emptying a jar of jelly, repeatedly stomping on the mess. "Shut up!"

Because Callie was watching his face, not his gun, she didn't see him aim but heard the click of metal on metal. She squeezed her eyes shut and considered screaming, but the closest cabin was Peter's. Tears ran down her cheeks but she made no sound. When she heard the bang and Jean's expletive, she waited for searing pain.

Instead, she felt nothing. Opening her eyes, she saw the raccoon lunge for the fallen toast, distracting Jean, making his shot go wild. Jean aimed for the animal, which scrabbled across the room. He missed and instead shattered a window. Another shot. A piercing shriek and a splattering of blood as the yelping, wounded animal protested the final minutes of its life. In the millisecond between shots, Callie ran. Out the door, across the

porch, into the woods. No coat, no shoes. *Shit, people die from exposure.* She sprinted between trees, through underbrush covered with snow, regretting for the first time the isolation of her cabin, and the finality of its location at the end of the road. Now the road was her lifeline. She ran parallel to it, knowing that if she lost sight of it, she could easily become disoriented in the dark woods. Jean crashed behind her, swearing in French and firing into the darkness. He kept to the pavement, swinging a powerful flashlight first to one side and then the other.

Callie calculated that the walk to campus was twenty minutes; she could have run it in ten or fifteen wearing shoes in warm, dry conditions. But across undergrowth, off the road in socks on wet snow, with a sore shoulder, a deep urge to vomit, and no clear landmarks, the task became a dark joke about the frying pan and the fire. Or the equivalent in degrees of cold.

Callie struggled to conjure a mental map of cabins on this road. *Who the hell lives up here besides Peter?*

Crunch.

Bang.

Crash.

Jean evidently thought they were alone. When she heard a car, she almost called out in joy. She clamped a hand over her mouth. *Could be Peter.*

On this moonless night, the distant winter stars were little help. She edged toward the road, cursing unbidden tears that made her face even colder and her nose run. The car was idling and she could hear voices—two or three—but couldn't identify them. From the cadence of the language she was pretty sure they were speaking English. This gave her hope. Peter and Jean usually spoke French.

Falling to her knees for better cover, Callie crawled toward the road and pulled herself up behind a tree, clutching its cold rough bark and hoping it would not be the last living being she hugged. Silently she lifted one foot then the other to push off the snow and rub feeling into her toes. She could see the car's headlights illuminating Jean and two other figures. She could barely make out Jean's words. His gun was not visible.

"*Oui,* I heard it too. A sound like a gun." His hands, now empty, gestured elegantly to someone out of Callie's sight. "Probably nothing. Branches falling."

In the dim light, Callie noticed for the first time that Jean was dressed for winter sports in expensive high-tech fabric—perfect for burying a body in the snow.

Hazel's musical tones followed Alexis' staccato responses, with Hazel offering him a ride. Jean demurred.

Callie weighed the disadvantage of showing herself to Jean over the advantage of having witnesses if he tried something. Fearing frostbite, she chose the latter. "Hey, Hazel, I'll take a ride." She hoped her casual voice compensated for skulking in the woods near midnight in the dead of winter without shoes or a jacket.

All three turned toward Callie's voice, unable to see her from the light to the dark. Jean moved toward her. Avoiding the light, Callie moved fairly silently on her socks, eager to put the car between herself and Jean. He seemed to have moved to the driver's side. When she reached the passenger side, she called to the two women. "He's got a gun! Get down!"

Why they didn't question her, she'd never know. But in the next instant all three women were huddled together on the edge of the road, beside the car door.

Jean's crackly voice assailed them. "*Mesdames,* you cannot escape. I'll kill you all if I must."

The three bodies crouched close to one another like fingers of a glove, offering Callie respite from the cold.

Hazel's melodious tones held authority. "Jean, I'm sure you're stressed. We all are. But this is no way to handle things. Put down the gun and we'll talk."

Callie envisioned Jean turning on Hazel because she was kind and rational. Her terror increased as Alexis grasped the door handle and pressed it open with a click as loud as a thunderclap. Callie suspected her hearing was distorted when Jean's footfalls thudded like a team of horses, galloping behind the car, away from the headlights. Alexis wrenched open the door, pitched forward, and released the parking brake. The car slid backward

toward Jean. He fired then scurried out of the way. In that moment, the women tumbled into the car. Alexis took the driver's seat. Callie and Hazel scrambled next to her. Alexis cut the lights and gunned the motor. The old Buick sped away from Jean, who shot again. The back window shattered and all three ducked.

"Oh shit. I'm hit." Alexis hissed her pain and dismay through clenched teeth. Blood soaked through her coat, dark and gooey in the dim starlight.

Hazel, voice thick with uncried tears, whispered a terse command, "Callie, you drive."

Wedged between terrified mother and daughter, Callie took charge. "Alexis, lift your ass and I'll slide under you. Keep your foot on the gas until I get mine there."

Alexis shook her head. "I'm too fat. We both can't fit."

"A couple hundred yards to the end of the road. Can you make it to the turnaround in front of my cabin?" Callie felt Alexis shudder with unspoken pain.

"Yeah, I think so." A few bloody moments later Alexis reached the goal and stopped the car.

A macabre clowns-in-a-circus-car routine ensued. Hazel and Callie pushed out the passenger side. Hazel jumped in again, arm around Alexis. Callie pounded around the car and flopped low into the driver's seat, fearful that the few seconds they stopped were long enough for Jean to catch up, knowing they were trapped. Every crackling branch sounded like a new gunshot.

Headlights still out, Callie gunned the car, hoping she was steering down the road and not into the woods. She flicked her head at Alexis and Hazel. "Stay down."

Alexis pulled her cell phone from her jacket, entering a code with her thumb. "Pick up. Pick up. Pick up." She howled into the phone. "I'm shot. I'm shot. Jean Frière is firing at us on the road to Callie's. Get us help, babe." Alexis dropped the phone, collapsing into her mother.

Hazel sniffed and sobbed through her soothing words. "Stay with me, honey. I love you."

As the vehicle gained momentum, Callie spotted a shadow on

the starlit road. She clutched the steering wheel, pressed the gas pedal, aiming straight for the moving target, scrunching as low as she could and screaming invectives. Jean's silhouette gained form, first brandishing a weapon, then jumping aside. The motion undid his bravado, as he apparently slipped on unseen ice. Callie saw the gun fly out of his hand. *Lucky break.* She hit the headlights and raced for campus.

The rest of the night took on a dreamlike quality. Callie remembered only snatches, the events strung together from accounts of others. Shauni'd summoned police, Coop, and Dr. Chen. The doctor attended to Alexis, still losing blood and fading in and out of consciousness, until an ambulance bore her to the Flambert ER, Hazel at her side. Shauni followed in Hazel's car.

The police set up temporary headquarters in Coop's office, while search parties sought Jean without success. They woke Peter, who professed no knowledge of his friend's activities but declared Callie a liar who probably invented the entire scenario.

Settling Callie in the Coopers' apartment, Dr. Chen inspected Callie's feet for frostbite and found them unscathed. A detective questioned Callie in Craig's presence, apparently satisfied by whatever she told him. Coop and Nora stayed with her throughout, murmuring reassurances and offering her blankets and hot tea. Callie begged to return to her cabin, but both Coopers knew a crazy idea when they heard one. They agreed to take her to collect a few things and close up the cabin. An officer accompanied them, entering first with firearm drawn.

The cabin was empty. The dead raccoon lay in a pool of blood too like her mom's. Callie jerked her head away, though she said nothing. Nora pushed her toward the bedroom, directing her to pack. Callie could hear sweeping and scrubbing while she stuffed underwear and sweaters into a duffle. She chortled wildly when Nora joked that Callie should give an A to each student whose paper Jean wrecked. Later she had no idea why it seemed funny. Coop nailed a sheet of plywood over the window, helped by the officer whom he apparently knew by first name. Coop spoke to Callie, too, she was sure of it. But she didn't remember his words. Nor did she remember their return to the Coopers'.

Slumber overcame everything else. She had a sense that Coop sat beside her bed, wakeful and watchful but that could have been a dream.

The sound of an unfamiliar phone jolted Callie upright and on guard.

The ringing ended abruptly. Now fully awake, Callie listened for signs of life. Silence. The Coopers' apartment felt cold and empty. Someone had folded her jeans and sweater neatly on a chair, a welcome addition to the long underwear she'd apparently slept in. The aroma of fresh brewed coffee pulled her out of the bedroom.

A note in Coop's scrawl lay on the table where she'd first dined with him and Nora, back when the worst thing she thought could happen in this paradise was a ski accident.

"Cancelled your classes for today. Take it easy. C."

Nora had added in turquoise ink, "If you need anything, I'm at work. Call me." A phone number followed, and a row of Xs and Os.

The phone rang again. Wondering whether Coop was trying to reach her, she waited through the outgoing message. No voice, just the click of a hang-up. At least it wasn't Blake's lawyer calling again. That would be the final straw. With a steaming mug of coffee in one hand and her backpack in the other, she settled into a plush armchair by the fireplace, though the logs were cold. She drew courage from the unstudied elegance of this room, its furniture and art collected by generations of Coopers. An insistent knock interrupted about three minutes of solitude.

"Yes?" She jumped, her heart pounding, even though the caffeine hadn't kicked in. The phone rang again.

A familiar voice called through the door. "Good morning, dear. It's Hazel."

Unlocking the dead bolt, Callie welcomed the older woman's smiling face with cheeks rosy from the cold. "Morning. Don't you have to teach?"

Hazel hugged Callie, her arms full. "Coop cancelled all classes today."

"All of them?" Callie accepted a white paper bag, a purse, and

a briefcase, noting the blue shadows of fatigue and worry etching Hazel's usually serene face.

Tossing her coat and scarf over the nearest chair, Hazel rushed for the coffeepot. "He brought in counselors to help the girls. Right now the houses are meeting and we'll have a school-wide assembly this afternoon. Coop and Dr. Chen are fielding parent calls."

The dark bloodstains on her friend's coat set off the shivering and fear of the previous night. Before Callie could ask about Alexis, the phone rang.

Hazel stopped mid-pour. "Don't answer, unless you want to talk to reporters."

"What can I do? I should be helping."

"I don't think you can."

Callie flared. "I may not be a trained counselor, but the girls trust me."

"Honey, I just mean the press will follow you around. The shooting is all over the news."

"How is Alexis?"

"Bullet missed all vital organs, thank heavens. She's weak, but not in danger. We already brought her home."

"Oh Hazel, doesn't she need you?"

"She wanted me to make sure you were okay. She's a trooper, that girl. Shauni will bring her to school later."

"Is it safe for her to jostle around in a car?"

Hazel tilted her head as if assessing a great work of art. "Never underestimate my daughter, even on painkillers. Besides, Coop and I both thought you might need some ..." Hazel paused, obviously choosing her words with care, "... company." She waved at the bag with too much vigor. "I brought pastry."

Callie squelched her usual don't-need-anyone-thanks mantra. "I'm grateful. But if we can't answer the phone, how can Alexis call you?"

"Cell." Hazel brandished it. "The school forbids cell phones for students, not faculty."

Coffee finally snapped all of Callie's synapses into place. "What reporters?"

"Reporters?"

"You said I'd be dogged."

"Oh right. TV crews are camped out on the steps of Admin. The local authorities are keeping them away from the girls. Jean was so worried about bad publicity after the ski accident—well now his face is on every TV." Hazel's chortle was a tonic for Callie.

"I think he went over the edge sometime yesterday. He wasn't making much sense even before he shot Alexis." Despite the mid-morning sun, everything seemed a little shadowy. Callie roamed the room turning on lights. When the phone rang again, Callie unplugged it. "Did they catch Jean?"

"Hasn't turned up. Cops and highway patrol are posted all over the campus—even at the bottom of the stairs here." Hazel absently touched her gray curls, as if to reassure herself that everything was in place. "They have a direct line to Coop—only he says who gets to see you. Getting up here was harder than getting on an airplane."

Callie opened the door and peered down the stairs, where she could hear a meeting in progress in the student dining room. Two young officers blocked the bottom of the steps. She waved to them and closed the door, wary of friendly captors. "Feels like prison."

"Understandable." Hazel doused her coffee liberally with sugar and milk. "Light the fire, dear. Looks like we're socked in here a while. Coop'll come back when he can." She opened the cabinets and found a delicate china plate for the Danish and croissants.

Callie struck a match and pushed it into the kindling beneath the expertly laid logs, guessing that the ready-made fire was Coop's early morning gift. "What about Peter?"

"In all the confusion last night, he got away."

CHAPTER 16

Callie clenched her hands, knowing that Peter's loyalty to Jean would hone his desire for murderous revenge. "He's dangerous."

"I think we all know that now."

"Where's Craig?"

"In Coop's office working on a press conference. He might want you to participate, but you decide." Hazel set the goodies on the coffee table in front of Callie. "Eat, dear."

Callie wasn't hungry but slid a croissant onto her plate and settled into the armchair. "What do the parents want?"

"All manner of impossible things—'Fly my daughter to me, Get Homeland Security to guard the school until the madman is caught, Teach the girls to use guns. And it's all Now! Now! Now!" Hazel imitated different parental voices, but kindly. "Most of the parents can't afford to miss work and come here, so they count on us to be *in loco parentis*. They want assurance that their children are safe. I don't blame them. But I wish people would have a little faith." She picked at *a pain au chocolate* but ate no more than Callie.

Callie, chilled, held her hands toward the early twentieth century fireplace, refitted as an efficient wood stove. The warmth seeped into her. She opened her backpack, only to find a new challenge. In her haste to pack up the night before, Nora had stuffed the worst of the jam-and-crumb-covered papers into a plastic bag.

Hazel stopped fussing with her plate and brought damp sponges. They wiped off the pages and placed them one by one in

front of the fire to dry. Callie rolled her shoulders, stretching muscles taut from days of tension. Finished with the goopy pages, she slumped into a chair.

When Hazel went to the sink and washed off the sponges, Callie felt rather than saw the older woman's mood shift. "Are you okay?' *How can Hazel be calm?* In the past twenty-four hours she'd learned that one colleague raped her daughter and had seen another shoot her.

Hazel daubed an eye with the dish towel. "I was better the minute that doctor said Alexis would recover."

"Alexis and Peter?"

"Still sorting that out. Yesterday Alexis and I talked for hours. Craig, too. I think we're all better for it, though I see counseling in our future." Hazel laid the towel on the counter. "Shauni told us you're researching Peter. That's why we were coming up to see you— we want to help expose him."

"And then she got shot. No good deed goes unpunished and all that." Callie used her comedy voice but didn't find it funny.

Hazel faced Callie with a straight back and determined jaw. "Did you fall for Peter?"

"No. Well, for about twenty seconds. But he's all smoke and mirrors. So very good looking, though."

"That he is. And so very charming." Hazel's voice slid over the words as if calling for the death penalty.

"I've never really known anyone like him or Jean—people with inherited wealth. I misread them both. I thought I knew all about the upper class because my stepfather was *nouveau riche* and surrounded by country club friends, but—" For once, Callie had no joke to lighten the mood.

Hazel moved behind Callie and massaged her shoulders, as Sophie had when Callie was a child. "You can't blame yourself for being conned by a con artist, Callie. I'm sure his social class helped him believe in his own entitlement. Criminal *chutzpah*. He fooled lots of people—even Coop."

Callie's shoulders unknotted. "On TV crime duos are thugs— shaved heads and violent tattoos. Beer and porn." She really meant juvie but TV would do. "I need more coffee. You?" She

leapt out of her seat, empty mug in hand.

"You can accept help, you know."

"Yeah." Callie found a bag of gourmet coffee beans in the freezer and poured some into a state-of-the-art grinder she found on the kitchen counter. The riot of beans against metal gave her a welcome respite from a conversation cutting too close. Silently, she called to Sophie for help.

When the noise subsided, Hazel continued. "None of this was your fault. In fact, you uncovered it all."

Callie looked into Hazel's kind green eyes, the color of life, matched perfectly by the artist's cashmere sweater set. Callie wanted to surrender, to tell Hazel everything, as she had Sophie. But could she trust this woman she knew so little? *It's a day of new beginnings. What the hell.* "Hazel, I know all the right words. I was in therapy forever, and in women's groups and I had the best mentor one could ever hope for, my Aunt Sophie."

Hazel held Callie's eyes with hers. "But?"

"But sometimes I think the damage has already been done. I don't see the world the way other people do. Maybe that's why I missed how fucked up Peter is—or maybe I was subconsciously looking for a kindred fucked up spirit."

Hazel threw a Danish at Callie's head, deliberately missing her target. "Bullshit."

Callie was so surprised she laughed aloud. Equally startled, Hazel took up the laughter and unable to stop, the two collapsed into their chairs. Callie reached for the crumbling pastry where it had fallen to the Persian rug and tossed it into the fire. It sizzled and smelled like burning sugar, engendering further hilarity. As the laughter subsided, Hazel found a carpet sweeper in the closet, pushing it over the flakes of pastry until the carpet was passable.

Callie prowled, touching a book here, an ancient Chinese vase there, coming to rest at the windows overlooking the campus. Police vehicles dotted the pedestrian-only sidewalks and officers milled around, speaking white vapor into walkie-talkies in the chilly wind. Holding rifles.

Hazel emptied the crumbs into the trash. "Why here? Why Alexis?"

"I think Peter and Jean both spent their lives figuring out where to be out of the public eye while feeding their ugly habits. I'm pretty sure Peter's sister applied to Cooper a couple of decades ago. Of course she wouldn't have been admitted, since the school doesn't take rich kids. After the usual shenanigans— law suits and so on—she killed herself. The family blamed the school."

Hazel's green eyes flickered cold and hard. "Shauni mentioned that coach scared the girls with tales of the school driving girls to suicide. No doubt he was thinking of his sister. But her suicide doesn't make sense. Her family could have bought her a place at a dozen prep schools. Fancier ones than this."

"Maybe she was mentally ill and any setback would have driven her over the edge. Or maybe it was teenage angst gone tragic. But my guess is that she was Peter's first victim and she accused Coop's father instead of her own brother." Callie, suddenly light headed, sat on the nearest stool. "I should have known he was a freak. I knew guys like that in—"

"In?"

"Juvenile hall." Callie waited for Hazel's disapproval.

"You poor dear."

And there it was. Callie gulped back unshed tears. Someone in the real world, not the private planet of Sophie and Callie, saw the injustice. Someone who didn't know the details and didn't ask for them.

"The guys you met in juvenile hall got caught. Peter's a whole other species—smart enough to be charming, rich enough to fly under the radar."

"Maybe."

Hazel put the sweeper away. "I spent most of the night at the hospital reading up online—so my knowledge is spotty and not that reliable. This much I'm sure of. Not all rapists are the same."

Callie, now overdosed on coffee and emotion, closed her eyes. "Peter has a picture of his sister. He told me he learned to cook because of her. He made it sound like I was the only one who knew."

"Those faux revelations were his protective coloration. His

confidences made us feel special. So we would sympathize if he ever seemed a little off. He counted on us saying, 'Well, gee whiz, that poor fella has been through a lot.'" Hazel's revulsion was palpable.

More pieces fell into place. "The only person he really confided in was Jean, who probably took the photos."

"Photos?"

"I'm sorry. I thought you knew. Peter has photos."

"You've seen them?" Tiny moist beads appeared on Hazel's temple.

"Yeah."

Hazel looked away, raising a hand as if to say she needed a break.

Callie tried to distract herself with class preparation until she became hyper aware that Hazel did not once look at the book she held. Hazel broke the silence. "And it's Coop you really fell for, right?"

Callie fought off the usual subterfuge. "Yeah."

"And you're worried you're not good enough for him."

"With my history, I guess you know why."

"Callie, I love Coop. Miriam was my best friend. But he's not perfect. Neither was she. Right now I'm so mad at them I could spit. How could they have not told me about Alexis?"

"She insisted on confidence. And at eighteen she was an adult." Callie knew how little comfort logic could be. "And Peter terrified Alexis—with threats against your life—she didn't tell anyone until she started seeing Shauni."

"I love the Coopers for respecting her wishes. I love Alexis wanting to protect me. But I'm still angry. Who else has seen these pictures?"

"I'm not sure—they just surfaced recently. Peter threatened to post them on the internet, but I think we'd know if he had."

"Nora. They threatened Nora."

"Not my story to tell." *Have I already said too much? Shit.*

Hazel squeezed her hand into a fist. "I should have known Peter was dangerous. We all should have. I keep blaming Coop for hiring him but we were all fooled."

Despite the fire, Callie felt cold. "Besides blaming each other for things you couldn't have known, what else?"

"Like we all hate hypocrisy, yet we're all hypocrites about one thing or another. Coop always held high ethical standards, but he and Miriam weren't married when Nora was born."

"Official sanctions aren't the same as ethics. They loved each other." How could Callie ever compete with the sainted dead Miriam? "Does Nora know?"

"She knows that much—even has early childhood memories of the wedding. Just assumes they were hippies."

"What's she missing?"

In a seamless narrative, Hazel told what she knew, had heard, and surmised. Despite pride at winning the Rhodes scholarship, Coop departed for England with a hole in his heart. He telephoned Miriam daily, shelling out ridiculous sums for the international phone rates of the time. Miriam discovered she was pregnant a couple weeks after he left and swore everyone—even his parents—to secrecy, fearing he'd give up grad school if he found out.

Hazel continued their story, now as a first-hand witness. "The phone calls made Miriam nervous. She was afraid he'd detect breaks in her conversation, gaps that said something was off. He has an almost eidetic memory so school was easy, but in those days he was completely clueless about emotional truth—and at the same time had great capacity for taking offense."

Callie measured that younger Coop against herself at a similar age. "He assumed she was unfaithful."

"Outrageous, but yes. He tried to catch Miriam with her imagined lover by calling at insane hours. One time she didn't answer because she was fed up. Mad as a wet hen, or in his case, a nineteenth-century cuckold, he took the next Heathrow-to-Kennedy, rented a car, and drove like a maniac, all the while holding hands with his best friend, Jack Beam."

"Jim Beam." Callie knelt to check the drying pages, willing herself not to compare Coop's jealousy with Blake's.

"Whoever." Hazel closed her unread book. "Luckily, it was late and the roads were bad, so no one else was out."

Callie pictured a young Coop, too drunk and angry to care about smashing into someone else. *Been there.*

"Coop pulled into Flambert at maybe three in the morning. He pounded on the door of Miriam's apartment, ranting and slurring. Miriam ran to the door. Terrified that he'd wake Nora, she whispered that he should come back the next morning when he was sober. This just made Coop madder. He kept repeating he knew why she was keeping him out. 'Who is he? Who is he? I'll kill him.' He hammered at the door with both fists. Big man. He splintered the wood."

Callie swallowed. "What did Miriam do?"

"Called the police."

"Uh huh."

"Miriam called me to stay with Nora. I got there about when the police did. My arrival convinced him she was alone in the apartment—though of course he didn't know about the baby. That night I saw Coop cry. I've never seen it before or since. Miriam followed the squad car to the station. Somehow she talked the police into dropping the charges and then drove him to his parents'. For the entire trip, he begged her forgiveness. At the Coopers' front door she told him two things—that he was the only man she'd ever loved and that she refused to see or talk with him until he graduated." Hazel touched a photo of Miriam on the side table next to her. "Nora slept through the night in my arms. She was a lovely baby."

How do people love that much? "Coop must have taken her seriously. He got two doctorates, right? Computer engineering and comparative literature."

"Yes, he really is one of the smartest people in the world. Academics turned out to be the very least of his problems."

"So Miriam raised Nora on her own." Callie tried to imagine Miriam with Nora, but the face that swam to her was her own mother's.

"Don't mistake Miriam for a martyr. Remember, she had a vested interest in his success. She wanted the father of her child to be the best man he could be. After graduation, he rushed here—his parents lived in this apartment before he did—to tell

them he planned to propose to Miriam. Everything was great until he saw that." She pointed to a photograph of baby Nora.

Callie read aloud the words etched into the tiny silver frame: "I love my grandparents."

"If it weren't for the inscription they might have convinced him it was someone else's baby. But with those words, Coop instantly realized he'd been deceived. He went berserk, threatened to tear into Miriam's apartment in Flambert for a repeat performance of the night he got arrested. His parents talked him down and made him promise not to be violent."

Another voice picked up the story. "And I wasn't, *technically*." Coop had entered the apartment without a sound.

CHAPTER 17

All Callie's excuses for prying into Coop's life rose, like bile, to her lips. Hazel, apparently unfazed, hugged him. Without asking, she got him a cup of coffee. "Catch us up. What's happening out there?"

"About the same as an hour ago." He held the coffee cup as if he needed its warmth. "I gather you were reassuring Callie that I am imperfect, male, and have dark secrets."

Hazel poked Coop. "Not so secret." She spoke with a quality Callie had experienced only vicariously through Sophie—the familiarity of an old friend. "It's your story, you tell the rest of it."

With directness that both thrilled and scared Callie, Coop's eyes found hers. "When I got to Miriam's, I demanded that she marry me. I didn't ask. I didn't mention how happy I was that we had a perfect child. I never said I loved her. I just barreled in there like the proverbial bull in a china shop and commanded her to make my child legal."

"And she agreed?"

Hazel snorted. "Miriam?"

Coop snorted in unison. "Not a chance. She threw me out. She told me to go away and come back when I'd found compassion and good manners."

"Miriam must have been pretty tough." *Like Sophie.*

"People often underestimated Miriam." A rueful smile played across Coop's face.

Patting her own generous middle, Hazel interrupted, "She was plump and rosy like a Renoir. Made it easy to miss how sharp

she was and how much of a fighter. She was heartbroken at the idea of losing Coop but knew what she wanted for Nora."

Coop set the coffee cup aside. "Right then I wasn't it."

"*People* underestimated her?" Callie deliberately emphasized that word.

His gaze returned to hers. "Okay, *I* underestimated her. I was twenty-four and a Rhodes Scholar, which, of course, meant I knew everything. I expected my parents to back me. To my astonishment, they both took her side. My mother suggested I needed to reconsider. My father was much blunter. He held honor as his highest principle. He said that my mistreatment of Miriam besmirched the Cooper name. They were both right, of course. But I didn't know it."

Callie nodded. "What did you do?"

"I went winter camping up there." He pointed through the window. "Skiing and the mountains have always been my refuge."

"Did it help?" *Get to the part where you aren't a jerk.*

"No. Skiing usually clears my mind but that time I was too self-absorbed for clarity. I believed all the people I loved had abandoned me. My next stop was Manhattan." He circled the room, lost in his own story.

"Why did you leave New York? Did you get fired?"

"Ironically, no. I became the perfect corporate operator. My superiors loved me because my department was productive and I terrified my staff into hours of unpaid overtime. I was legendary for firing people for my own mistakes." He punctuated his self-loathing with a deep growl.

Sophie's dictum that adversity spurs people to change for the better rang its little bell, but Callie knew it was only half true. "I knew someone like that. So what brought you back?"

Hazel sighed. "His father's heart attack."

"It wasn't fatal but he became too ill to run the school. My parents gave me a choice. Either I could take over his job at about a fraction of the salary I made in New York, or they'd hire a principal."

Hazel looked around at the traces of the Cooper legacy in books and objects nearby. "If he'd chosen the city, he'd be the

first Cooper in four generations to abdicate responsibility for the school."

"So you chose Cooper." Callie loved nineteenth-century-style happy endings.

"Not right away. I was bitter and power hungry. I liked having piles of money. I even got a weird thrill from being cruel." He stretched as if to release a pain deep in his muscles.

Callie stilled herself, not wanting him to see her react.

But he could read her, as always. "You're right. I was revolting. And selfish, and immoral." Cooper's face softened. "Happily, coming back to Cooper saved my life. My father dedicated every ounce of his failing energy to teaching me the job. And how to be a good man, mostly by example."

Hazel sighed. "Coop Senior had endless patience."

"I sneered at his folk wisdom, told him how stupid his ideas were, how boring it was to be here. I threatened to quit almost daily." Coop twisted his fingers through his thick black hair. "My mother was quite capable of running the school but wasn't interested. She claimed it was because she only married into the Cooper name."

"But so did Gwendolyn Cooper." Callie's forehead wrinkled in protest.

As if envisioning some other time and place, Hazel's eyes narrowed. "Mrs. Coop saw Gwendolyn as a visionary. She believed her son was, too."

Coop paced, moving dirty dishes to the sink, squaring pictures that were already straight, and in between returning his focus to Callie, as if measuring her responses with the same precision as aligning a book with others on the shelf. "Given how detestable I had become, it's hard to know why."

"Then you asked Miriam to forgive you." *Bring on the nineteenth century.*

"That took a while. Once I got over blaming her, I couldn't face her. When I finally admitted that I ached to share my life with Miriam and Nora, I was convinced I'd be turned away."

Hazel nodded. "I talked to Miriam every day. She wanted him to step up. Nora was two and a half. Waiting was driving her

nuts. But she was still standoffish when she answered the door." She pulled out her ringing cell.

Coop sat next to Callie and immediately jumped up again. "I began the hardest campaign of my life—courting my family. I had to prove to all of us that I could be the kind of husband and father they deserved."

Callie disconnected from the voices around her. *Are there men who can love?* When her attention returned to the present, Hazel was apparently mid-conversation. "Shauni, promise me she'll be okay in the car." Indecipherable sounds sputtered through the phone. "Put her on." A pause and then fragments of another voice. "Well, okay, but let Shauni drive." Hazel hung up. "Young people scare the shit out of me."

Now Coop seemed in a hurry to finish, to arrive at the ever after. "Miriam and I were married the following spring on Lover's Peak. Local justice of the peace. Hazel drove my father and Nora up the road to the summit. The rest of us hiked up."

Callie sighed. The vision of Coop's romance with Miriam was epic and magnificent but where did it leave her?

His pacing ended and he stood before her. "I needed you to know about my ugly side, though I wouldn't have picked today to tell you." He shot Hazel a sidelong glance. "I'd like to swear to you that those were the excesses of my youth, that I will never again be that man. But honestly, my struggle to be honest and honorable is a daily one ..."

"And Miriam was your salvation." Callie finished his sentence, unable to squelch the familiar warning in her head: *Men can't be trusted.* Why let herself grow so vulnerable to a man in love with a ghost?

Hazel tried to protest, but Coop held the floor. "Miriam didn't save me. I don't believe other people save us. That's our own job. Miriam was a guide and a companion and an example to live up to." He wandered moodily to the window. "My marriage was wonderful and enriching and exciting, but not exactly peaceful. We argued long and loud about things that seem really stupid now. We had a huge fight just before she died. I went to Boston furious and stubbornly self-righteous. I didn't even kiss

her good bye."

"Oh, Coop. I'm so sorry." Callie moved to his side.

"That's so you—I've been talking too much about Miriam and instead of yelling at me, as I probably deserve, you're comforting me. I told you she was someone to live up to, and I mean that. But so are you."

"Hang on a sec." Hazel, apparently talking with Craig but able to follow both conversations, muted the phone. "Listen to him. He's right."

If she really knew my past, she'd tell him to run.

Nora blasted through the door, talking nonstop. "The phone isn't working. Craig wants you all at Admin. Things are crazy over there but we're doing a press conference anyway. I'm really mad at the guys in the Channel 3 van because they drove right over the tulip bed, I mean it's all frozen now but who knows if they might've wrecked it and ..." She spied the pastries. "Wow, can I have one? I'm famished."

After a flurry of coats and gloves, they made their way to the Admin building, accompanied by the officers at the bottom of the stairs, who pushed aside microphones and elbowed through crowds of girls. Hazel spoke quietly to students, promising they'd hear everything in good time. Callie smiled and waved but said nothing. Nora shouted No Comment to anyone who'd listen.

Coop's office was noisy chaos. A television droned news coverage. Craig spoke with Dr. Chen while several paralegals, each with a laptop and a cell phone, seemed intent on gathering information. Police operated a makeshift control center, a card table holding a jumble of communications devices, headphones, and recorders.

Craig took charge. "Oh good, you're here. We have to brief you for the press conference." He gave Callie a statement to read. She was grateful that it was probably too generic and boring to generate sound bites.

"Is a press conference a good idea?" Hazel, ever the Jewish mother, touched Craig's arm, half-caress and half-restraint.

Craig's words got everyone's attention. "This scandal could shut the school down. We have to fight back. The Cooper School

has always been a safe place for girls who might have no other chance at a good education. If we can't change public perception right now, generations of girls to come won't get that chance because Cooper will be remembered only for hiring psychopaths."

"But is it safe now?" Nora looked at her father, the police, and Craig in turn.

The police chief clicked off a walkie-talkie. "I don't foresee any immediate danger on campus. As best we can figure, Frière went to Peter Guy's cabin and took his skis. We have trackers covering all directions. So far we can't find any sign of him, but the day is young. Those mountains have miles of uninhabited woods. Highway patrol is bringing in a chopper."

Coop pulled on a ski jacket. "I'm joining the search."

Nora reached for her coat. "Me, too."

The number of Nos! was uncountable. Coop spoke to Nora in an undertone that Callie couldn't hear.

Nora shrugged. "Alright, but be careful. Don't make me an orphan."

"I know these mountains better than anyone." Coop gathered his gear. Kissing Nora, then Callie on the cheek, he was gone.

Nora squeezed Callie's hand. "Are you okay?"

Despite adequate sleep and overly strong coffee, Callie felt fatigue at the cellular level. She longed to throw herself into someone's arms and wail about how unfair life could be for a girl like her. But she was no girl and laments were useless. And even if Sophie happened to pop back to life, it would only be to ridicule Callie's self-pity. "I'll be better when things get back to normal."

Nora grunted. "Could be a long wait."

A moment later a shout went up outside, accompanied by applause. Hazel was closest to the windows. "Getting shot apparently makes Alexis a hero. Never mind that Shauni's been taking care of her around the clock." She and Craig went to guide the two through the crowd. Callie, Nora, and several others followed them outdoors.

Craig gestured to the reporters. "We're ready." He kept the

press conference short and orderly, focused on the shooting as the lone act of a man who had been completely normal until he snapped. Dr. Chen delivered an official statement, accepting responsibility for the school while pointing out that Cooper had been peaceful for more than a century. Alexis, her coat draped over a cast, sniffled through Academy Award-style thank-yous. Using the blandest, most colorless words of reassurance in the English language, Callie stared into the cameras, implying she had no idea why Jean had chased her. None of it was exactly true or exactly false but it became clear that the press had not learned about the rapes. Neither had anyone uncovered Callie's past. Not yet. After the police chief fielded a few questions, the stations packed up their microphones and moved on.

An hour later they all trooped into the Cooper School gym, the only space on campus large enough to accommodate the entire student body, faculty, and staff. Armed police circled the building while faculty carefully checked IDs.

Questions and concerns from girls arrayed on the bleachers or cross-legged on the floor continued for most of the afternoon. "How long will the police be here?" "Where's Coop?" "Does your arm hurt?" "Did you pass out?" "Can my momma come and stay with me?" "Do we have to do our homework?" "Were you scared?" "Are you scared now?" "Are you okay? Really okay?" Most knew that Peter and Jean were friends and noticed Peter's absence. Craig and the police deflected those observations with words like 'ongoing case.'

The daylight streaming through windows high on the gym wall faded from bright to light to dusk and restless girls began to wiggle and drop things. House parents moved to marshal their charges, while everyone milled around and stretched.

Girls flocked to Alexis and Callie, as if getting close might clarify the incomprehensible. Celebrity status didn't please Callie. Celebrity so easily turned to notoriety. She longed to rewind or fast forward to a place without questions and cops.

The sound of the microphone going live again quieted the crowd. The police chief asked for their attention. "My officers just found Jean Frière."

CHAPTER 18

ean's fate was later attributed to everything from space aliens to insanity. Callie, by contrast, heard Coop's statement to the police with Craig filling in the details Coop didn't know.

After Callie's getaway, Jean, impaired by rage and alcohol, scrabbled after the gun, and then ran down the road to Peter's cabin. With Peter's help, he collected a backpack, camping supplies, Peter's skis, and a bottle of scotch. Jean was probably into the woods before Alexis' car made it to campus.

An expert skier and hiker, Jean had covered every inch of the mountains around the Cooper School over the years. He had long ago built a lean-to in the deepest reaches of Cooper property.

Nora interrupted. "But, Coop, you ski these woods all the time. Why didn't you come across the lean-to?"

Cooper shook his head. "Beats me. Good camouflage, I guess. I've chased away a few teenage boys out for a glimpse of girls in skimpy clothing. And I've made hunters get off the land. But Jean chose an area too treacherous for most people."

During the press conference, he explained, the search party fanned out across the woods, silent in the deep snow except for the occasional squawk of a walkie-talkie, a necessary tool in the mountains where cell phone reception was spotty at best. Jean had a twelve-hour start on them and covered his tracks. The search seemed hopeless to more than one young officer in inadequate long underwear. But Coop never considered giving up.

As the light faded and the searchers spread into ever-widening

circles, Coop moved toward the mountain behind Callie's cabin. Lover's Peak. For a moment the only sound in the room was the court reporter asking Coop to spell the real name of the mountain.

Coop went on. "An area with little caves fascinated me as a boy. Hard to get to, even in summer. Particularly treacherous in the snow. The climb was tough. Icy. I was about to turn back when I saw the sunset reflect off something—turned out to be an empty scotch bottle. Despite last night's storm, it was clear of snow. I knew it hadn't been there long."

He demonstrated how he had quietly reported his finding into his walkie-talkie, then turning off the device so it couldn't alert Jean to his approach.

"The officers heard Coop's transmission as static. Didn't know it was Coop or understand the message." Deep creases in Craig's dark face, usually so controlled, revealed affection for his long-time friend.

Coop said he moved as quietly as he could, mindful that the area had several precipitous drop offs, and that the caves faced over a deep ravine. Soon he could hear Jean, apparently preparing to hide at the lean-to until the search abated. Although Coop had no firearm, he counted on negotiating the terrain better than an inebriated lunatic who hadn't eaten or slept in twenty-four hours. Shedding his skis, Coop proceeded on foot.

Callie needed details. "If the cops didn't know where you were, how did they find you?"

A young officer responded. "We knew his approximate location. When he didn't check in, we told the chopper to look for his orange vest. After that it was flyover and triangulation until they saw him. Those walkie-talkies have GPS receivers."

Coop, though no doubt exhausted from the ordeal, didn't flag. "Frière's back was to me and he staggered a little. When the copter came over, he stumbled toward the caves. I laid low, waiting for backup, but I think he saw the vest. Next thing I knew, he was shouting at me. The copter was making so much noise, I couldn't hear his exact words, but it sounded like bragging about his weapon." Coop imitated Jean's accent. "'Thees

Theis ees a Smeeth and Wesson, *Monsieur*, a .357 Magnum.' Then he started firing."

Even with Coop right there and safe, the words reawakened Callie's fear. "Holy shit." Nora said almost the same words simultaneously.

Coop recounted his dive for cover behind a tree. "I thought it could be all over. In the next second, I felt rather than heard the police behind me. I wasn't sure until someone spoke on the bullhorn."

"What did they say?" Nora seemed intent on gathering all minutia.

"Who knows? To me they said, 'Today's not your day to die. Your child will not be an orphan.'" Coop squeezed his daughter's hand.

The young officer smiled proudly. "We said, 'Police! Drop your weapon!'"

"But it was Jean's day to die, wasn't it?" Callie spoke quietly.

"An accident, ma'am. When he heard us, he got confused and turned around. He still held his weapon, so ours were trained on him and we all kept our distance. We saw him jerk his arms like he was trying to get his footing. Then he was gone."

His account was punctuated by gestures meant to illustrate police work that reminded Callie of a bad game of charades. Officers repelled down the ravine in chase but Jean was no longer running. Or breathing. Searching the cave and recovering Jean's broken corpse required dozens of officers and as many hours.

"But he said he was an excellent marksman." Callie noted that in two days of shooting, he had only hit one target and Alexis had lived to tell.

The young police office seemed ready to explain more than anyone wanted to know. "You can point a revolver at a person fifteen feet away, get them in your sights, haul the trigger back, fire, and miss because your finger isn't in the exact right location. At your house, he was distracted by the raccoon. Then he fired repeatedly at the car. Pythons tend to go out of alignment with continued heavy shooting. By the time he got to the caves, his gun didn't fire correctly, it was dusk, and he was almost too

drunk to stand. Bad combination."

A few more clarifications and the court stenographer packed up her gear. Craig called Hazel, who arrived in a flurry of talk, insisting that the Coopers and Callie stay in Flambert. They got to the house well after midnight, but no one seemed inclined to go to bed. Hazel served cognac in crystal goblets, settling herself on the floor with an oversized knitting bag.

Craig continued the story they hoped the press would never know, the story of Jean and Peter, pieced together with help from Alexis' research. The two men met in prep school. Friends through their Ivy years, they partnered in business, managing hedge funds that made them both exceedingly wealthy. Outwardly they appeared quietly philanthropic, giving generously to good causes, even the Cooper School. Their gifts gave them social standing in their immediate communities, but they stayed anonymous as far as the general public was concerned so garnered very little press. Jean took time off to become a professional race car driver while Peter attended culinary school, grad school, and so on. Meanwhile they pursued their real passions. Stealthily, they burrowed into locations with lots of young women. And when accusations and suspicions arose, they simply moved on—sometimes together, sometimes separately but always reuniting. And within months, all records of those suspicious activities disappeared from the internet.

"Peter is a genius at breaking into secure records." Alexis hugged her knees. "But I'm better. I found plenty, though some of my searches weren't exactly kosher."

Craig interrupted, raising a palm. "Don't want to know about it."

"But with Peter's looks and money, he could have found girls anywhere." Callie ticked off a list. "The fashion industry, the stage, Hollywood."

Hazel's knitting needles clicked. "Let Craig tell the story, dear, or we'll be up all night."

"They weren't playboys, they were predators. They wanted to be out of the public eye." Craig's skill as a litigator was evident in his hurry to offer a counter argument. "Peter and Jean were quite

young when they recognized the sociopath in one another, Peter always the dominant one, the planner. As teenagers he figured out how they could cover for one other, providing increasingly elaborate alibis." Craig gestured with his snifter, and the golden brandy swirled elliptically, drawing the light from the fire.

Nora reached for a glass of cognac, eliciting a quick No from her father and a remonstrance from Hazel. "We don't serve alcohol to anyone under twenty-one."

"The law sucks. I vote. I could be drafted." Nora settled for a Coke but continued mumbling about the unfair plight of an eighteen year-old.

Alexis laughed. "Wrong house to disparage the law."

"Alibis. For assault on vulnerable young women. Girls." Coop touched his daughter's shoulder. "I should have seen it. I should have protected you. All the girls." He directed his next words to Alexis and Hazel. "I still wonder whether I could have stopped him by insisting that Alexis reveal who raped her."

Hazel sat on a cushion on the floor, intent on a knitted concoction that looked like no garment Callie had ever seen. The older woman didn't look up.

Alexis sat next to her mother, caressing the soft woolen sculpture. "Miriam tried. She visited me every day in the hospital and at home for weeks, always gently trying to pry. Peter visited too. It was sheer torture to have him in the room. When we were alone he said he'd murder my mother and make it look like an accident. No way I'd tell."

"Me either." Nora tilted her head to her father. "After Peter attacked me, he said he'd put Dad in jail and ruin the school. I couldn't let that happen. It was bad enough losing Mom to that monster."

Alexis looked directly at Nora. "Part of Peter's game was figuring out how to keep us silent. He could hurt us and then make us feel like accomplices."

"And Jean?" Callie took a tiny sip of the cognac.

Craig looked through the police reports for an answer. "We know he took the photos. Which, by the way, haven't been found. I don't think we know the extent of his perversity yet. We

do know he was desperate to shut you up—thought you knew something that could expose him. Any idea what?"

"Maybe it's in Nora's papers." Callie pulled them from her backpack and passed them around. Everyone dove in. Thirty minutes later, Callie found the missing piece. "Hey, it says here the police questioned witnesses after Miriam's accident and one of them was Jean."

Nora snatched the report. "What was he doing at the motel?"

Alexis sighed. "Probably taking pictures."

Coop looked from face to face. "Why didn't he leave before the cops arrived?"

Finally, Callie said what nobody else would say aloud. "He didn't have time."

"Oh, god." Nora covered her mouth.

Alexis finished the thought with a wave of her brandy glass. "Because he had to fix whatever he screwed up in Miriam's car, whatever he'd done to cause the car to go out of control."

"No evidence at this late date, though it's certainly plausible," Craig spoke while he read, "but what made him crazy yesterday?"

Callie hopped to her feet, her heart pounding. "The computer book! A how-to manual I borrowed from Peter. Last night when Jean was screaming at me about *le livre* I had no idea what book he meant."

Craig put a finger on his page to mark his place. "Where is it now?"

"Not sure. I had it the other day but it's not in my backpack now." Callie felt small and silly. The most important link to truth and she'd lost it.

"Got it." Craig snapped his fingers and rummaged in his briefcase, then thundered out of the room, apparently headed toward his upstairs office. Everyone was asking everyone what he meant when he returned, book in hand. "I asked for it after the fisticuffs at the hearing."

Nora looked at the book spine for the title. "Big deal. Most of the campus has a copy of that book."

"I have to tell the chief." Craig grabbed his cell and dialed.

Callie asked if she could look through it and followed

precautions to prevent obscuring fingerprints. She was shaking. *For this I almost died?* She turned the heavily highlighted pages and skimmed Peter's margin notes, apparently geared to lesson plans. Odd groups of numbers and random letters appeared here and there. *Maybe he taught software coding?*

Craig set his cell down on a side table. "Police on their way."

The police heralded another hour of questioning, this time at the Landers' dining table. Craig smoothed the way, stating that Callie had overlooked the information in the excitement of the past two days. The officers departed with the book in a plastic evidence bag.

Hazel bustled around, handing out linens and towels. "Nora and Callie, the guestroom. One real bed, one inflatable. Coop, the couch."

Nora and Alexis exchanged glances that suggested the room was full of fogeys more ancient than the hundred-year-old house. "I'll bunk with Alexis. Let Callie have the guestroom."

Assuming they needed private time, Callie acquiesced and within minutes was sitting on the guestroom bed peeling off her clothing. Sounds of the household settling in for the night drifted through the door. Just as she seemed to be the last one awake, she heard a soft knock.

"Come in." Callie wondered if Nora had changed her mind. She pulled a comforter over her mostly nude body.

Coop stood on the threshold.

Desire trumped misgivings and she waved him in.

He closed the door behind him and without speaking, sat beside her on the bed. Lips to lips, chest to breasts, hands to back.

Callie shrank back, pulling her knees up to her chin under the comforter. She whispered, aware that people were sleeping nearby, "You're my boss."

"I considered letting you go, but it seems a little extreme just to get a date." He grinned at his own joke, lightly caressing a hand she had forgotten to hide.

"I'm serious. There are already rumors and we aren't even lovers. A real relationship could be a disaster for you. For the

school." Her body rebelled against her words.

"Are you in love with me?"

On the brink of the hardest confession ever, she closed her eyes. "Yes."

"Look at me. What do you want?" His black eyes revealed his own answer.

"Of course I want you. But I'm not right for you. You overcame the adversity in your life. I didn't ... Some things can't be overcome." She remembered the cry of the Cowardly Lion as he offered to go into the Wicked Witch's castle: Talk me out of it.

"Go back to the part about being in love with me."

"Don't joke. I'm not like you. I can't get absolution for things that give me nightmares." *Truth or wall?* She didn't know.

"But you want to." He kissed the inner crook of her elbow.

"Yeah."

"And you know I'm in love with you, too." He gently massaged her shoulders.

The touch radiated to every pore. "I guessed."

"The school doesn't have a policy against consenting adults falling in love. Do you?" His head against hers, he breathed into her hair.

The moment belonged to Callie. He would do as she asked. If she sent him away, he would go. She had never felt that power with a man she cared about. She had never cared like this. "I think I'm having a regime change."

Somehow the act of stifling their laughter was a catalyst for more intense lovemaking than Callie thought possible. Clothing pelted the floor. Callie didn't feel the house cool to its nighttime temperature, nor could she hear Alexis murmur, "That plan worked" or Nora's retort, "Finally. Now, turn up the radio." Callie sensed only Coop.

Sometime later, she lay against his shoulder. "We should sleep." They did not sleep.

His was the next protest. "We'll be useless tomorrow if we don't."

Still later Callie traced the muscles on his chest with her palm.

"We can't honestly deny being lovers anymore."

He sat up with the easy grace of an athlete. "Do you want to?"

"Pardon?"

"Deny that we're lovers." Coop's back straightened as if preparing for a blow.

"It would be better for you."

"It would be a lie."

"In service of the greater good." She hated lies. Why defend them?

He spoke to the wall. "Bullshit."

"I don't want to get you in trouble."

"Too late." He rolled into her embrace. Moon and stars rose and set. Holding her, he murmured sleepy words of affection, drifting off.

Callie dreamt of trains. A locomotive in an old-fashioned Western raced across a dusty plain, steam pouring from a smokestack against an unnaturally blue sky. Instantly made miniature, it circled madly on a tiny bed of plasticine mountains dotted with stiff evergreens the size of moustache combs. A glittery yellow sun. A toy station complete with newsstand. A luxury car driven by a fine gentleman who wasn't quite the right scale. Callie was half aware that the chugging train sound followed the meter of Coop's heart.

Then she was awake and knew what she had to do.

CHAPTER 19

"C oop, wake up. Get up." Callie was on her feet, struggling into her clothing

He protested sleepily and rolled over. "What's wrong?"

She threw his clothing at him. "The book. I know why Jean wanted it!"

She banged on Craig and Hazel's door, quickly explaining her theory. Craig made phone calls. Hazel made coffee. Alexis and Nora packed toast and fruit into paper bags. Within a quarter hour they were idling Alexis' old car within sight of the Flambert train station.

Thanks to Craig's call, a squad of Flambert's finest had assembled around a corner.

Craig waved over the police chief. "News?"

"Nothing. Could be a wild goose chase. But just in case, move your car out of sight." A practiced eye might have spotted the chief's Ford as an unmarked police car, but with any luck it wouldn't be obvious to someone in a panic. They waited.

About an hour later, a sleek gray Porsche glided up the street. Peter scanned the street as he drove. He pulled close to the back door of the station and looked around as if searching for security cameras. Finding none, he pulled out a crowbar. For a man in a four thousand dollar leather coat, he proved remarkably efficient at breaking and entering. Within moments he was inside.

After a stern warning to Callie and company to stay back, the chief and his officers quietly followed Peter into the station. Callie and the others crept to where they could hear. At first the

only sound was metal on metal, accompanied by cursing in English and French. They learned later that Peter had gone directly to one of the station's larger lockers, the ones that required customers to provide their own locks. His was a custom-made password-plus-combination device more appropriate for a safe or a vault. Apparently lacking the necessary codes, he tried breaking the titanium lock. He was prying at the door when the lights went on.

"Put down the weapon," the chief's voice was distorted by a bullhorn.

Peter never lost a trace of his imperious manner. "So sorry about the damage. I'll pay, of course. I need some papers from my locker for a business trip."

"Crowbar down. Now."

Callie's group crept to the broken-down doorway. She could make out Peter hesitating amid the clicks of arms taking aim. With a graceful shrug, he let the tool fall. It clattered to the tiled floor in symphony with a recitation of Miranda rights and the snap of handcuffs.

Alexis and Nora tittered.

Alexis rolled her eyes, imitating Peter. "I need business papers." The chief glared at Coop. "I told you to stay out."

Coop raised both hands in a 'what me?' gesture.

"Crime scene. Stay there." The chief pulled on latex gloves. Police photographers and videographers recorded each moment.

Callie nudged Alexis. "Don't you work with these guys? Find out if they decoded the combination."

"I don't think they care. They can just take the door off. You did the big work—figuring out that Peter would come back. Then they just had to wait for him to show."

"The first time I met him he went into the station saying he had to pick something up and returned empty handed." Remembering that day, Callie flushed.

Nora leaned on her father. "He musta done that a dozen times and I never caught on. Criminey, why does he need so much storage?"

"Criminey?" Alexis tittered nervously.

A cheer from those working indicated that the locker door was off.

"What's in there?" Nora tried to see around the chief, though he was several yards away, blocking the locker.

Callie took Nora's hand. "I expect it's his trophies."

Nora seemed rooted to the floor, face colorless, shoulders hunched—a stark contrast to the busy anthill of impersonal evidence-gathering. While Coop kept an arm around Nora and Callie and Alexis buried her head in Hazel's shoulder, officials rolled yards of plastic sheeting over the tiled station floor. Officers methodically removed items from Peter's locker, one by one in numbered rows, taking notes and photographs and dusting for fingerprints.

Items passed from locker to officer to plastic. "It might not be there." Callie reached to caress Nora but Coop shook his head to stop her.

Nora spoke without turning to them. "I need to know if he had it, or if it was just lost." Coop wrinkled his brow. "Had what?"

Callie spoke reluctantly. "The ring Miriam gave Nora for her birthday last year." She caught something in his eyes she'd never seen before. Tears.

The Flambert police department's scant experience with major crimes materialized in the 'oh wow' responses that kept tumbling out. The chief scolded them while he barked a steady stream of orders into a cell phone, dispatching men and women to various tasks. He snapped at Alexis, "We could use a hand here."

Alexis nodded to her boss. "Whatever you need, chief."

Craig looked as put together as a distinguished member of the Black Caucus rather than someone who'd been rousted out of bed. He spoke with authority. "There might be a conflict of interest." He and Alexis exchanged looks. "Stay away from the evidence."

When the chief crooked his finger at Alexis and Craig and led them to a corner where they couldn't be overheard, Callie's attention returned to the locker, arranged with the same cold

elegance as Peter's cabin. He'd stacked equal-sized plastic storage boxes, apparently color coded. The ones with blue lids revealed dozens of photo CDs and DVDs labeled with first names. Red lids unveiled intimate garments, some torn and bloody, each in its own freezer baggie. Green lidded bins bore tiny trays of earrings, necklaces, and rings. A macabre jewelry box.

Hazel shivered despite her coat and boots. "Let's go home and let the cops work."

Callie longed for escape from the relentless step-snap of police voices and flashbulbs. She wanted time to mourn for every victim whose personal belongings were so coldly arrayed and classified. But Nora couldn't leave the steady stream of items making their way to their plastic resting place. "No chance." Her voice broke so Hazel didn't insist.

When Alexis returned, she announced her assignment was to keep their group "awaiting questioning as material witnesses." The police taped off their work area and Alexis led Callie and the others to a bank of wooden benches near the ticket booth.

Craig explained the procedure. "If they find Peter's fingerprints, they'll arrest him. Right now, they're calling him a person of interest and holding him for questioning. He won't talk without his attorney, who's due to arrive this morning from New York City." Craig looked at Nora. "Your testimony will be crucial."

Nora lay on a bench, her arm cradling her head, her words muffled. "Looking forward to it."

Callie sat by Nora, hands in her lap, accepting Coop's earlier remonstrance that the girl might not like to be touched.

Nora lifted her head again. "Alexis, can you see if something's there?"

Alexis asked Nora for a description and took detailed notes which she passed to an officer. "It'll take hours for them to catalog everything. The chief just invented the material witness thing so you could stay. Maybe we should go home and get some sleep. Y'know, I have a dog in this fight, too. That's why I have to stay with you. I wonder if this collection of stuff goes back far enough to include me."

Hazel appraised her daughter, as if seeing her as an adult for the first time. She hugged Alexis, murmuring praise and affection. "You're amazing."

Alexis held her mother close. "Funny, once I told you, the pain began to subside, as if all I ever needed was Mom saying it would be okay. And it is, you know. Fine. Just as long as you don't feel guilty."

Hazel caressed her daughter's cheek. "I can't believe you kept your secret to protect me. Let's never do that again."

"Deal." Alexis smiled. "In the spirit of honesty, I think you and Craig should get everyone out of here. We're going to need you functioning on all cylinders. Right now there's nothing to do but wait."

Clasping his hands behind him, Craig rocked back on his heels. "She's right. Come back to our house and get some sleep."

Coop spoke for the first time since learning about the ring. "Gotta find something to do. I'm going out to the school."

"I'll go with you." Nora struggled to a sitting position.

"I should probably teach. That would help the girls." Callie looked to Coop and Nora for protests, but neither disagreed.

An hour later they found the only remaining police presence at the Cooper School to be a pair of officers patrolling on foot. The press seemed to be gone, though Callie couldn't shake her fear of their return. She couldn't concentrate or even remember what she meant to teach. During a five minute break alone in her classroom, she sent Sophie a mental telegram. "Help me. I just have to get through today. Just today." Callie clung to her chalk as she paced the classroom, hoping to restore normalcy.

The girls straggled into class. Bright students answered in distracted monosyllables or stared out the windows. Some didn't show up at all, a rare occurrence at the Cooper School. A couple of freshmen hovered by Callie's desk but couldn't express what they wanted. Shauni lingered after the others left. "Alexis says you saved the day."

Callie slid papers into her backpack. "If I have to give up teaching, maybe I can get a private detective's license. Or take up dream interpretation."

"Not following."

"I got the clues in my sleep." Callie yawned. "Sleep. Now there's an idea."

"Don't even joke about quitting." Shauni watched Callie sling the backpack over her shoulder and reach for her overnight bag. "Let me carry something." The eighteen-year-old shouldered Callie's bag.

Callie was too tired to converse during the slow trek to the cabin. Just before the cabin came into view, the pounding of hammers disrupted the crunch-crunch of one foot in front of another. A curse escaped her, despite Shauni's presence. "What the fuck? Now what?" Parked on the road were Nora's bus and a blue pickup with a painted logo for a glass replacement company. As Callie and Shauni arrived at the front door, Coop and Nora emerged from the cabin, full arms loaded with debris from the broken window.

Nora wiggled a finger in greeting. "Damn. I was hoping to be done before you got back."

Thinking *What?* Callie nodded because that took the least effort among possible responses.

"The glazier's almost finished." Coop loaded bags of trash onto the bus. "I'll get firewood." He strapped on Callie's snowshoes and was into the woods before she could reply.

While thanking Shauni and Nora, Callie's befuddled mind obsessed on how little Coop had said. *Rejection? Men!*

Shauni set the overnight bag on the porch. "Hey Nora, could I get a ride to campus?"

Nora laughed. "Sure, lazybones. Get in."

Shauni raised her eyebrows in joking reproach. "Me lazy? You're the one who drove up here. I walked. Carrying heavy stuff."

"Time for a pity party." Nora offered an exaggerated *moue.* "I win. I was up all night."

Shauni climbed onto the bus steps. "Slut."

"You're just jealous." Nora plopped into the driver's seat. The two young women waved to Callie as the bus pulled away.

A wiry little man in a work shirt and tool belt came through

the door. "Good as new. Oh, hi. Where's Coop? You must be Ms. Franklin." He extended a calloused hand.

Callie shook his hand. "What do I owe you? Coop'll be back in a minute."

"Cooper School has an account. Triple glazed windows ain't cheap." The man began loading his tools into his truck. "We replace a couple every year. Branches through the windows or y'know a baseball or somethin'. First time for gun shots, though. Coop and Nora cleaned up pretty good, but you might be careful on bare feet for a day or two."

Callie heaved her belongings through the door while he continued. "Some people think it's dangerous out here. Y'know—the girls aren't the right sort, colored and foreign and all, and now with the shooting. But I never had no problems."

Callie's inner voice screamed, *Get lost*, but aloud she was noncommittal. "Lucky." *That I don't knock you down.*

"Thanks, Joe." Coop appeared through the trees with the log carrier full of firewood. He stacked logs as the blue truck departed. The roar of the gunned engine and the smell of fuel hung for an instant in the air. "This'll only take a minute. You look beat."

A trail of backpack, jacket, boots, sweater, and jeans marked Callie's progress to the bedroom. Her next conscious act was lifting her nose to the tantalizing smell of coffee and opening her eyes to a rosy fingered dawn worthy of Homer. Coop's distinctive scent hung faintly over the other pillow, where his head had left an indentation. "Coop?" She couldn't hear him and was afraid for a moment that he had again left her with a brew and a note.

"Yes, sweetheart?" He appeared at the door, steaming mug in hand. "Coffee?"

Sophie used to say you could tell that someone really knew you when they knew how you took your coffee. Either Sophie's wisdom was tainted by her caffeine addiction or she was on to something.

"You're a treasure." Callie pushed herself upright. "Did you get any sleep? What time is it?"

His black hair, wet from a shower, lay plastered against his head. She couldn't remember when she'd last bathed. She flushed, wondering how bad she smelled.

He picked socks off the floor and sat on the bed next to her, pulling one on. "About five-thirty. Plenty of sleep. Not enough sex." He shot her a playful glance over his shoulder, arching an eyebrow.

"We could fix that. If—"

"If?" He pulled a condom from his pocket as if trying to anticipate her concern.

"If." She made a face.

"You smell great. You smell like you."

Giggling at his mindreading, Callie set the half empty cup on the bedside table. "You put your socks on now, after walking on glass shards?"

"The glass is gone." He reached for the sock he had just put on and pulled it off.

He smiled playfully until she kissed him. She no longer feared his judgments. His anger and coldness, so often present, was gone— for now. Men generally puzzled Callie, though desire sometimes overrode reason. *Ergo Peter. Don't think about the unforgiveable. Feel, Callie. Feel your body respond to Coop.* Never before had she felt sex as communication, sharing. Never had the moment of a man entering her body felt so much like a joining, so little like an assault. They moved together, at first playfully and then so easily, finally so intensely that she cried out, then sobbed.

He lay with his full weight on her, his large solid body a warm enveloping quilt. "Don't cry, honey."

"I can't help it." *Sobs.* For one fleeting second she wondered if he missed her wisecracking and self-sufficiency, now a creature who would soon weave a blanket from his hair or hang stars in his name or—""Does it bother you? The crying?"

"Are you sad?"

"Not at all."

He held her hand. "Has this happened before?"

"No." She wiped her eyes with the edge of the sheet. "Never felt safe enough."

Lazily entwined, they watched sunlight fill the window. Now she could smell the cold coffee, his sweat and hers, the sex in the air. She dozed. About an hour later, her alarm sounded its normal wakeup call. "Take a shower with me." She shimmied out of bed and winked at Coop who watched; his own body uncovered, arm bent at the elbow, his hand propping his head.

"Hell no, the view's too good from here. Besides I can't afford to get distracted."

"Distracted. I see. So sad that you've already lost interest." She snapped a towel at him and sashayed into the bathroom.

They raced through dressing and tore down the road, arriving at their respective offices just before class. Callie turned her mind to teaching, terrified of possible missteps.

Words could save or scar.

CHAPTER 20

allie's first words to her students were simple. "The shooting." She asked two volunteers to write on the blackboard. She directed the others to yell out whatever came to mind.

The girls hesitated at first. Then someone spoke quietly, "Scary."

Callie told each girl at the board to write 'fear' or 'scared' in any lettering and any size.

"What if the school closes and I have to go back to foster care?" The student who spoke now was one who rarely participated. A heavy unkempt girl with loose, nondescript clothing, she held her books tightly, as if someone might yank them from her hands.

The girls at the board needed no more direction. One wrote 'foster care' and the other wrote 'school closed.'

Callie mentioned other emotionally charged moments. 'Jean's death.' 'Alexis's wounds.' She omitted only one subject: Peter. The girls didn't seem to notice. The responses came faster than the two girls could write. A third and fourth girl joined the two at the board until all ideas were exhausted. Then Callie asked each student to draw colored chalk lines connecting words that had a kinship for them. Soon the board looked like a spider web. Toward the end of the hour, Callie asked the students to evaluate the exercise.

A tiny redhead raised a hand holding a pen festooned with an iridescent aqua fur ball. "At first I thought it was all about right answers and everything. Then it looked like there wasn't any

right answer. I don't like what Jean did but I wish he coulda gone to jail."

"That's stupid. Jean was a criminal. I'm glad he's dead." Dark braids cocked toward the redhead in a challenge.

Is it okay to allow students to wish someone dead?

Another girl slammed a book against her desk. "Shut up. She can think what she wants." She pulled out the world's tiniest pink Swiss Army knife and waved it in the air.

Callie grasped the hand holding the knife and slid the item into her own jeans pocket. "You may recall that the school has a rule against weapons."

A small uproar of voices protested that the knife wasn't really a weapon, since it couldn't do any harm. Callie considered telling them ugly stories of juvie, where so-called non-weapons had punctured arteries. Instead, she asked if anyone disagreed.

A girl with a Puerto Rican flag on her jacket and another on her backpack murmured inaudibly. "A guy next door to my house in Queens threw a little sharp rock at a stray dog and it hit my brother Tony in the eye. He bled out before the ambulance got there."

The girl who had held the knife apologized. "It's so little, I thought of it like decoration or something but ... am I gonna get suspended? My mother'll kill me."

Callie made a snap decision. "Not today. But I never want to see another weapon in my classroom again. Understood?"

A ripple of yeses.

Callie appraised the blackboard with its Pollack-like design. With well-practiced false confidence, she stepped among the desks, trying to gauge body language. "Anyone else?"

A girl who had giggled all the way through the discussion, passing notes to her neighbor, sat up and pointed at the board. "It's like a roadmap. You can start anywhere and get anywhere else. So maybe I was real mad and somebody else was real sad but we could both take the road over to the other thing."

"Right through foster care." Almost everyone laughed.

"Ms. Franklin, Callie, is the school going to close?"

Callie saw the United Nations of faces, all stricken by the

question. She wished Sophie could whisper the right answer in her ear. "Honestly, I don't know. The school doesn't depend on tuition or government money, but it needs its reputation. I won't lie. I see rough times ahead." She wanted to gather them all in her arms but instead she wrote 'rough' on the board.

"Like what?" The girl who asked often read graphic novels in class instead of paying attention. She had tattoos on every visible part of her body.

Derisive snickers. "What planet are you on?" "Retard." "Jeez."

Callie clapped her hands for silence. "No name calling, please. Someone give a real answer."

An African American girl in a pale blue Yale sweatshirt and matching blue boots bounded up to the board. She grabbed a pointer to emphasize her observations. "Look—it's all up here. Jean shoots at Callie. He also fires on Hazel and whazzername, Hazel's daughter. He falls off a cliff. What kind of school will they think this is?"

Callie knew the girls were missing key parts of the puzzle, particularly Peter's role. She was in a quandary—if she revealed Peter's criminality would it help? Another of his victims could be right here in the classroom, not ready to reveal her secret. Craig had said to talk with no one, but Callie rarely followed rules when she considered her own instincts better. "How would you answer?"

"This is the best school in the world. Jean was a freak, but he was just one guy. It's not like those Catholic schools full of bad priests." The student who spoke wore a small gold crucifix.

"Yeah, we told those reporters that we didn't feel scared, we felt lucky."

Callie let each class continue testimonials until the time was up. At the end of the day, Nora appeared at her classroom door.

"Come to our place. Peter's out on bond and Coop's worried."

CHAPTER 21

A larger police presence had returned to campus. An officer greeted Callie and Nora, scanning the perimeter of the campus with binoculars, a rifle slung over her shoulder. Her partner, also heavily armed, spoke into a walkie-talkie repeating 'yes sir.' Callie and Nora walked between the two, military style, until they arrived at the Coopers'.

Several students in the first floor dining hall greeted Callie. She longed for that idyllic past when she could gaze at the mountains and have no agenda more important than teaching Jane Austen to inner-city teenagers.

The aroma of roasting meat teased Callie's senses back to the present as she and Nora mounted the stairs to the Cooper residence, offering to bring plates to the officers now posted at the bottom of the steps.

Nora yummed aloud. "This should be a great meal. Coop always cooks up a storm when he's upset. And man, is he ticked at that judge who let Peter go."

The prediction proved to be an understatement. Coop had apparently emptied all his anger into chopping and peeling. The results were an array of dishes deliciously new to Callie. Shutting out thoughts of Peter, Jean, or semi-automatic weapons, she followed a rule she learned from Dr. Chen: To appreciate a meal, limit table talk to recipes and preparation, offering one extravagant compliment after another. "You'll teach me to make this cake, right?"

Coop seemed to appreciate the diversion. "If you're willing to sift flour and caramelize sugar, sure."

After Nora loaded plates for the guards and handed them out the door, she poured tea. "Lovely culinary *blah blah,* but don't we have stuff to deal with?" She sat by the fire, gesturing for Callie and Coop to join her. "Did you fire Peter?"

Coop sat in an armchair, his large hand wrapped around a mug. "Craig advised me to put him on paid leave. We informed his lawyer. Got someone to cover his classes. That reminds me— I'm planning to hire Shauni to coach hockey."

Nora seemed pleased. "Good."

Callie cleared the table. "Why Shauni?"

"She was our star until she quit the team last year." Coop stared into the fire, as if watching the past in its embers.

"Cuz that asshole raped her girlfriend." Nora poked at the fire, causing tiny sparks to rise and fall.

"Shauni as coach is a win-win." Coop frowned. "We can use the year to figure out what to do with the hockey program and she can save for college."

Nora half coughed. "If anyone can save the hockey program."

"What are you talking about?" Callie knew she was missing something.

Coop paused as if determining what to share. "Most of his victims over the years were on the team." He dropped his head into his hands. "So many flags." Coop ticked off on his fingers, "The rules never applied to him. He never turned in his grades on time, found excuses not to do things he found boring. With the exception of Frière, he had no friends, though most people were charmed when they first met him. Blamed others for his errors. Was the king of starting insidious rumors."

"He told me Nora was a drug addict, which he knew was a lie." Callie watched Nora clench a fist. "As long as we're talking about firing, what should I do? Quit for having an affair with my boss?"

Nora and Coop spoke simultaneously, one word each. Coop's was "Affair?" Nora's was "Dumb."

The familiar desire to run overwhelmed Callie. *California, say. Nice and warm. And far.* "Think of the tabloids." She wrote headlines in mid-air, ending with exclamation points. "School

shooting reveals sex ring! Teacher in bed with principal! Talk about the appearance of impropriety. It will be a miracle if any students stay."

"Dr. Chen says the calls and emails are running about ten to one in support." Nora chuckled. "We even got some telegrams— I'd never seen one before. Most girls want to stay. A few have already left, but only a handful."

Callie waved off too much good news. "Nobody knows about us yet. When they find out—"

Though Nora was still talking, she apparently heard Callie. "Yeah, right, they'll be way more upset with two favorite faculty than with a child molester."

"We're doing our damnedest to keep Peter out of the news." Coop's deep voice made it sound doable.

"Yeah, because it's so easy to keep secrets with the national news nosing around." Nora nudged her dad. "Tell her about— you know."

Callie looked from one to the other. "What?"

"Dad talked with the Lieutenant Governor."

"Really?" Callie kicked herself for being impressed.

"One of his early conquests." Nora grinned. "Before Mom."

Coop rubbed his hand on the arm of his chair in mock sensuality. "I was eight, I think. She went to Cooper. My babysitter."

"Oh right." Callie remembered seeing the Lieutenant Governor's photo on the school website. "A Cooper School success story." Callie thought again of the painting of Gwendolyn Cooper in Coop's office—mountains dwarfing a small courageous woman. She wanted to be on Gwendolyn's dream team—guiding girls over the difficult terrain of high school and into a bright shining … She shook herself. "What did she say?"

"That the public has a short memory." Coop shrugged.

Callie sighed. "Wrong. Once a scandal always a scandal. I had to change my name back to Franklin and virtually disappear."

Nora choked on her tea. "Back to Franklin from what?"

"If you marry me, in about thirty seconds no one will care that we had sex out of wedlock. She offered to officiate." Coop's arm

circled Callie's waist.

Nora groaned. "That is the lamest proposal I ever heard."

"Hey, Callie asked what the lieutenant governor said. I'm just the messenger." Coop nuzzled Callie's neck.

"Oh grow up. In case anyone cares, I'm. Going. Up. To. My. Room." Nora barked one word per stair as she stomped to the third floor, stifling a laugh.

After watching Nora's ascent, Callie breathed deeply and silently stacked the dishwasher. Her mind tripped like a pinball machine—lights, bells, images, random flashing and dinging.

Coop took a dish out of her hand and set it on the counter. "I can think of worse reasons for a wedding."

Good as the kiss was, she pushed him away. "We met a few months ago. If I were a car you could still get repairs under the original warranty."

"Callie—now is the time for honesty. If you don't want this relationship, tell me." For once, his black eyes were unveiled, telegraphing hurt.

"I don't know." Callie stepped back and poured herself a glass of wine.

Coop stayed at the counter. "You know what you want."

"I don't trust what I want. I wanted Peter. I wanted Blake to die. I'm seriously damaged."

"Seriously damaged is the new normal. But when you and I get derailed, we switch the tracks. We don't rape and murder." He moved closer in precise increments but did not touch her. "I need an answer. What do you want?"

The red wine in Callie's glass caught the light allowing her to focus. "I still want you. Just like yesterday. And a lot of days before that. And no doubt, tomorrow." She passed her glass to him.

He drained it. "That's a relief. I pictured myself in a mountain shack with a grizzled white beard staring at your fading photograph, my only companions a bottle of hooch and a trusty old beagle."

"A mountain shack? The Cooper School trustees would never let you build another shack. The last one attracted a lunatic who

fell off a cliff." Callie kissed him, tasting the wine on his tongue.

"You think the trustees go up there? We could build a Taj Mahal replica and they'd never know. So what do you say? Marry me?"

Callie imagined the two of them hanging laundry over pine branches, eating squirrel stew, melting snow for water. "I want my own shack."

"You've got emotional evasion down to a science. I'm serious, Callie." He took her hand. "I'll buy you a diamond and kneel in front of the whole school if you want."

"God, no. I don't need a public declaration and I don't want a rock dug up by exploited miners." Callie filled her glass with water. "If it's better for the school, I guess we could, er, be engaged."

"No faux engagement."

"Okay, fine. But I can't talk about marriage until we've been together longer." Callie slid a hand along his arm. "I don't doubt your ethics. I question my own."

Coop growled and socked a fist into his open palm. "Oh, fuck you, Callie."

"What?"

"You like to think you're Peter in a skirt. Bullshit. You shot a murderer and went to juvie. Not even prison. And as near as I can tell, only because you had an inexperienced lawyer."

"So I'm not even a good enough criminal? I am so sick of your judgments. You think you know so much about me. You know nothing." *Lies are good. They build walls.*

The man who had battered down Miriam's door with his bare fists stood absolutely still as if fearing his own power.

Callie moved to the other side of the kitchen island. "Look, except for Sophie and my mother, I've never loved anyone. I don't know how. I've barely had friends. I learned two skills in my life— how to fight and how to cover. I'm good at those."

"Liar."

"Okay, I'm not even good at those."

He slapped the counter. "Stop."

She clenched her teeth. "Don't be a dick, Coop." They stared.

They stood. Eons passed.

He lunged toward her.

Callie braced, ready to parry, to kick. To flee.

Instead, Coop pressed her firmly against him while she stiffened like a corpse. He held on. She somehow knew that if she struggled, he would release her. Perhaps forever. Gradually her rigid body relaxed, the unexpressed screaming becoming unexpressed tears. And then real ones. He pulled her into a chair, still folded in his arms and waited for her to stop sobbing. Taking her face in his hands, he stared into her eyes and then grinned. "You're right. We should spend more time together."

A few moments of nervous giggling triggered queasy guilt. "I lied."

"I know."

"It's not true that I never loved ..."

"I know."

"Not just you. Nora. Hazel."

"I know." Coop handed her a glass of water. "And you're good at more than hiding and fighting, though you're a scary good fighter. You forgot teaching." He called toward the stairs. "Right, Nora?"

Nora clambered down from her eavesdropping post on the stairs. "Yeah, you're a great teacher. Everyone says so. But, Dad, Peter in a skirt?" She seemed intent on finding something in the refrigerator. "I've never seen Callie wear a skirt."

Coop rolled his eyes. "I'm going over to Admin."

"I'd like to go back to my place." Callie felt like a homing pigeon.

The pop-top on Nora's drink hissed. "No way."

"Too dangerous." Coop shook his head. "If you need something, we'll send an officer. With a gun." He took her hand. "Do you think I'm leaving to get away from you? The phone list is there." He kissed her and went out the door, jacket slung over his shoulder. "I am crazy in love with you. You can't put me off with some tough girl act. Lock up behind me."

"It's not an act." *Great. You finally meet the guy of your dreams so you try to get rid of him.*

Nora moved random items in an upper cabinet until she found potato chips. "Dude, it's hard to find junk food around here." She offered Callie the bag. "I thought it was close there for a minute. Really afraid Dad would screw this up."

Callie grasped a handful of chips so hard they crumbled. "Your dad? Not me?'"

Nora threw her arms around Callie, still crunching the chips. "Hey, I refuse to be the flower girl this time. Will Hazel be your matron of honor? Can I design your dress? Can we not have any really dumb music? The girls have a rock band."

"Not so fast." Callie stuffed the crumbles in her mouth.

"Because you won't marry him or he won't get fake-engaged to you?" Nora flung herself cross-wise into a chair, her legs hooked over the arm, the bag of chips in her lap. "You two are certifiable." She clicked the TV remote.

Grateful for the mechanical drone of the TV, Callie struggled through the rest of the evening trying to focus on lesson plans, eventually climbing into Coop's bed. She didn't hear him come in but slept fitfully, dreaming of monsters.

When she became aware of his weight on the bed and heaved herself into wakefulness, he was pulling on boots. She mumbled without opening her eyes. "Whassup?"

"Gotta be somewhere."

"Now? It's not even dawn."

The door slammed.

CHAPTER 22

Callie had never dealt with a reasonable man in a rage. Only unreasonable ones. *Is Coop angry with me? After Peter? Has something else happened?* Peering at the illuminated dial on the clock, she clicked on the lamp next to the bed and dialed Hazel, wondering if what she felt was a heart attack.

Alexis answered, apparently not quite awake. "H'lo?"

"Sorry to call so early. Can I talk to Hazel?" Callie heard Alexis yell for her mother.

"What's wrong?"

"Sorry. I didn't know who else to ..." Callie felt like a cliché and was annoyed with her own panic.

"You can always call me." Hazel shushed someone in her house.

Callie finger-combed her tangled hair. "Coop just ran out saying he needed ... I'm worried he'll do something crazy."

"Wait a sec." Hazel recapitulated to Craig while Callie pulled on clothing.

Craig came to the phone. "Shall I call the chief?"

Fatigue created a horror show. A showdown. Coop, gone. Like Sophie. Like Callie's mother and Miriam. "I don't know."

Hazel and Craig conferred, but Callie couldn't make out their words. Hazel returned. "Exactly what happened?"

Callie tried to remember. "I don't know. We had a fight. I thought we were okay when he went to the office so I went to bed. When I woke up he seemed really upset. Just took off ..."

"Oh my god, what's the date?"

"The date?" Callie shivered. *Have I fallen down some particularly*

cruel rabbit hole?

"Oh, honey, I know where he went. Try not to worry. I'll be there ASAP. Pour some coffee in a thermos—with some brandy." Hazel hung up.

Stumbling into the kitchen, Callie found Nora at the counter, listing to one side, stirring coffee that had long since gone cold.

Callie put on a fresh pot. "Nora, are you okay?" *Obviously not.*

"It was today. My mom. We were going to visit but in all the confusion ..."

So that's where Coop is. "She's buried on Lover's Peak, right?"

"Not buried. Cremated." Nora's eyes, red and swollen, circumnavigated the room as if she'd never seen it. "My parents were married there when I was very little. We three used to hike up on their anniversary in May. A sacrosanct ritual. Last year on their anniversary, me and Dad scattered Mom's ashes there. Exactly a year ago today. We were going to snowshoe up just ... just to say ... I guess he went without me."

Callie took Nora's hand. "Not without you, Nora. Just first. He had to talk to Miriam."

"About what?"

"You. Peter. Me."

"Are you sure?" Nora sounded hopeful.

"When Hazel asked me the date, I thought she'd gone batty."

Nora nodded. "Insanity trumps reason as an explanation of human behavior. Yeah."

They drank coffee, prepared the thermos Hazel requested, and dressed for the weather.

"I have to get up there." Nora fiddled with her zipper and looked out the window.

Hazel's dulcet tones, as if on cue, sounded at the door. "Hello darlings." Jackets and boots assembled, they were off after Hazel explained their mission to the guards, who followed in a squad car.

Early morning pinks and oranges glimmered off new-fallen powder. Hazel's car, equipped with snow tires, climbed the unplowed road as if it were June. Nora asked Hazel where she serviced her car. "Flambert Motors. Why?"

"That's where Mom's car ... Just thinking that Mom needed a better mechanic ..." Nora shivered.

"It was a freak accident, Nora. Your parents both grew up in these mountains. They took good care of their vehicles." Hazel turned off the ignition just before the end of the road. Waving to the squad car behind them, she pushed the thermos into a backpack. "Let's go. The cops'll follow but I asked them to give us a little privacy."

Callie hesitated. "Maybe I should wait in the car." Nora pulled Callie's arm. "Don't make me drag you."

Donning snowshoes, the three women followed the remnants of a dirt road, now encrusted with ice. Among the ancient evergreens, humans and nature had conspired to create an open meadow that would ripple with wild flowers come summer. Coop stood alone, as if in silent communion. In the dim light, Callie couldn't decipher his expression. As the others launched themselves through the deep snow, tumbling into his embrace, she hung back. But in two strides, he lifted her into his arms, murmuring thanks.

Callie silently telegraphed her own gratitude to Sophie, and then to Miriam, for this perfect moment. She belonged in their inner circle. The perfect safety of family.

Perfection—always gossamer if not illusory—vanished with Nora's impatience. "Now what? It's not like we usually pray or anything."

Hazel raised purple gloved hands to the brightening morning, swinging her arms wide. "Let's sing."

Nora cocked her head. "Know any Pink lyrics?"

Hazel took Nora's hand. "Your mother had a favorite song for moments like this." Hazel offered her other hand to Coop. "We sang it at your wedding. The Shaker song."

Without discussion, Callie completed the circle. Her alto rose, strong and clear in the mountain air. "'Tis a gift to be simple ..."

The others seemed momentarily stunned. A measure into it, though, Hazel, then Coop, joined in. Even Nora seemed to remember some of it. By the final verse, all four choked the

words through tears.

"'Tis a gift to have friends and a true friend to be,/'Tis a gift to think of others, not just me,/And when we hear what others really think and really feel,/Then we'll all live together with a love that is real."

Hazel directed them to sip the coffee-brandy concoction in a ceremonial toast. Looking to Coop for permission, Nora hesitated. He nodded. She drank. "I love you, Mom."

Hazel held the cup high. "We're all fine, honey. Rest in peace."

Callie wasn't sure what was appropriate. "Hello, Miriam. I'm Callie."

They all waited for Coop. He turned from the others, his words for Miriam alone.

As Hazel steered the car down the mountain behind the police car, Nora slid her arm through Callie's. "How'd you know that song?"

"Sophie's friends sang their own version as part of their spiritual practice. They changed the chorus, though."

Hazel, watching the road carefully, tossed her words over her shoulder. "Yeah, I never liked the chorus. The Shakers got some things right, some not."

Nora seemed almost combative. "Like what?"

"Like they were against sex so they eventually died out." Briefly, Hazel grinned.

Nora pushed on. "Which part's the chorus?"

Hazel hummed as if to remind herself. "When true simplicity is gained / To bow and to bend we shan't be ashamed./ To turn, turn will be our delight,/ 'Til by turning, turning we come round right."

Nora tapped Coop's shoulder. "Maybe that was Mom's little joke for her wedding. After all, I was there. Clear evidence of sex."

Coop raised his eyebrows and glanced sideways at his daughter.

Nora returned the eyebrow lift but addressed Callie. "What words did your aunt sing?"

"When true freedom is gained,/ To be, um, different, uh, we shan't be ashamed." Callie recalled the assemblage of graying men and women holding hands, pledging to improve the world in Sophie's name. "To change, change will be our delight,/ Fighting for justice, we'll make things right."

Nora stretched and rolled her eyes. "Just as corny."

After a hurried breakfast, the school day claimed them. After work Callie and Nora sat by the fireplace drinking tea, chatting. Nora drifted into a story about learning to drive at fifteen with Miriam and Hazel both instructing.

"No Drivers' Ed?" Callie stretched her fingers around an imaginary steering wheel, demonstrating a new driver negotiating mountain roads.

"I don't believe Coop even thought of it until Peter convinced him to hire Jean. French and Drivers' Ed." Nora shook her head. "Two for one. In ways we never imagined. No students are allowed cars on campus so we provide practice vehicles."

An entire scenario unrolled in front of Callie like a blood red carpet—a chilling, impossible story. "Did Jean maintain all campus vehicles?"

"Yeah, but Mom didn't like him so she always took her car to Flambert." As if mention of her mother inspired her, Nora dialed her dad. From Nora's side of the conversation, Callie surmised that Coop wasn't on his way. Nora sighed. "It's Mom's day. I wish he'd come home."

Callie wished so, too. She needed to burn off steam. "I'm going to the gym. You can stay here. I'm sure that's why we have two coppers—one for you, one for me."

"No, no, I'll come with you."

The Cooper gym stood at a distance from the central campus, surrounded by outdoor tennis courts, a separate hockey rink, and an outdoor running track. As the four women approached, two in uniform, two in sweats, deep shadows surrounded the snowy grounds while the building blazed with light.

One cop in tow, Nora changed then took the stairs to the Olympic-sized swimming pool. "Meet you after. Locker room."

Callie nodded and climbed to the second floor indoor track

that overlooked the basketball court. At this hour, the court often doubled as a practice room for musicians and actors. The gym was busy and noisy, though with dinner time imminent, activity was waning. Callie was glad for the distraction of runners and performers. She noticed that Officer Deplaine kept her in view while scanning the building constantly.

The rhythm of foot to track, often so useful in driving thought away, instead echoed a chorus: Marry me. Marry me. Marry me. After forty minutes, the crowd had dwindled to a few stragglers. Callie headed for the showers, hoping to avoid small talk. Any talk, really. Fortunately, the few students in the locker room were saying their goodbyes. Nora was not among them. *Is something wrong?*

Callie and the police officer tore down the basement steps to the pool area, nearly tripping over Nora's guard, collapsed and unresponsive. Deplaine dropped to her knees to check her partner's pulse. Signaling to Callie, she touched a finger over her lips and drew her weapon, flattening herself against the wall. She pointed for Callie to stay back and kicked the door forcefully. A quick inspection later she returned. "Nobody." She clicked on her walkie-talkie.

Without asking permission, Callie left the officer and sprinted up the stairs two at a time, intent on finding help. Ignoring Deplaine's remonstrances and her own tired muscles, she ran on, pushing horrifying bloody images out of her head. Most of the gym was now dark, the attendant probably doing rounds.

Uncharacteristically, his office was locked. Callie banged on his door. "C'mon, c'mon. Open up." Her voice sounded weak yet shrill. "Help! Somebody! Somebody help!"

The gym's back door was ajar. *Maybe the attendant stepped out to smoke. Didn't he know something's wrong?* No one was outside and no telltale scent of cigarette smoke hung in the cold mountain air. She yelled again. Only silence responded.

Back inside, Callie pulled the door closed and heard it lock. She raced up to the track and flipped on the lights—no one. Down to the main gym again, breathless from fear as much as exertion. She returned to the locker room. As she yanked the

door open, it occurred to her that this was unwise. The cavernous room with rows of lockers provided a perfect place to hide, and the last students left at least ten minutes earlier. The pulse in her neck pounded. Licking dry lips, she flipped on the lights. Only wet towels and a hair clip. Not Nora's.

In the main area of the darkened gym, a light in the weight room triggered a sour stomach.

Nora's voice. Momentary relief transformed to a heart-pounding silent scream as she heard snarls. Not an animal. Peter.

Callie strained to hear Deplaine, debating whether to call out. The walkie-talkie emitted a mechanical buzz. She sidled along the wall outside the windowless cubicle where Nora cried, cursing the gym's architect for designing rooms without windows facing the basketball court. *Focus.*

Through the weight room door, she heard Peter. "You've always known the deal. Keep your mouth shut and I won't kill your dad like I did your mother." Laughter, low and ugly. Here was the thing Nora was afraid to tell anyone, even now. Here was the proof. Jean and Peter somehow sabotaged Miriam's car. Not by accident. Deliberately.

Callie pictured Peter prowling like a caged tiger and ran to the top of the basement stairs to signal Deplaine. The officer was no longer there. Her injured colleague remained inert, the walkie-talkie spitting static to no one. Callie whispered into the darkness. "Help." No answer. She returned to her listening post at the door.

"She thought she had me." Laughter punctuated Peter's words. "Waving the pictures of Alexis. But your mother—" He dragged out 'mother' and punctuated his pause with a contemptuous harrumph. "Died a horrible, fiery death. Alexis knew better than to talk after that. So did you."

Nora's howl was muffled. *Did Peter gag her?* Callie surveyed the gym floor for a makeshift weapon. Nothing. She slid toward the adjacent equipment room, hoping he couldn't hear her footfalls. Unlocked. *Godsend.* Inside, she closed the door and flipped the switch, quickly assessing the shelves. She grabbed a length of rope and a baseball. *Where are the bats if not here?* She

stuffed a starter pistol in her waistband.

Back in the gym, Peter's voice droned on. "You were too old for me. And kind of ugly. At least you weren't a fat pig like your mother. I knew how much you wanted it. How ripe you were for the picking." He laughed at his own cliché. "And now you don't appreciate all I've done. Brat."

Callie's hand clamped the ball. Then she heard the sickening slap, fist against skin, and Nora's muffled cries, one after another. Punch. Cry. Slap. Wail.

Shaking the rope across the doorway, Callie's left hand teased a moving S pattern on the floor while her right arm threw the baseball hard against the far window. Thank heavens for an old building without shatterproof glass. At the sound of glass shattering, she flattened her body against the wall, still shaking the rope. She grasped the starter pistol, the first firearm she'd held since she shot Blake twenty years earlier.

Peter lunged from the exercise room. She yanked the rope when he stepped on it, making him stumble. He nearly fell. His body jerked back and forward as he swore, but he regained his footing. "What the fuck—"

"Put up your hands." *Still on his feet. Damn.* She counted on the darkness to disguise her weapon and shouted as if she had a posse behind her.

He turned unsteadily toward the sound of her voice. The spill light from the exercise room illuminated his face. Every feature she had once found attractive was now distorted, inhuman. His eyes radiated a blank madness. That square jaw, once evocative of GQ, now glistened with spittle.

"Calinda Franklin. I might have known." Running manicured hands through his hair, he smiled with easy aristocratic grace. For a second the man Callie once yearned for reappeared. In that tiny gap of unreality she imagined how it might be if Nora emerged from the room right now, unscathed, and they all had a good laugh over the charade. But as he advanced, all his charm disappeared.

Aiming the empty starter pistol at him, Callie stood tall, an Amazon with her bow. "Hands up, Peter. Now."

"Go ahead. Shoot me. They might not let you off so easily a second time." He smoothed his uncharacteristically wrinkled designer shirt and smirked.

How did he know? Years of practice kept confusion off her face. She wasn't sure how well he could see her but couldn't take a chance. "Now." *Where the hell's Deplaine?*

Peter stopped smiling and kicked the rope. "Bitch." He blocked the way to Nora.

Callie braced for a torrent of ugly taunts and a hail of fists, so familiar from Blake and juvie boys, already violent adults by thirteen or fifteen. Peter held something. *A gun?* The rope was still in her hand. She whipped it forward and ducked at the same time, hoping his aim was poor. The item in his hand turned out to be a spray can of mace. She could smell it, but he missed her eyes.

"Shoot me, you man-hating cunt." He sprayed again. "Shoot me."

"I don't hate all men. Just you." *And Jean. And Blake.* She wound up her pitching arm and threw the starter pistol at his head, striking his forehead.

Blood gushed from just above Peter's eye. He flailed, losing the can but scrambling on the floor for the gun he thought would give him the upper hand. In that split second, Callie ducked into the room with Nora and twisted the deadbolt. Peter pounded on the door hard enough to shake it.

How long 'til he breaks it down?

Nora was still in her wet swimsuit, shivering and blue, her dripping rainbow hair plastered against her head. Her suit was in shreds. Bruises and bloody injuries tattooed her face, limbs, breasts. Peter had gagged her with a filthy jockstrap, apparently brought for this purpose. *Premeditated. How many days had he waited, hidden in the gym, for this opportunity?* With sharp-edged plastic bindings, he'd lashed Nora's arms to the handlebars of a treadmill and set the belt on high.

Callie unplugged the treadmill and wrenched off the gag. "Holy shit."

"Oh my god, Callie, I thought I was dead." Nora heaved with

sobs. "He pulled me out of the pool, dragged me up the stairs, and started punching."

Callie couldn't untie the bindings at Nora's wrists and searched for something sharp. "We're not out of the woods yet, honey."

The door shuddered. Peter had thrown himself against it, but the bolt held. His loud, nonstop invectives devolved into a meaningless inhuman chant. "Bitchcuntassholefucker."

When Callie stretched to throw her jacket around Nora's shoulders, she felt a lump in her jeans pocket and pulled out the tiny pink pocketknife she'd confiscated in her classroom a short century ago. She hacked at Nora's bindings as Peter battered the door.

It splintered.

CHAPTER 23

Beyond the door, the pounding stopped abruptly and Peter screeched the piercing wail of the trapped predator. His cries joined a greater cacophony distorted by the wooden door and echoes within the big gym. Thuds, clanks, phones. Voices.

"Callie, open up."

Callie barely recognized Coop's voice in the din.

Nora, still hanging by one wrist from the treadmill grabbed Callie's arm. "Might be a trick."

Brandishing an inch of Swiss Army metal that could inflict no more than a scratch, Callie grabbed an eight pound barbell, swinging her arm back to punch Peter if he lay in wait. When she turned the lock, the door flew open.

Every light in the gym was on. Police everywhere. A sullen Peter in handcuffs. Closer, almost out of focus, Coop, his foot raised to kick down the door.

"Dad!" Nora wailed with relief and sorrow. Coop leapt to envelop his daughter, still bound to the treadmill. She squealed in pain.

Callie slid down the wall, too tired to stand. The crash of the barbell falling from her hand seemed distant, fictional.

Many police interviews later she nestled into the plush comfort of Coop's armchair in front of the fire. Everyone talked at once, despite bloodshot eyes and deep yawns. Hazel served hot chocolate and sandwiches. On the floor beside Callie, Coop held her hand, surveying his extended family like a lion with his pride.

Nora waved a sandwich at Callie from an ottoman at her feet.

"You must be starved."

Hazel set a plate of sandwiches by Callie's elbow. "Food will cure you."

Glancing at the red marks on Nora's wrist, Callie felt a new pang. "The cop—Antoine was it?—is she ...?"

Hazel wiped her hands on her apron. "Minor injuries. Probably get a big commendation. Deplaine, too. Damned rookies." She thumped her cocoa, splashing the table. "You were the real hero."

"Speaking of rookeeth," Nora spoke through a bite of sandwich. "Why did Deplaine leave the gym?"

"To use her cell. The walkie-talkie wasn't working and the idiot locked herself out." Hazel wiped the spill vigorously. "I ask you. Commendation?"

Another memory spurred Callie. "Where was the gym attendant?"

"Peter locked him in his office, bound and gagged. He's shaken but okay."

"Why was Peter screaming?"

"Yeah, Dad, did you consider what might happen to me if you went to jail?" Nora punched her father's arm.

Coop raised both hands in surrender. "Never laid a hand on him. Broke his own arm trying to escape." Taking a healthy swig of something stronger than hot chocolate, Coop grinned at Callie. "Lucky for him I thought the blood on his shirt was his own."

Hazel didn't share his mirth. "You're not a brawling teenager anymore. People depend on you."

"One brawling teenager allowed per family," Nora joked but her eyes scolded as she picked at chipped stripes of garish color on her nails.

Callie watched Coop assessing the truths, the overreactions, the company. *How often is he challenged in this universe where he's bigger, smarter, and more powerful than anyone else?*

Craig came in from the study, raising a finger for silence. He read from a legal pad covered with notes. "My investigator says Peter's suspected of raping teenage girls in five states. Never got caught, apparently because he's a tech whiz. Hacked into the

internet—even police records—and deleted most traces of himself. And Jean. Most of what we know about them was fabricated and carefully planted online."

Callie cringed. "All that evidence is lost?"

"Is he getting out?" Nora clutched her father's arm.

Craig shook his head. "Not a chance. Jean photographed almost every rape in progress. Peter kept souvenirs. Their criminal and—as it turns out—quite useful fetishes— will link Peter to many open cases. Survivors will come forward. He'll go to prison for several lifetimes."

"Survivors." Nora lifted her hot chocolate. "I'll drink to that."

Craig directed himself to Nora. "He'll also be charged with your mother's murder, though that might be harder to prove. After Miriam brought you home the night of the rape, she went out again. That always struck me as odd. Why would a mother leave her child after such an ordeal? Phone records show that she called Peter. Though we'll never know what she said, she must have threatened him. Perhaps he somehow convinced her to meet him. We believe that Jean—at the motel filming the assault— tampered with her brakes while she confronted Peter. Contrary to rumor, she was just driving away from the motel when she hit the semi. Jean was an able mechanic but he couldn't have planned that. Maybe he hoped she'd go over an embankment and burst into flames."

Coop raised a hand to silence Craig, but Nora shook her head. "I need to hear this."

"The collision demanded everyone's attention. The police now believe that while the motel personnel responded to the accident victims, Jean undid whatever he'd done—at least enough to fool investigators."

Much, much later, after Craig and Hazel left and Nora was asleep, Coop and Callie retreated to his bedroom, exhausted.

"Thank you for saving my daughter's life." Coop pulled a comforter around Callie.

"All in a day's work for the feisty Miss Marple."

"Please don't joke. If not for you, I'd be planning Nora's funeral—on the anniversary of her mother's."

"You and Miriam raised a hero. Nora protected you and the school against a maniac. She's amazing. Peter and Jean routinely taunted her. Her secret could have driven her to drug addiction or insanity. Instead it's in her art."

Exhaustion won the battle over further conversation.

* * *

Within weeks, spring arrived as an assault—crocuses pierced the earth like tiny warriors, blossoms thundered in like armies attired too brightly—proving that April was, indeed, the cruelest month. The girls settled back into classes. The adults imitated normalcy, but Callie felt decidedly unsettled. As finals approached, she filled her days with teaching and gym, evenings at home prepping, and nights in Coop's bed. She came and went stealthily. None of the girls knew. Nora kept their secret, a silent stamp of approval.

The morning after graduation, most students had already left. The few summer program girls were housed across campus. Free from the constraints of prying and gossip, Callie and Coop planned to sleep in. Paradise. Lost when the phone rang.

"Ignore it." Coop moved a pillow to muffle the sound. "It's nine. Too early."

Callie grinned sleepily. Most mornings he worked out and was at his desk before seven-thirty.

Nora shouted from the kitchen. "Pick up. It's Craig."

"Now?" Coop reached for the receiver without opening his eyes. "Yes?" He stroked Callie's shoulder. "For you." He fished for clothing.

Callie took the phone. "Craig?"

The lawyer's voice crackled over the line. "Callie, I have bad news."

She sat straight up. "Peter?"

"No. It's … I'm sorry but your stepfather has died." Craig sounded ready to offer condolences.

"Good." Callie tossed the phone on the bed. She pulled on a t-shirt. "Excellent."

"Callie?" Coop muffled the phone's microphone with his palm.

"Blake's dead and I'm glad. I think Craig's shocked."

Coop took over the call. "They weren't close. Do we need to do anything? ... Thanks."

Callie attacked her hair with a brush.

Hanging up, Coop gently extricated the brush. "Blake's lawyer wants you to call him. Something about his will." He took over the task of brushing her tangles.

For a few minutes Callie let herself sink into the pleasure of his rhythmic strokes, but the news wouldn't go away. "How did Craig hear?"

"Blake's attorney's been trying to reach you for months. Finally informed Craig as the school's legal representative."

"Blake spent every penny on his defense. What could be in his will? An NRA membership?" Callie slid into a pair of slippers, inexplicably unable to see them clearly.

He tuned in without missing a beat. "What is it?"

"I don't know. I guess ... what's that Faulkner thing? 'The past is never dead. It's not even past.' Blake tortured my mother for most of their marriage. I couldn't save her. He lived another twenty years."

"In prison."

"Breathing. And, apparently, writing a ridiculous will." Callie looked through the bedroom window. The morning glimmer on the distant mountains hinted at ancient secrets. "I was pretty little when they met. Blake courted her like a princess. After the wedding, she could do nothing right. He oversaw every little detail—from how she dressed to her table manners. Routinely beat her up and probably raped her repeatedly, though she kept the worst from me."

"Why stay with a batterer?"

"Not sure. Possibly for me." Callie shivered, pulling a quilt around her, for once gathering the patches of her life instead of pushing them away. "Maybe she lost track of who she was,

especially after he banned Sophie from the house. Maybe she believed she loved him. He was charming, handsome, rich. Think of all the people who were taken in by Peter. Me included."

"No thanks." He dressed slowly, his eyes on the scene beyond the windows, now bursting with new green.

Hours later Callie had almost the identical conversation with Hazel. They sat across from one another in the school library, ostensibly sifting through classroom materials. The clock crept toward dinner time.

"I'm glad you told me. Alexis said you had a terrible childhood but would say no more." Hazel smiled.

Callie tried once again to organize her notes for next fall, but they made no sense. "I'm a hypocrite."

"Dubious. Why?"

"Because I told Alexis and Nora that Peter's behavior wasn't their fault."

"Right. And?"

"I can't shake the feeling that Blake hurt my mother because of me."

"You wouldn't be the first person deaf to her own good advice."

"When he wasn't ignoring me, he was criticizing. I was ugly, cost too much to feed, clumsy, embarrassing. Said it was Mom's fault I was high strung—" Callie couldn't continue.

Hazel flashed a we're-in-this-together smile. "Well, you certainly made a great comeback."

"What if I'm permanently screwed up?"

Hazel laughed aloud, stifling it immediately. "Honey, everyone's screwed up one way or another."

"Doesn't Coop deserve someone he can trust?"

Hazel barely bothered to whisper. The few remaining summer students and the librarian had migrated to the adjoining checkout room. "Don't you mean someone who trusts him? Trust is earned. Do you trust that he loves you?"

"Um." Callie avoided Hazel's eyes.

Hazel spoke sternly. "Callie."

"I'm a novice at all this."

Hazel put the library books on a cart. "Look how far you've come. You've created a whole new family."

Callie sought Hazel's eyes. "I'm ..."

"Scared? Of course you are. Your mother died at her husband's hand. Sophie died while you still needed her. For you love is perilous, trust lethal." Hazel reached for Callie's hand but lay hers on the table instead, as if unsure how much affection to show. "But you're too brave to let fear run your life." Hazel changed from consoling to teasing. "Come to think of it, I'm a little jealous that the girls consider you such a hero."

Before Callie could deliver her best smart-ass retort, she heard familiar footfalls in the adjoining room, followed by the librarian's admonishing sibilants.

Nora appeared in the doorway. "I've been looking all over. I need you."

"Why?" Callie and Hazel spoke almost in unison.

Nora looked around conspiratorially. "Not here. Ms. Asabe just yelled at me for making noise. Coop's cooking. Craig and Alexis are there. Shauni's on her way. C'mon." Nora raced away.

"Now what?" Callie slung her backpack over her shoulder. "Don't look at *me*. I have no idea why all those people are at your place." Hazel raised both hands as if to deflect responsibility.

"My place is at the top of that road." Callie pointed toward her long-underused cabin.

"A room of your own." Hazel smiled. "Virginia Woolf. I get it."

Callie doubted that but didn't argue as she tramped toward the Coopers' at a pace that kept Hazel panting too hard to talk.

The apartment was aromatic and noisy. Craig was on the phone. Shauni and Alexis played chess, giggling as their pieces advanced. Humming to a jazz CD, Coop stirred at the stove, waving away offers of help.

Nora dragged Callie and Hazel up to her room. Her work table, usually a jumble of art projects, held only a line of official-looking thick manila envelopes. Nora wiggled her fingers as if casting a spell. "If they're big it means they want me, right?"

Hazel tilted her head quizzically. "I thought schools did

everything online these days."

"Not if you ask for hard copies." Nora caressed each envelope as if divining its contents.

Callie read return addresses. "Rhode Island School of Design. Carnegie Mellon. Nora, when did these come?"

"A while ago. Alexis kept saying, 'Just open them already.' But time's up. The latest emails and letters say they need answers by next week."

Callie reached for the first envelope.

Hazel stopped her. "We're just the Greek chorus."

Callie offered Sophie's chant. "What's the worst that could happen?"

"They all reject me and I'm ashamed to show my face in public."

"We'll mock you to the multitudes. Open." Hazel offered a carved letter opener from Nora's desk.

When the contents were divulged, Nora had four letters of acceptance, two with full scholarships. "Holy shit." Nora stared at each of them. "Oh, God. Coop. He doesn't know." Nora shouted gleefully as she galumphed down the stairs. "Dad, guess what?"

The dinner was a happy blur of congratulations and too much wine, with Hazel guarding against excesses by the underaged.

Many goodbyes later Callie dried the last dishes. "Why did we have a dinner party tonight?"

"It just happened. Craig came to my office to update us on the case. Alexis came with him. Because of her cast she isn't driving yet and she wanted to see Shauni. Nora invited them all to dinner."

"And expected you'd cook?"

"Callie, when have I ever not wanted to cook?"

Callie nodded, considering the happy labyrinth of personalities—friends. She reached for the novel she'd been meaning to read and settled into a chair. But without warning the chair stopped being comfortable. Second guessing, she wondered whether she was like a character in one of her favorite old movies, *Bagdad Cafe,* who rejected "too much happiness." She hesitated. "Don't be mad, but I want to go back to my cabin."

Silence. "Coop?"

"Fine."

Callie couldn't tell whether he was lying, which bothered her. *One small step for independence, one giant leap backward for connection.*

"I'll drive you." Coop pulled out his keys.

"But ..." *Should I tell him about my discomfort?* She knew he'd have a logical argument. But right now she didn't want logic.

He seemed to struggle to speak without barking. "What?"

"You're upset."

"I'm not."

"What, then?"

Coop directed his single word to the wall. "Afraid."

She responded with bright insincerity. "The raccoon won't be back. Or the rats—Jean's dead. Peter's in a supermax prison."

He leaned against the door, unconsciously barring it. "Why are you leaving?"

"I need to go home."

His eyes closed and opened, in a not-very-veiled stalling technique. "Home?"

"Home is—"

His voice rose, "Where the heart is? And where is your heart, Callie?"

"Don't yell."

"I'm not yelling."

Her voice rose to match his. "Why do yelling people always say they're not yelling?"

He deliberately shut his eyes again and drew in a breath. "You're right."

Callie shook her head, wondering—not for the first time—how she could possibly deserve him. She felt a shift. "This apartment, this whole school, is your territory. You're practically king. I need to go back to my own little corner of the world and regroup."

"I won't fight you, Callie. Do what you want."

She wanted to snap that she just needed to think and couldn't do it here for some reason. But he wasn't the reason. "Come with me."

Coop's rare amazing smile appeared, as if someone had grabbed the remote and changed the channel. He practically bounced. "Clothes. Fire kit." He issued rapid-fire orders as he stuffed a small duffel. "We'll need breakfast. Take some milk and eggs. Cheese, maybe. See if we have OJ." Helping Callie fill a bag, he brushed her fingers. "It's time to talk about that marriage thing."

He was opening a can—and it wasn't juice.

CHAPTER 24

At three the next morning, nothing was clearer. Callie paced her main room, muscles protesting. If she sat, she'd fall asleep mid-sentence. Though the days were warm, May evenings brought a mountain chill. Coop built a fire, made tea, and performed every chore he could invent.

Callie pressed fingertips against a throbbing temple. "Don't push me. We aren't a random teacher and principal. A couple months ago we were all over the news."

He sighed. "The world has gone on and so should we."

"Great, let's go on. As we are." She paced.

"All you say is 'no, no, no.' Ever heard of 'getting to yes?' You make me dizzy." He sprawled on the couch, reaching for her as she passed.

She evaded his grasp and staggered onward in her self-imposed march. "Enough." A groan from the couch.

"I like you."

"You love me. Say it."

"Blake said he loved my mother and what did that mean?"

"If you're not ready, I'll wait."

"I'm bad news for you."

He frowned at her hundredth repetition of her worries.

Rubbing her eyes, she frowned back. "Think like a reporter. An unqualified teacher—let's call her Callie—gets a job at the Cooper School. Disappears into the woods with the French photographer during a school outing." She rolled the r in the word French. "Jean goes to Callie's cabin late at night and they do god-knows-what. Her boss arrives. Coincidence? Perhaps not!

Could it be——?" Callie struck a Sherlock Holmes pose. "Jealousy?"

"If they ask me whether I'm jealous of other men in your life, I'd have to say yes. But who would be jealous of Jean?"

Callie kissed his cheek and resumed her counterfeit newscast. "Within days, the French teacher, in a murderous rage, shoots at Callie, wounding a bystander. Her shady boss retaliates by chasing Jean off a mountain."

Coop yawned. "The police report says I was nowhere near him."

"You think reporters care about facts?" Callie snapped a finger and pointed at Coop with a flourish. "The boss isn't just Jean's rival, he's the school principal charged with protecting impressionable young girls. And now he's tangled up with a scarlet woman." She blushed as if to demonstrate. "Some hair-sprayed cable anchor will drool over our misfortunes."

"So what? The girls love you. More registered for your fall classes than we can accommodate."

She finally said what she most feared. "And what happens when they find out I was in juvie for shooting a guy?"

"They won't."

Callie threw up her hands. "You did. Peter did."

"What we found is no longer there, thanks to Alexis's considerable internet skills. Besides, every one of our students knows somebody in jail—many wrongly accused and poorly represented." He stood up. "The press finding out about Peter—that's a real threat. As a parent, I'm more scared of a principal with bad judgment than a beloved teacher whose so-called crime happened twenty years ago."

"Peter doesn't exist in the public version. Just us. Craig and the chief have kept Peter out of the news and the judge issued a gag order. So far, everyone's buying Dr. Chen's story that Peter left because he's distraught over Jean's death." Callie sank down beside Coop. "Most of the teachers you've hired are fantastic. Only one is a jailbird—or, at least, only one who's still on campus."

"Don't be melodramatic." With his arm resting around her shoulders, he twirled a strand of her hair. "By the end of summer

vacation most of the parents will be glad the girls are back here."

"Don't distract me with logic. Or seduction." *Wait. Forget that last thing.*

"Oh, right. Let's just stay up all night inventing preposterous stories."

Uncontrollable giggles. "Preposterous?" Daffy-Duck-like, she popped the pees and hissed the esses.

Coop turned off lights as they progressed toward the bedroom. "Tha-a-at's all folks."

Minutes later he was snoring softly. Despite bone-deep fatigue, Callie couldn't close her eyes. Every tiny hair on her body stood rigid and alert. 'We belong together' looped endlessly, a repeated musical phrase, simultaneously melodic and discordant. 'I love you' followed closely behind.

She slid out of bed and sat on the cold oak floor for a moment, breathing deeply to slow her heart. After silently packing her well-worn suitcase, she crept into the study and wrote a note to Coop. "I can't be responsible for ruining the school. Or you." She wrote a simpler one to Nora. "I love you, I love your dad. Always." And to Hazel. "Thank you for your friendship and wisdom. Please tell the girls I had a family emergency. You know I'd stay if I could." She sealed envelopes, inscribed with their names, and propped them on the kitchen counter.

Outside, she hurried down the road, all too aware that she was in flight from everything she thought she wanted. Success, intimacy, family. All now tainted with the threat of someone revealing her past. Maybe Coop was right that she overestimated her own power. But why take the chance? *Or is it the chance of happiness I'm running from? Focus.* She was strong enough to walk the twenty miles to Flambert but not before someone caught up with her. At least she wasn't wearing the idiotic boots that brought her here.

On the dark campus, only one window was alight. Dr. Chen was in his office early—or late. Formulating a plan, Callie climbed up the Admin steps, walking through the dim corridors to his door. He answered in exercise attire, holding a cup of steaming tea.

"Could you give me a ride?" Callie doubted he believed her jumbled story and it didn't matter.

Within a day she was back in Troyville, skyline gray with the smokestacks of abandoned factories. Sophie's circle of kindly aging activists offered their homes and vegetarian feasts. Sophie's oldest friend, Lana, offered her a room "til you get on your feet." *When would will that ever happen again?* She called no one at the Cooper school. Instead, she read, helped out, and watched old movies, exploring once-habitual solitude. Lana convinced Callie to get out of the house and volunteer at Troyville's tiny Peace Center.

One day, a mild remark from Lana called Callie's attention to her belongings strewn around the guestroom. Guiltily, she hung clean garments in the closet and stacked books on a shelf. As she gathered laundry and systematically emptied pockets, she found the umpteenth note from Nora beseeching her to please call Blake's lawyer, and "get this guy off my back." On impulse, she called, ready to tell him off— meaningless, since he'd never find her here. *But who better to feel my wrath?* The shouting stopped almost before it began. After listening a long time, she replaced the receiver and sat with a thud. *Now what?*

"Blake left you his fortune?" Lana asked after Callie was finally able to tell her about the phone call.

"Millions. Evidently he wrote out an apology for killing my mother, too. Worried about his immortal soul on his deathbed. Bully for him. It's blood money."

Lana waved a dismissive hand. "Any money could be blood money."

"No. Auto workers or secretaries—they earn their money." Callie thought of her mother, Sophie, her former colleagues at Cooper. "Real work. Teachers. Maids. Farm workers."

"And the people who pay them?"

"Where is this going?"

"Bear with me." Lana plucked a book off a shelf, extracting her bookmark, a worn movie ticket. "Let's call this a dollar." She handed it to Callie ceremoniously. "A woman earns it from, say, data entry. But the factory owner's a major drug lord. That same

dollar came from selling crack to a nine-year-old." Cocking her head to one side, so like Sophie, Lana smiled. "Hard-earned or ill-gotten?"

"What would Sophie say?"

"Doesn't matter. What will make you happy? Are you sure you don't want to call your young man?"

Privately amused at the description of Coop in his forties as a young man, Callie shook her head. "I honestly don't know." Callie put the movie ticket back in Lana's book, probably in the wrong place. "I've never been in love before. Does it make you happy?"

Lana peered over her trifocals. "Married forty years and still figuring that out."

Callie smiled dutifully but silently growled to Sophie to cut it out and deliver a message already. "I need to be useful. My only time off since juvie was Sophie's final months." When Lana visited daily.

"Terrific. Sophie would approve. Teach. Unionize. Work for a candidate. Collect for the homeless. Create art or music or theater or film for social justice." She stretched out her arms to embrace the world of possibilities. "Or something else."

"Tell me what to do." *Have I ever said that before?*

"Only you can figure out your place."

"Maybe the Peace Center?" Callie found numb satisfaction in stuffing thousands of envelopes and arranging them in zip code order on a rickety wooden table.

Lana wrinkled her forehead. "Your help is always welcome, but I suspect the Center is a placeholder for you." Her eyes strayed to her desk calendar, full of scribbled appointments and tasks, signaling the end of the discussion.

Callie longed for a calendar full of commitments to her passion. She considered calling Coop or Nora or Hazel. Sometimes she dialed, but never all seven digits. The longer she stayed away, the more impossible to reconnect it felt.

Weeks later Callie was alone in the Center, still obsessing on options, still chastising herself for avoiding the Cooper School yet still avoiding it.

A young Hispanic man delivered a huge carton of medical supplies. "Where's Lana?"

"I'm covering today. I'm—"

"Callie." He grinned. "I remember." He waited for her to recognize him. "Luciano." He slid his hands into the pockets of too-snug jeans showcasing a compact athletic body.

The ringing phone reprieved her. "Peace Center." Callie raised a finger and looked past Luciano to indicate how hard she was listening to this terribly important call.

Lana sounded distracted. "I forgot to tell you Luciano is bringing medical donations." She started to describe him and then short-circuited herself. "Maybe you recognize him? Works at the hospital."

"He's here." *Holy Moly! Luke.*

"I'm on my way. Ask him to wait." A dial tone followed.

Callie hugged Luke at arm's length, hoping he'd forgotten the touch and tempest of their last encounter. "How are you?"

"Good. Real good." He pulled her closer and held her too long.

Hasn't forgotten. Damn. She reached for a pen and began cataloging the contents of his package.

"I was real sorry to hear about Miss Harris passing." His eyes followed every curve of Callie's body, not obtrusively enough for her to protest.

Damn, he's good. "Thanks." *What the hell do you do with insignificant ex-lovers?* "Sorry I didn't stay in touch."

"No problem." He tossed back unruly black hair, reminding her of Coop. "I met Lana at the hospital while your aunt was there." Eyes still on Callie, he began routine clerical tasks. "My priest says helping out is good for the soul."

How does someone make priest and soul sound lascivious? She resented her body for responding.

Lana's arrival saved the day. But no man would keep Callie from the Center, placeholder or not. Her discomfort around Luke gradually ebbed as hard facts about world events edged out obsessing over moments at the Cooper School. Luke flirted indirectly, suggestive glances accompanying witty cracks about

foreign policy. She mostly enjoyed his attention and told herself it was harmless.

Meanwhile, back at reality, she turned to Lana. "My savings are running out and I can't find a job without asking Coop for a recommendation. I don't want him to know where I am. And I haven't decided what to do about Blake's money."

"I've often wondered when to give you this." Lana opened her utilitarian desk and handed Callie a letter in Sophie's handwriting. "Dear Lana," it began, "I am a total coward."

One portion jumped out as if in neon. "I should be thrilled to be at the site of Prague Spring, accepting our award for the center and meeting peace activists from all over the world. But you and I both know I'm here to avoid my sister's wedding. Blake's a disaster. He does nothing but criticize, maybe worse. Says she's fat, so she lives on lettuce and weighs nothing. Heels and lipstick—like a 1950s doll—his idea of a society wife, not hers. Most of her friends have fallen away because he's insulting and rude. Her only happiness is Callie, though Blake whines regularly about supporting another man's child. When I begged her to leave him, we had a huge fight. Please check on her."

"I came over for tea. Do you remember?" Lana looked past Callie at a wall photo of Sophie and other Center founders, including Cecilia. "You were very little. Your mother looked like a ghost, pouring out while the water was still tepid, rushing me out before Blake came home."

Callie remembered her mother nervously washing a teacup, probably Lana's. Erasing the evidence. Anything to avoid setting Blake off.

Lana fingered a silver dove pin she always wore on her lapel. "Sophie gave me this for my seventieth. To remind me that inner peace is as important as world peace. And to honor the sacrifice of others."

"I have one, too." Callie touched the dove at her throat. *Okay, Sophie, I got it: Mom sacrificed herself to save her only daughter. To a monster. Living well is the best revenge, thank you George Herbert. Step one: You can't live without money.*

Phone calls. Lawyers. Meetings. *Ugh.* Shopping. *Wow.*

Technology when money's no object. Callie's first and only email was to Dr. Chen. "Thanks for your help. Will let you know when I'm settled." Then she closed the account. That way she wouldn't be tempted to look. Or write. No Facebook persona for her.

Her lawyer called her state-of-the-art cell. "The attorney from the Cooper School—Craig Landers?—wants to speak with you."

Callie conjured Craig's kind face. "I'll call him."

"You haven't responded to his last five calls. Sure you don't want me to give him your number?"

"I'm sure."

Summer humidity reigned. Callie hid in movie theaters and libraries, unwilling to admit so much time had passed since the brief happy interlude in her otherwise bleak life. She took a luxury suite in the hotel where she'd first met Coop, only to check out a day later because she couldn't stand passing the conference room. She leased a furnished apartment, joined a gym, wrote a check to the Center, lost herself in contemporary novels, packing away her much-read old favorites. Margaret Atwood reminded her of Hazel. *Pride and Prejudice* of Coop.

At Lana's suggestion, Callie hired Luke to teach Spanish to Center volunteers. Attendance was sporadic and one evening Callie and Luke were alone.

"We were good together, Callie." He passed her a cup of coffee, his arm grazing hers. "No strings." He grinned bashfully, though Callie doubted he was inexperienced.

"I'm in love with someone else."

"Don't see nobody." He pointed to a line in a Neruda poem they'd been translating, *"Ode a la Esperanza"*—to hope. "Like Pablo says, '*Todo será cumplido.*'"

Removing her eyes from the text, she caught her image in a mirror. Good haircut. Professionally waxed eyebrows the hairdresser had talked her into. *Is this me?* She translated. "Everything will be fulfilled?"

He kissed the palm of her hand. "Why not?"

Why not? 'Don't look back,' as Bob Dylan sang and generations of fans repeated. Or maybe, 'Don't think twice, it's alright.' Anything to stamp out thoughts of Coop. They locked the Center and rushed to

her apartment.

Luke glanced around Callie's digs, littered with still-unfamiliar new clothing and recently published hardcover books, his assessment halting at the king-sized bed. "Nice place." His tight-fitting tee-shirt slid over his head and his belt buckle snapped open, leaving jeans hanging precipitously. He watched her unbutton her silk blouse and unhook a designer lace bra she'd purchased because a convincing saleslady needed the commission. "Wow."

His open palm gently caressed her shoulder. Her revulsion at that 'wow,' the last word spoken between them, marked her alteration, the official notice that she was no longer a carefree sexual adventurer. He didn't smell right, his aftershave wasn't the scent of the woods. Moans and whispers that might once have fed her pleasure now distracted her, and not in a good way.

As he dozed in post-coital exhaustion, she showered, failing to scrub away the one feeling she'd never before associated with sex—shame. Deliberately choosing a bulky terrycloth bathrobe, she twisted her hair into a towel, knowing how unglamorous she looked.

Luke, nearly dressed, barely glanced at her. "I'll call tomorrow, babe."

"No. I can't do this again."

Balancing one hand against the absurdly fancy wallpaper, he pulled on a boot. "The other guy?"

"Sorry." If only she could resume her former identity.

He grinned as if he assumed she was lying. "You know where to find me." He brushed rough lips against her cheek and left.

Clarity arrived during the ninety minutes it took her heavy hair to dry.

A day of travel through summery mountains dragged her through despair, guilt, uncertainty.

And hope.

CHAPTER 25

Callie stepped onto the Flambert station platform donning sunglasses to cover eyes puffy from tearful sleeplessness. She'd reserved lodging and a car—a car!—but had no plan beyond that. *Could I call Coop?*

"Where the hell have you been?"

Callie whirled, half-expecting Sophie's ghost to prove her insane once and for all.

Hazel, gray curls in a tangle, stared up at her. "You look like a million bucks."

"Thanks." Involuntarily, her hands lost their grip on her bags and they fell to the pavement.

"It wasn't a compliment."

"I'm sorry." Callie stared down at her sandals, wishing they were less new.

"How could you just disappear? After everything?" The volume of Hazel's voice attracted a few stares.

Public humiliation. Great. "I was a—"

"Jerk. A total jerk. I thought Peter hired a kidnapper or something. Someone who forced you to write that stupid note. Family emergency? Your family emergency was here, dammit. Thank heavens Dr. Chen saw you leave. A phone call would have been nice. Email. Smoke signals. Alexis said she could find you through cyber-sleuthing. We were ready to break all sorts of laws."

The tears in Hazel's eyes drained Callie's fight-back. "Did you come here to yell?"

"Yes. Yes I did." Hazel drew herself up to the top of her five-

two frame. "And I'm not finished."

"Please forgive me."

"Not yet." Frowning, Hazel blinked. "I have more to say. Then we'll see."

Tough crowd. Callie distracted herself by collecting her fallen luggage. "How did you know to meet me?"

"A former student runs the car rental place. I asked her to keep an eye out."

"You knew I'd come back?"

The older woman lifted her chin. "I hoped."

"You knew I'd rent a car?" Callie hadn't even had a license when she left.

Hazel gestured to a window in the station. "She can see everyone who arrives."

"Anyone else know?"

"Craig and Alexis. I don't run out on family like some people I could mention." Hazel turned her eyes toward Callie without moving her head. "Or do you mean Coop?"

"Um." Callie pulled her sweater close despite the warm spring air.

"Not sure what he knows. But it's just a matter of time before somebody in my family tells somebody in yours."

"Mine?"

"Yes, yours. Do you think everyone just went about their business after you left? There was major mourning around here. I can't believe you, of all people, would be so selfish."

Selfish. Family. Selfish. Family—a dance so thunderous, it drowned out other sounds.

Callie collected the car and at Hazel's suggestion drove them to an out-of-the-way coffee shop. Looking around at Formica tabletops and polyester gingham curtains, finding a table, ordering—nothing served as an adequate diversionary maneuver. Callie chattered about popular culture and the Peace Center, minus Luke. Downloading random shallow forays into her solitary life didn't rekindle their former closeness. She ordered pie.

Hazel raised an eyebrow. "Hungry work, isn't it?"

"What?"

"Avoiding anything substantive."

"Hazel, I——" Callie straightened the flatware in front of her.

Hazel signaled to the waitress for a coffee refill. "Not one more word about Sandra Bullock or Dan Brown."

"Turned out Blake was rolling in dough and left it to me. I took it. I guess I am selfish."

Hazel squinted at Callie, as if mentally connecting dots. "That explains the designer luggage. But the money can't be the whole story. A big inheritance didn't change Jane Eyre."

"She inherited from a relative she'd never met. Convenient. Blake murdered my mother." Callie shivered again. "I profited from that."

Hazel offered her a shawl from a voluminous tote bag and whisper-sang a few notes, "You're a queer one, Julie Jordan."

"*Carousel*. A musical celebrating spousal abuse. Not Rogers and Hammerstein's finest work."

"You just inherited a gadzillion dollars and you're not jumping up and down and ordering a Rolls." Hazel slid an imaginary divider to direct a make-believe chauffer. "Julie Jordan-ish."

"I don't trust it. Tons of lottery winners lose everything and die young."

"Because they do crazy things."

"Yeah, like quit their jobs." Callie buried her head in her arms.

"Well, it's not like you need the money."

Callie's head, too heavy to lift, lolled to one side. "Blake's final assault. Choose between becoming the idle rich with a sweetheart—if he'll take me back—or the teacher whose only life is her students."

Hazel pointed a finger. "Drama queen."

"Maybe I'm fated to be a rich spinster. Like Gwendolyn Cooper or Jane Addams."

"Gwendolyn was a widow and Jane was a lesbian. They both believed in love." Hazel stared. "Do you?"

Callie squared her napkin with the edge of the table. "Let's say I give the money to Civil War widows or something, and my life

goes back to normal."

"Civil War widows?"

"You don't like it?"

"Very deserving if they weren't dead." Hazel focused on the menu. "Look. I think you and Coop are great together. I think you saved his life in more ways than one. And maybe he saved yours."

"But it's ethically dicey to work for him."

"If you needed an income, I might feel differently. You can't live without money." Unaware she'd quoted Sophie, Hazel signaled to the waitress. "And apparently you can't live without Coop."

"Done both before."

"And we all know how good that was." Hazel sighed. "What would Sophie say?"

"Hard to know. Sophie lived by ethics but hated rules. She might tell me to quit or just as soon say the rule is stupid."

"So you can choose which rules to follow? Already you're thinking like a tycoon."

"Or a revolutionary."

Hazel rolled her eyes.

Callie sighed. "That's what worries me. When I came here I couldn't afford useful boots. Now I could buy a different pair for every day of the year. My bills—not just my bills, my whims—are paid, presto. I even paid off my college loans. Ironically, just when I don't need it, I got my teaching certificate. I'm not just rich—bad enough—I'm the idle rich. The one percent. I don't stay up late any more figuring out how to explain nineteenth century novels. My most pressing engagements are with my trainer." *And my Spanish teacher.*

"You won't like stagnation for long. Your circumstances have changed. Not your values." Hazel's scolding felt like a comfortable old sweater. The older woman straightened the salt and pepper shaker. "Dilettante or dissident? Choose, honey."

Callie stared into her empty coffee cup, wishing it were tea and that she believed in tea leaves. The waitress arrived and Callie grabbed the bill. "How's Nora?" She added an extravagant tip.

"Furious with you but otherwise fine. Shopping for college. She and Alexis are no doubt spending far too much at sample sales in the Big Apple right now." Hazel led Callie outside. "Don't you want to know how Coop is?"

Pulling car keys from her pocket, Callie forced herself to sound casual. "Sure."

"Then ask him." Hazel looked beyond Callie across the street.

Callie followed Hazel's gaze to a tall man leaning against a telephone pole. *Holy shit. Coop!*

The man who never before approached her without invitation crossed the street and wrapped his arms around Callie.

She didn't pull away. "What are you doing here?"

"I could ask you the same thing."

Hazel hastened away, waving farewell.

Coop held Callie, covering her hands with his. "We need to talk." He looked around for a suitable place.

"My hotel."

He didn't argue, though Callie sensed irritation. He said nothing as she handed her no-limits credit card to the proprietor of Flambert's most luxurious Bed & Breakfast, a man he addressed by first name. Nor did Coop raise an eyebrow at her baggage. Once in her suite, he opened a window as if only fresh air would let him breathe.

Callie tried to remember her plan. She'd had one, she was sure of it. But now it seemed indefinite and fragmentary. "I didn't want to wreck your life."

"I know."

"I'm so sorry."

"Callie, you belong here."

"Maybe." *Ode a la Esperanza. Thanks, Mr. Neruda.*

"Don't equivocate." He studied the facades of Flambert's downtown.

"You don't know what I've done."

"I can guess."

Could he? "I need to tell you."

He spent far too long adjusting a shade to block out a nonexistent glare. "Was he ... important?"

~ 220 ~

"Yes." Callie heard Coop stop breathing. "He's evidence."

"Evidence?"

"That you've ruined me."

"Come again?"

"I can't be with anyone but you."

Coop turned toward her, finally, filling the window. "Do you love him?"

"I barely know him." She remembered how inscrutable Coop was the first time she met him at that hotel conference room in Troyville. *Should know more by now.* "I love you."

He stared at her, through her, whether to the past or future she couldn't tell. "You finally say it and all I want to do is break his neck."

"He's a cipher. It was me. All me. I wanted to forget you and I failed." Callie plunged into the bathroom. She didn't know if Coop would be there when she came out.

He wasn't.

CHAPTER 26

allie threw herself onto the bed, slamming her sunglasses against her face. "One fucking mistake. You slept with a harem of women in New York, for christ sakes." The walls didn't answer. She flung the glasses across the room. Then her shoes. An hour passed, maybe three. Her stomach hurt. An erratic rhythm drummed against the back of her eyes. Lifting her arm hurt. Lifting a finger to click the TV remote hurt. The brightly outfitted reporters spoke sports. Or Hollywood. Or Greek.

Sharp raps on wood propelled her toward hope of a happy ending. The proprietor offered a note for C. Franklin in Coop's hand. She clutched the unopened envelope until her damp hands softened the paper. Much later, she smoothed the crumpled B&B stationery. Two words. "I'm here."

Oh. My. God. She tore out of the room in stocking feet. From the B&B living room, she heard the drone of Public Radio and two quiet male voices. Just before she entered, she stopped, stood tall and prepared for the final frontier. Coop and the proprietor were playing chess.

When Coop saw Callie, he turned the red king on its side. "Thanks, Earl."

Returning to the suite took some doing since Callie had locked herself out and Earl wanted to trade a spare key for chat. "My daughter went to Cooper. Best thing that ever happened to her." He showed Callie an official photo on the wall. "She's the lieutenant governor, y'know."

Several politely endured anecdotes later, they were alone.

Callie shut off the TV. "I thought I lost you."

"You know me, Callie. I can't think indoors."

"And now?"

"I walked. Ran. Stumbled. I covered about a hundred blocks—in a town that only has a few dozen. Finally I knew I needed to come back."

She studied her recently manicured fingernails. "I inherited a fortune from Blake. Is that a problem?"

"Depends." Coop pulled bottles of water from a tiny refrigerator. "What are your plans?"

"Not 'Why did you sleep with that guy?'"

"I did a lot of compensatory fucking in my New York days. Double standards don't help." He handed her a bottle.

She unscrewed the top, feeling like Pandora. "Does the money bother you?"

"Not me. You're the one who doesn't like rich people."

"I don't know." She scrutinized the label, hoping for inspiration.

"Callie, you tell the girls they're the masters of their own destiny. Why not you?"

"Too much damage."

"Gimme a break. Our students' lives could out-soap-opera yours any day."

He was right. She searched for the source of her dread. Sophie's letter. "Mom was afraid Blake'd kill her if she left. Violent abusers do that, you know. Kill the ones who try to escape."

"Yes."

"She wanted to protect me." Callie held the water bottle against her chest like a shield. "I think that day she finally said no."

"And he couldn't let her go."

She backed away. "I had to leave."

"To see if I'd let you go?"

She nodded.

"Are you afraid I'll change, like Blake?"

Callie hesitated. *Am I?* "No. You're the most honest person in the world. But ..." Truth hovered and then landed. "I'm afraid I

will."

"Turn into Blake?"

"I can be really mean. You haven't seen the worst."

"Maybe not, but I've seen the best."

"What if I let you down?"

"Making a life together has endless ups and downs. I'm sure we'll both feel let down sometimes. But I hope not betrayed."

"Men always meant danger. Or might've. I never stayed long enough to find out." She looked at the wall and the ceiling, anywhere but Coop. "Until you."

"Until me. Great. What if I have a bad day? Look at you cross-eyed. Lose my temper?"

"You're just as apprehensive as I am." She sat on a straight-backed chair near the door, like a patient awaiting a final diagnosis.

"I have doubts, sure. We live in divisive times. But I have a lot of faith in us. What are you really afraid of?"

A shadow from the street pulled her attention, painting pictures she usually didn't let in. Blake's fists, the blood, the shattered glass, Mom's body. The gun that couldn't stop it. "I was too late for Mom. Nearly too late for Nora—"

Somehow Coop followed her to the past. "Oh, sweetheart. None of those were your fault."

Those words, never before believable, finally rang true. Years of self-defense training, therapy, and Sophie's million reassurances fell into place. He held out a hand but waited for her to take it. How many times had he given her this choice? Stay or go. Yes or no.

Entwining her fingers in his, she ran the palm of her hand along his cheek. Later they would call the next moment 'the honeysuckle kiss' because of the gentle scent through the open window. Kisses led to soft touches, then bolder ones, and the musical sighs of finding one another.

Well past moonrise, Coop and Callie, breathless from reconciling, struggled out of bed.

Callie spoke the first uncomplicated truth of the night. "I'm famished."

Already on the phone, Coop discovered that the town's only pizza place was closed. He dialed another number. "You up? ... Starving ... We'll be there." Coop took Callie's hand. "Hazel was expecting us. Go figure."

Within a few minutes they sat at Hazel and Craig's dining room table, devouring Hazel's elegant pasta and salad, punctuated with Craig's expensive cognac. Coop's hand still held Callie's. "That was some note you left me."

"And me, too." Hazel snickered. "At least it wasn't, 'Love means never having to say you're sorry.'"

"Or, 'You complete me.'" Callie's laughter joined Hazel's. Coop rolled his eyes and Craig responded in kind.

Callie ran a finger around the crystal rim, creating a high whine. A look from Craig stopped her. She squeezed Coop's hand. "I wanted to talk to you every hour of every day. But I had nothing. I can't teach without endangering the school—unless I give you up. And I can't. Your father learned the consequences of merely seeming improper, even when it's a lie. Ironic. That's where it all started, with Peter's sister falsely accusing your dad."

"She probably didn't know any better. Her brother was a nightmare and she had no defense." Hazel pointed to a framed picture of Susan B. Anthony with her quote: Woman must not depend upon the protection of man, but must be taught to protect herself. Hazel rubbed her eyes. "Rarely does protection require lying."

Callie sat forward. "That's it! A women's center. Like the one Miriam wanted. Classes and workshops and self-defense and Sex Ed and—"

Coop touched her knee, as if to bring her back to reality. "Here, right? Not Timbuktu?"

"Here."

"But not now." Hazel opened the door and pointed outside. "Tomorrow."

"Tomorrow." Callie felt hopeful for the first time since her checking account had grown too large for one bank. *First, though, Nora.*

The next afternoon, Callie stood on the station platform amid

a scattering of locals waiting to greet the train. Above the fading screech of brakes, she heard Nora and Alexis, laughing as they skipped down the steps. When Nora saw Callie, she dropped her boutique bags and ran to her waiting hug.

"I knew you'd come back." Nora gripped Callie's arms as if debating whether to embrace her or wrestle her to the ground. "Didn't I say that? Alexis? Didn't I?"

"Hey, Callie. Welcome back. Shauni'll be pleased." Alexis patted Callie's arm, still engaged in hugging Nora, and waved goodbye as she departed.

Nora cocked her head to Alexis without losing Callie's gaze. "I'm seriously mad at you."

"I'm sure." Callie appraised Nora's wild hair and homemade jewelry. "You look good."

"You look rich."

Each waited for the other.

"Let's get out of here, Nora. Go hiking." Callie walked Nora to the rental car.

"You sound like Coop." Nora lowered her voice to imitate her father. "Serious talk? Let's run ourselves ragged."

In the car Callie, stalling before the emotional talk to come, described the women's center. "I'll name it after your mother if that's okay."

"Can I paint a mural?"

"Is that a yes?"

"That's —awesome-exclamation-point-like-OMG-I'll-be-your- interior-decorator YES." Nora watched Callie drive, something she'd never seen before. "I see you took adult drivers' ed."

"Yeah. I passed with flying colors and didn't learn a damned thing." Callie, still nervous, kept her eyes on the road. "So I have your approval?"

"Do you have to ask? You always seem so confident."

"On the outside. The juvenile justice system taught me to act tough and cover everything else." Callie rolled down the window. "Not into shutting down anymore."

"Me either."

An hour later they were climbing Lover's Mountain. A warm breeze carried the scent of summer earth and foliage. Callie remembered when this path had been too icy to pass. Halfway up Nora sat on a fallen tree. "I need a break. You're in better shape." Sweat stained her shirt. "Before you ask, yes I have sunscreen." She pulled out a tube and slathered it on. "I'm protected. If yer gonna talk, talk."

Callie peered through Nora's dark lenses, trying to decipher the girl's mood. "I didn't leave you."

"Sure felt like you did." Nora tipped her head defiantly.

"I went home to Troyville." Callie reached toward Nora but didn't touch. *How can I show affection without intrusion?*

Nora neither shrugged off nor accepted Callie's hand. "What were you thinking?"

"I wasn't thinking. I was running."

"You're an idiot."

True that. "I love your father and I love you but—"

"I love waffles but I don't have a crisis of conscience about them." Nora grabbed a leafy stick and stabbed the deep crevices of rotting bark on the fallen tree. "The night you left you said you wanted to go home."

"You heard all that?"

"I sat at the top of the stairs like I always did when Mom and Dad argued."

Callie clapped her hands. "Until this moment I hadn't seen a single upside—for me, that is—of you going away to school."

"Why do you do that?" Nora tore a leaf off the stick and tossed it into the bushes.

"What?"

"Make jokes whenever stuff gets serious."

"Survival device, I guess." She sat next to Nora on the log. "Honesty's not so easy, right?"

"Right." Callie squeezed Nora's shoulder, this time without asking. "Maybe we can all work on it together."

"Until you want to go home again."

"Turns out my home is here."

Time could be measured in the sound of insects if one knew

how. Callie didn't.

Nora turned her NY Mets cap so the brim covered her neck. "Thanks, ugly stepmom."

"Stepmom?"

Nora waved her stick like an orchestra conductor. "Don't need to be married to be a mom. Teach that at your center."

Callie snatched Nora's hat and swatted her lightly. "How about respect for your elders?"

Laughing, Nora chased Callie up the mountain until they reached the summit and fell exhausted. Callie got her breath back first. "It's weird being rich."

"Weird good or weird bad?"

"Both, I guess." She sat up and hugged her knees to her chest. "It's like another planet. I've been broke all my life. Some childhood memories are living in a fancy house where nothing was for me. Blake kept my mother on a strict allowance so she couldn't escape. He had millions but she was worn down by hiding pennies and stealing from him when he slept—not to mention her anorexic diet because he liked her skinny. One time she amassed enough to get us to Sophie's and for three or four glorious days nobody supervised our food or bathing or ..."

"Bathing?"

"He always watched me. Never touched me but ..."

"Eew, totally creepy." Nora screwed her eyes tightly shut as if to erase the visual.

"Blake hated Sophie because she was never charmed by him and never stopped calling him on his abuse. He knew Mom would run to Sophie and she'd shelter us and lie to protect us. He hired a private eye who waited slouched down in a nondescript car outside the house. One day, without asking, I went out to play. Big mistake."

"How could you know? You were a kid."

Callie poked a finger into Nora's shoulder. "You would do well to take that advice yourself."

"Don't change the subject. What happened?"

"I guess the detective called Blake because I was still on a swing when Blake and his cop friends arrived, banging on the

door with warrants, accusing Sophie of kidnapping. Of course, the charges disappeared after we got back to his house. Who knows if they were even real? One of my mostly horridly vivid, indelible memories is him dragging her from the car, her knees scraping the pavement while she screamed. He locked me in my room and beat her for hours. That was the night before … before …"

"Before he killed her." Nora's tears slid from under her sunglasses. She pulled Callie into an embrace. "You thought it was your fault. Like I did about my mother."

The two women sat quietly as insects and birds took over the conversation.

Nora coughed and wiped her eyes. "Your stepfather wasn't just rich. He was a psychopath. Like Peter."

"Legions of psychopaths roam the earth. The ones who aren't easily identified are usually rich." Callie wondered irrelevantly how Scrooge McDuck would be received today.

"Yeah, but does it follow that it's good to be poor?"

"In juvie, like prison, you count on people from the outside bringing extras like cigarettes and toiletries and so on. Sophie didn't have much but she brought me books from her own library. That's when I first read *Jane Eyre*. Those dog-eared copies were my lifeline. After I got out, and especially after she died, I didn't know month to month whether I could make rent. Poverty gnaws at you. But I had her books and the alternate universes they offered. I got through school by working full time while taking maximum credits. One lousy job after another where I answered to some creep who looked down on me—yet I could only keep the job by kissing his ass."

"That's why you were so cagey around Coop when you first met him." Nora pushed hair off her neck.

"I kept thinking 'one wrong step and he'll kick me to the curb.' I couldn't believe I was finally earning a decent salary. My soundtrack was a chant—'You'll never have enough' followed by a mean little Blake voice whispering 'You'll never *be* enough.' Of course, that pissed me off. I got to be proud of how much I could save, what bargains I could find." Callie glanced at her new hiking

shorts, periwinkle like the sky.

"And you worked out until you became the Amazon I see before me." Nora flexed her biceps, impersonating a body builder.

"Yeah. Without benefit of gym or equipment. At first, I just wanted to win the fights. I'm not stronger than most guys, but I'm quicker and have better training."

"Like Lisbeth Salander."

"Who?"

"*The Girl with the Dragon Tattoo*." Nora glanced sideways as if checking whether Callie approved of popular fiction.

Callie was elsewhere. "I keep asking myself whether I can use my money as well as I did when I couldn't afford a checking account."

Nora, who'd grown up in a stable family with financial security, seemed puzzled. "Why wouldn't you?"

"I don't know how to be rich. When I first got the money I spent indiscriminately—clothes, hair, fancy stuff I don't even like. Random strangers started asking me for cash. Sometimes I acted like the worst of my jerky bosses."

"Callie Legree." Nora pulled at a tall stalk of wild grass.

"I can do whatever I want. I always hated that about rich people. The rules don't apply. And now I'm out here in millionaire land figuring out which rules to discard."

"I hope you throw out the stuff that made you run away." She tossed the weed at Callie.

"Working on it. I finally picked winners. You, your dad, Hazel. Shouldn't that help me trust myself?"

Nora's voice quavered, "When my mom got killed I stopped thinking of myself as a winner. You changed that."

In a tree above the meadow where Coop and Nora had scattered Miriam's ashes, a squirrel chattered, no doubt about storing nuts.

Nora sat up. "What did you do in Troyville, anyway?"

"Visited Sophie's grave." Callie elbowed Nora. "Volunteered, worked out. Thought I could get more done outside the Emerald City."

"The Cooper School as the Emerald City—gives me an idea." Nora stretched her fingers up, outlining the clouds. "Let's go. Coop's on his way into New York to interview potential teachers. I gotta ask him to pick up fabric swatches."

"Swatches?"

"In case someone needs a wedding dress." Nora moved down the trail ahead of Callie.

"Not sure about that." Callie delivered Jane Austen in sing song, "A single woman of good fortune is always respectable."

"Emma wasn't in love when she said that."

"I'm pleased you remember your English novels."

"In the very end, Emma married Knightly. For love. Even though he was way older."

Callie caught up to Nora. "Coop's only ten years older than me."

"Only."

"I'll be thirty-two pretty soon."

"Callie, I'm teasing. I want you to marry Coop. We all do. You're the only holdout."

"I guess you've forgiven me."

"Secretly, I forgave you the minute I saw you at the station." Nora punched Callie playfully. "Last winter I thought I couldn't live without you—like you were my mother reincarnated, come to rescue me. But when you left I had to rely on myself and, you know, count my blessings—Dad, friends, school. My art."

Callie hugged Nora. "You can't get rid of me now because you don't need me anymore."

"Did I say that? I don't think so. Every girl needs a mom. Even an ugly stepmom."

Callie had never experienced an August like the one that followed. Hazel's decision to throw a joint celebration for Callie's birthday and Nora's sendoff occasioned untold cooking and baking. Brightly colored tents rose like giant cartoon mushrooms on the lawn in front of Admin, filled with long tables and chafing dishes and bowls of flowers. Friends of Coop and Nora arrived from all over the world and Lana led a small battalion from Troyville.

Coop took a quiet moment before they joined the fray to show Callie the board's letter of approval for the women's center. "We can invite everyone back for a groundbreaking this time next year. Maybe that could be a two-fer celebration, too." He caught Callie around the waist and kissed her.

"I'm warming to the marriage idea. If you're sure you're not after my money." Further kissing undercut Callie's joke.

"You haven't figured out that I don't need it."

"Right, that's why your daughter got a scholarship." She checked herself in a mirror and ran a comb through her hair.

Coop looked out the window at the neatly groomed grounds. "The money recognized her achievements. We didn't accept it."

Callie checked her face in the mirror. "Pardon?"

Coop pulled her into his arms. "Remember those headlines about obscene salaries for financial industry executives?"

"Hard to miss." Her look warned him not to underestimate her, though he rarely did.

"When I worked in New York, my combined income from salary, patents, bonuses, and stock options was comparable. I set up a college fund for Nora, a retirement fund for the faculty, and an endowment for the Cooper library."

"You could retire." *Have any girl in the world.*

"I love my job." He gently straightened Sophie's dove necklace on her neck. "I don't need you, Callie. I want you."

Callie leaned close, wanting to forgo the party. "With no worries, how can love survive?" She sang her final phrase, a *Sound of Music* song about millionaires in love.

"No rides for us on the top of a bus, indeed."

She was inexplicably pleased he knew the song. "And they say straight men don't know musicals."

"Whoever 'they' are." He messed up the hair she'd just combed. "Running a school and a center will keep us plenty busy. But I think we can make time for other activities." Grinning, he slid a finger under the spaghetti strap on her summer dress and kissed her uncovered shoulder, then her neck, then the rise above her breast.

Eyes closed, Callie guided his hand to greater intimacy, her

fingers seeking the buttons on his shirt.

Just in time, Nora thumped through the front door, carrying a stack of empty packing boxes. "I walk away for a second and next thing you know it's a French movie. I'll be down as soon as I dump these—and I expect you two to behave."

Callie and Coop pulled apart, straightening one another's garments, murmuring, "Later.'

Hazel arrived almost instantly. "Time to join the party." She called up the stairs. "Nora!"

In moments, Nora and Coop were greeting guests on the lawn. Callie watched them, silently calling to her lost family. *Sophie. Mom.* She pulled on Hazel's arm. "Pinch me. Tell me this is where I belong. Tell me I'm doing the right thing."

Hazel gently pinched Callie's cheek, then planted a kiss to make it all better. "Who can really know what's right until it's over? Don't wait. Happiness is a mitzvah—a blessing."

Love Books?

SUPPORT AUTHORS – buy directly from their publishers. This puts more royalty dollars into the pockets of your favorite author – and gives them time to write their next book.

Visit us for links to many vibrant publishing companies to find the book for you.

Van Velzer Press
Americana with a Twist

These ARE The Books You've Been Looking For.

ABOUT THE AUTHOR

Jan Levine Thal began writing fiction in grammar school, once winning a copy of Ernest Hemingway's *Old Man and the Sea* as first prize in a contest. Until then, she had no idea that writing might pay off. She awaits further confirmation. In the following decades, she moved to several cities where she wrote for and edited myriad publications. After settling in Madison, Wisconsin, she became a radio personality at WORT-FM, penned a popular advice column in the *Madison Insurgent*, and volunteered for community theater. Several short plays have been produced by Madison theater companies. Her feature-length plays, *Cassandra's Gift, Esther's Descendants, and Fake Mom were* produced in Madison, WI. She served as president of the Board of Directors of Broom Street Theater, one of the oldest continuously operating experimental companies in the USA, and was a founder and the Artistic Director for the Kathie Rasmussen Women's Theatre, producing work written and directed by women With degrees from Harvard University, Northwestern University, and the University of Wisconsin-Madison, she made her living as the managing editor of an academic journal in economics for more than three decades. She has one son, Jeremy Thal, a French horn player who has performed with The National and Neutral Milk Hotel as well as co-administering Found Sound Nation and OneBeat.

www.JanLevineThal.com

ACKNOWLEDGMENTS

Many people contributed to this novel one way or another. Thanks to Sheila Zukowsky for help with the French and Chuck Winant for firearms advice. Elizabeth Browning and her New York City acting class staged key moments in early drafts, bringing the Cooper School to life. Thousands of phone hours with Beverly Moran, Lisa Rosman, Robin Schulberg, and Holly Yasui from Nashville, Brooklyn, New Orleans, and San Miguel de Allende, respectively, built confidence in my voice.

My Madison, Wisconsin, creative circles fed me in every possible way. They include Lou Berryman, Peter Berryman, Kurt McGinnis Brown, Catherine Capellaro, Kathleen Chung, Cynthia Crane, Walter Dickey, Tracy Doreen, Melanie Herzog, Wendy Fern Hutton, Ingrid Kallick, Greg Lawless, Michael McDermott, Mary-Elizabeth Pasquesi, Heather Renken, Andrew Rohn, Autumn Shiley, Gail Sterkel, Sally Stix, Mary-Ann Twist, Geremy Webne-Behrman, and Sarah Whelan. I send a shout out apiece to the Kathie Rasmussen Women's Theatre, Broom Street Theater, and the Rasmussen Rowdies.

I am forever indebted to Laurel Yourke and dozens of writers in her workshops whose insightful critiques convinced me to trudge on through the laborious journey that became Callie's first adventure.

Diana Burnett deserves ten thousand gold stars for endless good humor and practical advice. Trisha Lewis for helping to upgrade the edits and get this wonderful book into the hands of readers.

I'm sure I've left out several key important readers and advisors but that makes them no less important.

For a full and fascinating life that led me to this endeavor, I thank my fabulous friends and family, including Solomon Levine, Elizabeth Levine, Sam Levine, Michael Levine, Elliott Levine, Mirette Seireg Ohman, Sean Levine, Sybil Levine, Reed Levine, Josh Levine, Zoe Levine, Marianna Baretto, and especially my son, Jeremy Thal.